PAINTED ARCHITECTURE AND POLYCHROME MONUMENTAL SCULPTURE IN MESOAMERICA

PAINTED ARCHITECTURE
AND POLYCHROME
MONUMENTAL SCULPTURE
IN MESOAMERICA

A Symposium at Dumbarton Oaks

10TH TO 11TH OCTOBER 1981

Elizabeth Hill Boone, *Editor*

Dumbarton Oaks Research Library and Collection
Washington, D.C.

Library of Congress Cataloging in Publication Data

Main entry under title:

Painted architecture and polychrome monumental sculpture
 in Mesoamerica.

 Bibliography: p.
 1. Mayas—Architecture—Congresses. 2. Mayas—
Sculpture—Congresses. 3. Aztecs—Architecture—
Congresses. 4. Aztecs—Sculpture—Congresses.
5. Indians of Central America—Architecture—Congresses.
6. Indians of Central America—Sculpture—Congresses.
7. Indians of Mexico—Architecture—Congresses.
8. Indians of Mexico—Sculpture—Congresses. I. Boone,
Elizabeth Hill. II. Dumbarton Oaks.
F1435.3.A6P35 1986 729'.4'097281 85-4514
ISBN 0-88402-142-4

To the memory of
Donald Robertson
12 May 1919–18 October 1984

Contents

Color Plates

Preface

MUCH MESOAMERICAN ARCHITECTURE and sculpture was brilliantly painted, the stones enlivened with color that also added to the symbolic meanings of the structures and carved forms. Yet the use of color on buildings, reliefs, and other three-dimensional works is often overlooked in studies of Pre-Hispanic art and architecture, because much of the paint is gone and because today color seems relatively insignificant to us. So little color remains on Mesoamerican sculpture and architecture that scholars are accustomed to seeing the bare stone or the white of the plaster coating. Certainly no one is startled when a seemingly unpainted building or sculpture is excavated; to the contrary, we are surprised and delighted to discover a "Red Temple" next to the Aztec Templo Mayor or a polychrome Chacmool in the Templo Mayor proper. In our own culture, paint is so relatively unimportant in all save domestic architecture that we do not generally seek to find the traces of color that might remain on ancient monuments; the presence, or indeed the absence, of color is rarely mentioned in studies of, for example, Aztec architecture or Maya sculpture.

By and large, we in the twentieth century consider the visual arts to be divided into three principal and distinct categories—architecture, sculpture, and painting—each having its own set of materials and techniques, formal parameters, and function, and each being taught separately in schools or departments of art. In the wake of Louis Sullivan's ethic of "form follows function" and the subsequent Bauhaus movement, modern architecture is rarely embellished with color or with rich sculptural programs that would hide the structural design and the materials of construction. In sculpture of the last several centuries, too, there has been a particular concern (at least until Pop Art of the 1960s) with allowing the essential properties of the material—be it metal, stone, wood, or plastic—to determine the color of the work, with the interchange of volume, void, and texture dominating over any artificial coloristic additions. We have thus been conditioned to expect that architecture and sculpture are basi-

cally monochromatic. Of Aztec stone carving, Henry Moore said, "Mexican sculpture . . . seems to me to be true and right. . . . Its 'stoniness', by which I mean its truth to material, its tremendous power without loss of sensitiveness, . . . make it unsurpassed in my opinion by any other period of stone sculpture."[1] His praise is well targeted, from his own point of view, to the Aztec sculptures on display in the Sala Mexica of the Museo Nacional de Antropología, which are devoid of color, but from the perspective of the Aztec citizen, Moore's praise is wide of the mark. Moore did not consider that Aztec sculptures were once polychrome, that the colossal jaguar *cuauhxicalli* of grey andesite, for example, was originally plastered and painted a bright yellow with black spots, which destroyed its stoniness but heightened its visual impact and assured its identification.

In Mexico and Guatemala, color has traditionally been an important component of the built environment. The interiors and many of the facades of Colonial churches were painted brightly, and this interest in polychromy is still seen in the painted surfaces of homes and shops in small villages, as well as in urban centers where they compete with the "industrial" exteriors of the International Style. In Pre-Hispanic times, color may have been even more prominent as an integral part of architecture and sculpture.

The 1981 Dumbarton Oaks symposium on "Painted Architecture and Polychrome Monumental Sculpture in Mesoamerica," of which this volume is the result, sought to focus attention on what remains of the original color of Mesoamerican architecture and sculpture. Donald Robertson, who ably chaired the symposium, proposed the topic because so little attention had been paid to the use of paint in Mesoamerica and because the existing polychrome was being continually destroyed by the elements of nature and increasingly by atmospheric pollution. A planning committee, composed of Robertson, Gordon Willey, Robert Sharer, George Kubler, and myself, met to organize the symposium.

Although the spectacular murals discovered at Cacaxtla in 1975 were still very much on everyone's mind, and there were fresh reports of murals from the then-ongoing Templo Mayor excavations in Mexico City, figural murals per se were excluded from the conference, because we wanted the focus to be on the use of paint in a broad sense rather than on the interpretation of individual murals. It was hoped that the conference would assemble information on monumental polychromy from the major cultural areas of Mesoamerica. By excluding murals, however, the painted architecture and sculpture of Teotihuacan was omitted, and our limit on

[1]John Russell, *Henry Moore* (New York, 1968): 12.

the number of speakers precluded complete coverage of the Gulf Coast, the Postclassic Maya, and a number of sites in Central Mexico. My summary at the end of the volume attempts to fill at least some of these gaps and give an overview, but it is clear that this volume is only a first attempt to investigate the use of color.

Taken together, the papers in this volume describe the use of color over a broad geographic and temporal range. The Maya approach to painted architecture and sculpture is covered by David Freidel (Preclassic Lowlands), Linda Schele (Classic Southern Lowlands), and Jeff Kowalski (Northern Lowlands); the situation in Oaxaca from the Preclassic to the Conquest is addressed by John Paddock; and the use of color in Postclassic Central Mexico is considered by Ellen Baird (Tula) and H. B. Nicholson (Aztec sculpture); unfortunately Mercedes Gómez Mont's presentation on painting associated with the Aztec Templo Mayor was not submitted for publication.

Linda Schele complained to me that hers is a "library paper," and so are they all, for each author had to return to the original field reports to find notices of color, and it speaks extraordinarily well of Mesoamerican archaeology that so much color was retrieved and recorded. A surprising number of buildings and sculptures throughout Mesoamerica were painted either entirely in red, with red designs on the plain surface, or with polychrome.

Each author additionally seeks to explain why color or specific colors were used. Most of the papers address the general function and meaning of colors among the people who used them, and Freidel and Baird concentrate more specifically on the symbolic significance of color in the context of the particular images at Cerros (Freidel) and Tula (Baird). Schele also discusses the chemistry of Maya pigments, and she, Kowalski, and Paddock all consider the economics of paint, pointing out that red may be the color most widely used simply because red iron-oxides are more readily available, and thus cheaper, than other pigments. Certainly red dominated Mesoamerican architecture and sculpture.

In popular contexts and cross-cultural comparisons, some Mesoamerican art styles are often compared with the products of Greek civilization (i.e., the "Greeks of the New World"). With respect to color, it might be useful to remember that Greek sculpture and architecture, appreciated for its simplicity and the clarity of its form, was brightly painted, too.

This volume is dedicated to the memory of Donald Robertson, an innovative and broadly humanistic scholar and a great man. Don was one of the foundation piers of Pre-Columbian art history. With his *Mexican Manuscript Painting of the Early Colonial Period* (Yale, 1959) he virtually

established the art historical study of Mexican pictorial manuscripts, and he continued in his other writings to present new ways of seeing Pre-Columbian and early Colonial art and architecture. On a personal level, Don was exceptional, too. He delighted in Pre-Columbian art and had that rare talent of infecting others with this delight; and, with his legendary wit, he could and did poke fun at Pre-Columbian studies when and where it most needed it. At Dumbarton Oaks, Don served as an Advisory Committee member and then as a Senior Fellow from 1976 to 1980. The program in Pre-Columbian Studies owes much to him, for he brought to Dumbarton Oaks the same enthusiasm and fun, mixed with a fundamental seriousness of purpose, that characterized his humanism.

Elizabeth Hill Boone
Dumbarton Oaks

Polychrome Facades of the Lowland Maya Preclassic

DAVID A. FREIDEL

SOUTHERN METHODIST UNIVERSITY

INTRODUCTION

THE MASTER PAINTERS of the Late Preclassic era (350 B.C.–A.D. 100) in the Maya lowlands preferred pyramids to pots. The work on Tikal's North Acropolis during the 1960s (Coe 1965b) showed that the plain stucco modeling of Uaxactun's famous Structure E-VII-Sub. (Ricketson and Ricketson 1937: 72–93) was not the standard convention for early Lowland Maya architectural decoration. The dominant building on the North Acropolis, Structure 5D-Sub. 1-1st, had an elaborate upper facade of modeled elements painted red, black, and pink on a cream ground. A small shrine in front of this temple, Structure 5D-Sub. 10-1st, bore beautiful murals in black, red, and yellow on backgrounds of pink and cream.

During the 1970s, the available sample of Late Preclassic buildings in the lowlands was considerably enlarged. Architectural decoration is now reported from Cerros (Freidel 1981: 207–223), Lamanai (Pendergast 1981: 39–42 and personal communication, 1981), and Cuello (Hammond 1980) in Belize; and from El Mirador (Richard Hansen, personal communication, 1981) in Guatemala (Fig. 1). Facades at Cerros and Lamanai were polychrome, and the exposed portion at El Mirador shows bichrome painting. The sample is still very small and only in the preliminary stages of analysis and presentation. Nevertheless, some observations on technique can be made and some directions for future inquiry outlined.

MODES OF LATE PRECLASSIC DECORATION

The Late Preclassic decorative range appears to include unpainted modeled stucco, flat painted outdoor murals, and a combination of paint and modeled stucco. Unpainted stucco, now only reported from E-VII-Sub. at

5

David A. Freidel

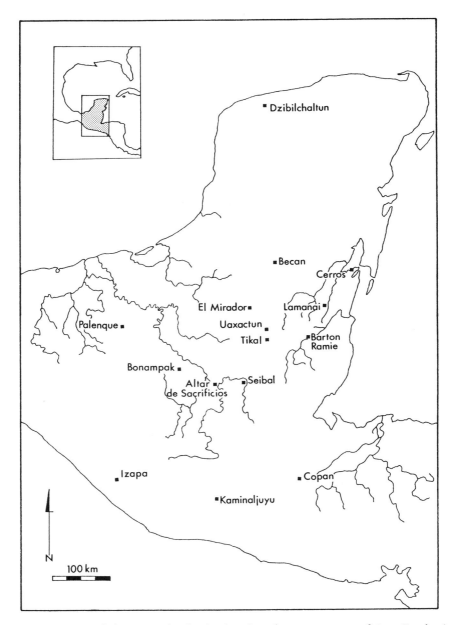

Fig. 1 Map of the Maya lowlands showing the occurrences of Late Preclassic architectural decoration and the major Classic sites.

Uaxactun, is distinctly the exception. There is always a risk when reporting unpainted stucco that one is dealing with a heavy calcite precipitate layer over painted surfaces. However, there are several reasons to think that unpainted modeled stucco is a genuine mode: 1) fallen fragments of facades do not usually acquire precipitate and can indicate the presence of paint even where paint cannot be discerned on sections still in place; 2) the E-VII-Sub. masks show a clear emphasis on modeling in areas rendered in paint·on facades elsewhere (e.g., teeth and eyes); and 3) at E-VII-Sub., a red line was reported as "unique" on one of the masks of the central tier, and traces of red paint were found on the upper masks (Ricketson and Ricketson 1937: 84–86), indicating tht observers were alert for signs of paint. It remains to be seen if the unpainted modeled stucco mode is of regional importance or is merely the idiosyncratic practice at Uaxactun.

Painted flat surfaces, as in exterior mural painting, is a demonstrated mode at Tikal (Coe 1965b: 17–19) and is found decorating the stairway of a small pyramid at Cuello, Structure 35 (Hammond 1980). There is also some evidence from Structure 29B at Cerros to suggest that mural panels were incorporated into an overall decoration otherwise dominated by modeled and painted decoration. A stuccoed, well-dressed jamb-stone, with red and black fragmentary designs on it, was found in the debris. It is worth noting, however, that Structure 5D-Sub. 10-1st at Tikal (Coe 1965b: 18–19) is evidently a commemorative monument over a tomb. Other mural painting was discovered in Late Preclassic tombs in the North Acropolis, and the mural painting at Cuello contains cartouched elements that might be glyphs (Norman Hammond, personal communication, 1980). Tombs, texts, and murals go together in Early Classic times; perhaps outdoor murals will be found to have similar associations in the Late Preclassic.

The combined use of polychrome paint and stucco will, I believe, emerge as the hallmark of Late Preclassic architecture among the Lowland Maya as the sample increases. There are many practical advantages that result from the combined use of these media, as discussed below; but in addition, it is likely that colors already carried significant symbolic value to the Maya and conveyed important information about the images modeled in stucco.

Painting is used to enhance the effects of modeling and also to express distinct messages. Our most complete example of this mode is currently found on Structure 5C-2nd at Cerros, and I will therefore draw examples from these panels. The lesser-known buildings at Tikal and Lamanai provide sufficient data to indicate that the following observations will hold generally for the region.

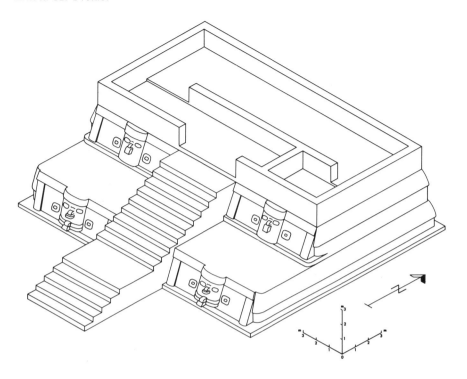

Fig. 2 Isometric rendering of Str. 5C-2nd at Cerros. Drawing by James Garber.

Paint is used to highlight modeled elements throughout the 5C-2nd facade (Figs. 2, 3). In general, the background between elements is a bright red, while the base color of the raised and modeled elements is cream. For example, the four bosses on the ear-plug flares (Fig. 3) are painted cream and are distinguished from the cream surfaces of the flares by red outlines. Similarly, the human noses on the main masks have red highlighting to distinguish the modeled surfaces of bridge and nostril. The pervasive use of red as background and highlight on these panels results in an interesting effect: the areas left cream (the base color) stand out strikingly as the principal design. This is, in essence, a negative painting technique, a strategy analogous to, and perhaps derived from, negative resist painting on pottery.

In addition to actual highlighting, paint is used in a number of instances to supplement, enhance, correct, or replace elements otherwise rendered in

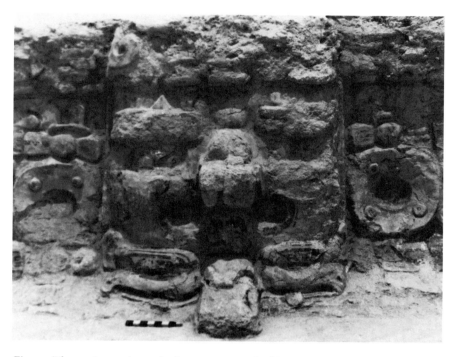

Fig. 3 The main mask on the lower east panel of Str. 5C-2nd showing the painted detail (see also Fig. 6).

modeled stucco. For example, the breath-scroll on the profile polymorph on the west side of the lower west panel (Fig. 4) was modeled as a rectangular block. Evidently dissatisfied with this departure from the usual curvilinear appearance of this element, the artisans responsible for painting the highlights gave the element a curvilinear look in paint. On the other side of the lower west panel (Fig. 5), the profile polymorph was too close to the edge of the building. As a result, there was insufficient space for the breath-scroll to flank the upper mandible of the polymorph, as in other instances. The painters therefore rendered the breath-scroll in red on the mandible itself.

In other circumstances it is not as easy to tell whether the replacement of modeling with paint was meaningful or merely expedient. The tooth ridges, fangs, and breath-scrolls of the lowermost main mask on the lower east panel are all modeled and then detailed in paint (Fig. 3). On the lower

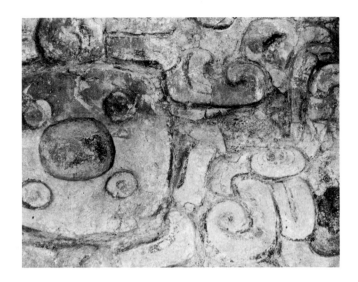

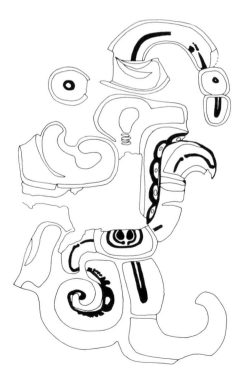

Fig. 4 Detail of the lower west panel on Str. 5C-2nd: a) *above* Photograph showing most of the profile polymorph with the breath-scroll delineated in paint; b) *left* Drawing of the profile polymorph; c) *opposite* The profile polymorph divided into its elements and motifs.

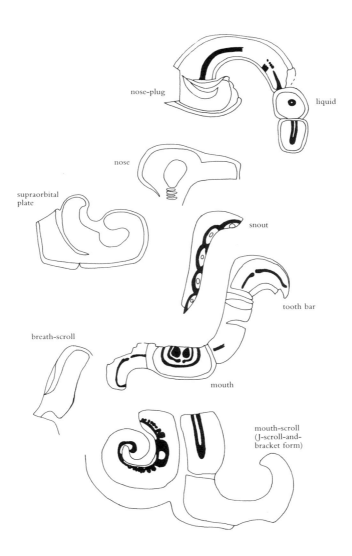

nose-plug

liquid

nose

supraorbital
plate

snout

tooth bar

breath-scroll

mouth

mouth-scroll
(J-scroll-and-
bracket form)

Fig. 5 Detail of the lower west panel on Str. 5C-2nd showing another breath-scroll (see arrow), rendered only in paint on the mandible of the profile polymorph.

west panel (Fig. 4), these same elements are rendered in paint only. Because there are several clear iconographic contrasts between the eastern and western panels in general, there is the possibility that this technical contrast is intentional.

The existence of unpainted modeled stucco might suggest that paint, where it is found in conjunction with modeled stucco, is a secondary complement, but the panels from Structure 5C-2nd show that this is not the case. Modeled stucco and paint are fully integrated to convey primary imagery and are partially interchangeable media. Sometimes paint pro-

vides definition where stucco cannot be used or has been forgotten. Certainly the use of panels for eye, mouth, and brow areas on the main masks anticipates the use of paint to convey the subject matter. Some stucco elements are designed specifically as flat panels for exclusively painted motifs. The prime example of this at Cerros is the panel attached to knot tassels on the ear-plug assemblages of the eastern side of Structure 5C-2nd (Fig. 6a, b). Analogous panels are found on Structure 29B at Cerros (Fig. 7). Glyph panels are also part of the ear-plug assemblages on the Structure N9-56 facade at Lamanai (Pendergast, personal communication, 1981).

THE EVOLUTION OF PAINTING IN THE LATE PRECLASSIC

Pursuing technical considerations a bit further, there are hints of an internal developmental pattern within the mode of polychrome modeled stucco. Structure 5C-2nd has three principal colors: red, black, and cream. Minor colors include various shades of pink and orange, no doubt produced by mixing red with other materials. There is also a yellow ochre. This final color is minor only in the sense that it is extremely rare on the facade of Structure 5C-2nd. The same set of colors is found on a substructural facade of Structure 11, a small public house in the Cerros settlement zone (Scarborough n.d.: 108).

In contrast, the facades of Structures 5C-1st, 6B, 4B, and 29B at Cerros all have a broader range of polychrome wherein yellow ochre and green join cream and red as solid colors and black outline is abundant (Pl. 1). Not only does this more elaborate "full" polychrome have more principal colors, it also has several new secondary colors including flesh tones, pastel green, yellow, and grey. In brief, the shift between the stratigraphically prior "early" polychrome and the "full" polychrome is quite dramatic at Cerros.

It is difficult to know whether or not the trend seen at Cerros occurs at other lowland Preclassic sites. There are, however, some indications of the trend at Tikal and perhaps at Lamanai. Structure 5D-Sub. 1-1st at Tikal evidently has the same principal colors found on Structure 5C-2nd at Cerros: red, cream, and black. A slightly later addition to the North Acropolis, Structure 5D-Sub. 10-1st, shows extensive use of black outlining and respectable quantities of yellow. Only the absence of green on these Tikal murals distinguishes them from the "full" polychrome at Cerros. At both Cerros and Tikal the shift from "early" to "full" polychrome occurs in the span of a single construction episode in roughly the same fifty-year span. The newly discovered Late Preclassic Structure N9-56 at Lamanai also exhibits the use of "full" polychrome lacking the green (David Pendergast, personal communication, 1981). Whether or not there

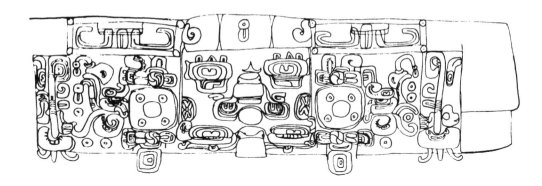

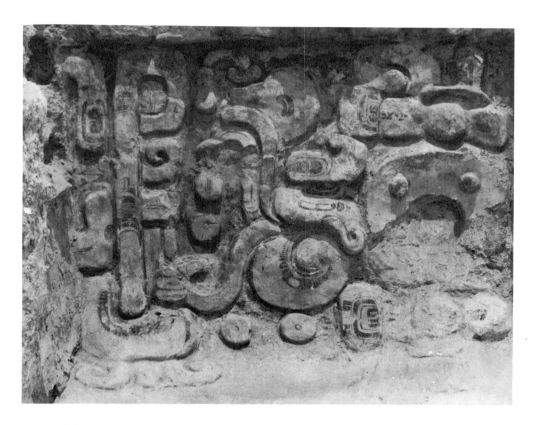

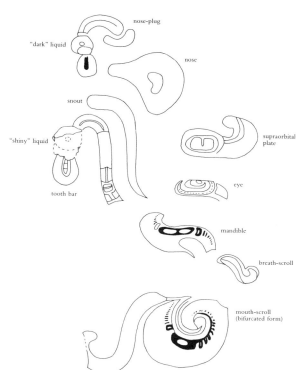

Fig. 6 The lower east panel on Str. 5C-2nd: a) *opposite above* Restored drawing of the panel; b) *opposite below* Photograph of the west section of the panel showing the ear-plug assemblage with attached glyph panels, the flanking profile polymorph, and the descending profile polymorph that forms one head of the double-headed sky frame; c) *below* Drawing of the flanking profile polymorph; d) *right* The flanking profile polymorph divided into its elements and motifs.

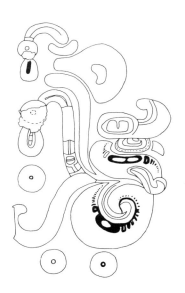

Fig. 7 A panel on Str. 29B at Cerros showing glyph panels (see arrow) attached to the ear-plug knots.

are examples of "early" polychrome buried inside Structure N9-56 remains to be seen. Only further work can tell us if the sequence at Cerros is a regional one, but the implications of such a modal convergence should be obvious: it would have been occasioned by an intense communication between centers and possibly by a merging of the local schools of art in the southern lowlands.

When viewed in the larger perspective of Maya history, the polychrome paint and modeled stucco mode emerges rather abruptly in the lowlands. The Maya were already painting some public buildings solid red in the Early Preclassic period at Cuello (Hammond 1980), and this simple decoration appears to have predominated well into the Late Preclassic period, that is, until about the first century B.C. At Cerros, the earliest public platform, Structure 2A-Sub. 4-1st, is decorated with plain apron moldings painted solid red. At Tikal, the earliest identifiable public buildings in the North Acropolis are reportedly also red with apron moldings (Coe 1965b: 13). The Tikal buildings date to Chuen times, or as late as 150 B.C.; the Cerros building dates to 90 B.C. At both Cerros and Tikal the initial use of polychrome paint occurs in conjunction with modeled stucco as part of an explosive acceleration of architectural construction in the first century before Christ. There are hints of similar changes at other Maya centers such as Lamanai (Pendergast 1981: 39–42) and Uaxactun (Ricketson and Ricketson 1937: fig. 98; Freidel and Schele n.d.; and Schele n.d.a).

The sudden appearance of a developed art style in the Maya lowlands is currently under investigation (Freidel and Schele n.d.). Preliminary analysis suggests that the current corpus displays a unitary cosmological program establishing the basic iconographic parameters of later Classic Maya theology. The coeval appearance of fundamental elements and motifs shaped in stucco with polychrome color indicates that colors already carry clearly understood symbolic references in the Late Preclassic period. In light of research on this subject in the Classic period (Schele, this volume), it is worth speculating on the nature of Late Preclassic color symbolism. It will be argued that the key to color coding lies in its association with elements that carry iconographic meaning.

COLOR AND THE ICONOGRAPHY OF LIQUIDS

Linda Schele (this volume) suggests that during the Classic period the color red has a significant connotation as blood. Her argument follows a seminal work by David Stuart (n.d.) in which he identifies the "casting" gesture of many rulers on Classic stelae as the act of blood-letting. The image consists of scrolls decorated with dots and volutes (Fig. 8), or

Fig. 8 Lintel 2 from La Pasadita showing the casting gesture and the bifurcated blood scroll decorated with dots. Drawing by Ian Graham (after Simpson 1976: fig. 4).

simply cascading dots. Stuart's identification is confirmed by the epigraphic analysis of accompanying texts that refer to auto-sacrificial bloodletting by the rulers portrayed on these monuments.

The notion that dots represent liquids is well established in Maya iconography (cf. Thompson 1950: 272–273), but most discussion has focused upon water. Schele herself (n.d.: 27) has argued that lines of dots—particularly dots of descending size—represent water. She further identifies lines connected by dotted circles as water and dotted scrolls found intermixed with lines of dots in Classic examples as water signs. The association of the same iconography with water and blood may not be so much contradictory as conflationary. In the Postclassic Dresden and Madrid codices, a range of substances is depicted with dots. Lines of dots clearly represent both standing water and rain in the codices (Kelley 1976: figs. 86, 87). Kelley (1976: fig. 52) also illustrates an example of tongue-piercing in which the blood is displayed as flowing dots. On Madrid page 38b (Kelley 1976: fig. 53), a god is shown making fire with a drill, and the fire is represented by rising dots. The associated texts document that the action is fire-making. On Madrid pages 86–87b (Kelley 1976: fig. 58), smoke from cigars is also pictured as dots. In the codices, then, blood, fire, smoke, and water are all iconographically represented by flowing dots.

There are indications that such an iconic category of volatile substances also existed in the Classic period. Stuart (n.d.: 51–52) has noted examples of the scrollwork emanating from the forehead of the manikin scepter god, God K, that carry dots and other elements he can identify with blood. Robiscek (1978 *passim*) has made a strong case for the identification of this scrollwork as smoke. Moreover, Schele (1979: 47) argues that the name of God K means torch and black stone. The association of smoke with black and blood with red is graphically reasonable. The iconographic conflation of these substances may have been cross-cut by color codes that signaled the particular "state" of the generic substance of which blood, smoke, water, and fire were aspects.

The association of blood with smoke could be a rather straightforward one: in order for sacrificial blood to be consumed by a divinity, it would have to be burned and transformed into smoke. A graphic display of this relationship is given on Yaxchilan Lintel 24 (Robertson, Rands, and Graham 1972) where the male principal holds aloft a torch over a female who performs auto-sacrifice over a bowl of blood-spattered paper. Clearly the transformation of blood into smoke involved fire as an agent. Magically, smoke may have been the agent that brought forth life-giving water, the ultimate source of blood. The responsibility of the Maya royalty for the perpetuation of growing things through sacrifice, and the intimate associa-

tion of fertility with water, have been dealt with extensively by Linda Schele (1976, n.d.a, n.d.b). If we postulate that blood is associated with red and smoke with black, it would be plausible to envision fire as red and, hence, water as black, if these two colors define the "states" for the generic substance. This color arrangement places water and smoke, and blood and fire, in structural categories that cross-cut other properties. Water is liquid and falls, smoke is volatile and rises; blood is liquid and falls, fire is volatile and rises. The color categories would thus contain a significant paired opposition.

The notion that the Maya had a generic category of volatile liquids including blood, fire, smoke, and water, in which the category was signalled by certain iconographic elements and the "state" was signalled by color, can be investigated in the Late Preclassic program found on Structure 5C-2nd and other structures at Cerros.

On Structure 5C-2nd, applique stucco disks rendered in cream and black are stuck randomly on the red background color (Fig. 6a, b, c). This suggests that the background is to be understood as liquid and, given the color, as blood or fire. The connotation of ambient space as blood is commensurate with Stuart's (n.d.) interpretation of the Middle World as being composed of blood (see also Schele, this volume). A graphic display of the dotted scroll as blood occurs on the upper main masks of Structure 5C-2nd. Painted on the chins of these masks are red scrolls forming the J-scroll-and-bracket motif (Fig. 9), and inside these scrolls are dots rendered in black and cream. This blood flowing from the mouth is clearly paralleled in Classic depictions of auto-sacrifice as on Yaxchilan Lintel 24 (Robertson, Rands, and Graham 1972) where the scrollwork is shown in profile as the bifurcated scroll rendered in dots.

It can be argued that the bifurcated scroll, ubiquitous in Classic Maya art, which is composed of a tightly curled scroll and a long, sinuous one (Fig. 6c, d), is derived from the J-scroll-and-bracket motif constituting the top-line motif throughout Late Preclassic southeastern Mesoamerica (top-line of Fig. 6a). Norman (1976: 23–26) argues that this motif represents the mouth of divinity, and the clear association of the motif with mouths on Structure 5C-2nd supports this idea. In frontal view, the J-scroll-and-bracket terminates the mouths of the downward-facing side panel profile polymorphs (Fig. 6a) which, together with the J-scroll-and-bracket top-lines, comprise the double-headed sky serpent framing the main masks. On the lower west panel (Fig. 4b, c) the flanking profile polymorph carries the full-view J-scroll-and-bracket in his mouth. Other depictions of the flanking polymorph (Fig. 6c, d) show the profile version of this motif as the bifurcated mouth-scroll. Classic examples of the double-headed

Fig. 9 The J-scroll-and-bracket mo-
tif, painted red and decorated with
dots, on the chins of the upper main
masks of Str. 5C-2nd.

serpent carried as a bar by rulers (cf. Stelae B and D at Copan, Maudslay
1889–1902, 1: pls. 34, 45) have this profile version of the J-scroll-and-
bracket at the end of the snout. The bifurcated scroll, then, can be glossed
as an orifice and as a scrolled, liquid substance emanating from the orifice.

The association with liquid, more generally with the generic category of
volatile substance, can be seen in the elements decorating such bifurcated
scrolls in both Late Preclassic and Classic period iconography. Virtually all
the bifurcated scrolls on Structure 5C-2nd are decorated with large flat-
tened disks flanked by lozenges and dots of descending size (Figs. 4b, 6c),
the motif identified by Schele (n.d.: 27; see also Kelley 1976: fig. 55) as
water. In the present case, it is likely that several substances are expressed
by this element. In the first place, this liquid marking occurs on the
mandibles of profile polymorphs as well as on the bifurcated scrolls or
J-scroll-and-bracket motifs. It also occurs on the tassels of knots found on
the ear-plugs. Indeed, most of the elements on Structure 5C-2nd are
marked thus as liquid or alternatively as "shiny" (a double line often
marked into rectangular ladderlike segments; cf. Schele and Miller 1983:
fig. 3 on the graphic development of the T617a mirror glyph). In many
cases, the liquid dot element is combined with the "mirror" element, as in
the elements depending from the snout scroll of the profile polymorph in
Figure 6d, with the connotation of shiny liquid. When several such liquid
elements are juxtaposed, as in the profile polymorphs, the markings on the
mandible, snout, and mouth scrolls display significant contrasts in color.
The shaping of these elements shows them to be distinctive parts of the

polymorph, the liquid markings show them to be composed of a generic substance, and the color contrast shows that the distinctive parts are made of different "states" of the generic substance, i.e., blood, fire, smoke, or water.

It is clear that such contrasts in the use of black or red to mark liquid elements and motifs were not arbitrary on Structure 5C-2nd. On the lower east panel (Fig. 6c, d), the "falling" bifurcated mouth scrolls are decorated with red liquid markings, while the "rising" mandibles above them are decorated with black liquid markings. In the postulated scheme presented at the beginning of this section, these would be blood and smoke respectively. On the lower west panel, the color coding is reversed: the mouth scrolls are decorated with black markings, while the mandible preserved on the extreme west side is decorated with red markings. On the eastern side of the lower west panel (Fig. 4a, b), the mandible was ritually removed at the time of burial, but the snout (Fig. 4c) carries a series of red-painted "rising" dots. In the postulated scheme, this would be fire rising out of the upper part of the polymorphs, water or rain falling out of the mouths.

Other combinations occur on Structure 5C-2nd. For example, on the downward-facing profile polymorphs forming the ends of double-headed sky frames (Fig. 6a, b), a doughnut-shaped element terminates the snout at the bottom. This falling element is decorated with red liquid markings. Depending from the doughnut-shaped element are J-scroll-and-bracket motifs decorated with segmented double lines ending in lines of dots—i.e., shiny liquid. These decorations are painted black and are also falling downwards. The combination would seem to be blood and water, with water flowing out of the blood. This is the ultimate result of the cycle of transformation appropriately placed on the terminals of the east-west sky path of the cycling sun and Venus (cf. Freidel and Schele n.d.). It is not surprising that the colors of this axis remain red (east) and black (west) in Maya theology to the present day.

As discussed in the opening sections of this essay, red and black are the initial primary colors in Lowland Maya architectural decoration found on examples of Late Preclassic buildings throughout the southern region. Although the present corpus is still limited, the association with liquid elements does occur on one published example, the frescoes on Structure 5D-Sub. 10-1st at Tikal (Coe 1965b: 18–19). Here the figures are surrounded by bifurcated scrolls marked by dots of descending size on their inner surfaces. These scrolls are rendered in red, and since they are horizontal, both rising and falling, in the present scheme they would signal both blood and fire. It is worth noting at this juncture that the glyph for

fire in Classic and Postclassic times consists of a cartouche containing dashed dots flanking a double line surmounted by a rising bifurcated scroll (Kelley 1976: fig. 54), and Schele (1982: chart 16) observes that this glyph often occurs in blood-letting contexts. These scrolls on the frescoes are further punctuated by the stacked dot motif which Schele (n.d.: 28) identifies as water, here more generally another liquid marker. The frescoes graphically depict the central role of persons in the perpetuation of the cycle of transformation from sacificial blood to water, a position clearly expressed in the Classic corpus as discussed below.

The other colors rapidly incorporated into the Late Preclassic corpus evidently also relate to the generic category, although they may have other referents. The "full" polychrome profile polymorph on Structure 6B at Cerros (Pl. 1) shows a combination of elements and colors important through the Classic period. This image is a variant of the polymorphs depicted on Structure 5C-2nd, but the bifurcated scroll at Cerros is reduced to a red-painted forked tongue. More prominent are the modeled black-on-cream spheres lining the front of the upturned snout/scroll, signaling liquid. Similar circular elements are painted on the snout in yellow and green. These presumably also signal liquid, but of different states. Behind these painted disks is the slanted double-line motif signaling shiny. These elements are placed upon a band of red traversing the snout, suggesting that yellow and green are qualifications of red, one of the primary colors. David Stuart (n.d.) has noted that the Classic period images he would identify as flowing blood often have infixed *kan* and *yax* glyphs. These glyphs occur both on the "falling" images I would identify as blood and water and on the "rising" images I would identify as fire and smoke, depending on color coding (which is often problematic on Classic depictions, perhaps indicating a desirable ambiguity [cf. Schele, this volume]). While the broader connotations of these glyphs is a matter of controversy (cf. Kelley 1976: ch. 3), it is generally agreed that *kan* refers to the color yellow and *yax* refers to green. Following the development of hieroglyphic notation in the Protoclassic period, the substitution of glyphs for actual colors is an understandable change, particularly in light of the trend towards red/blue bichrome in the Classic (cf. Schele, this volume).

The manner in which these colors and their glyphs relate to the postulated cycle is currently problematic. Nevertheless, the association with the category of volatile substances is sustained even into the Postclassic codices. Madrid page 11b (Kelley 1976: fig. 59) shows God B casting dots while standing in falling rain. The accompanying hieroglyphs are *yax* and *kan*. Kelley (1976: 158) reads this as *yaxkan* and infers that the god is holding a dibble and that the glyphs mean to sow seed.

The agricultural association receives some Classic period support from the Temple of the Foliated Cross at Palenque (Schele 1976: 21–22, fig. 10), where a corn stalk grows from the head of a *kan*-marked polymorph. The corn stalk is marked with dots and "bone" elements indicating that it is also composed of liquid substance. Schele (1976: 21), following J. Eric S. Thompson, identifies the *kan* glyph here with water. Along this panel's baseline, the *kan* polymorph is flanked on the left by a *cauac* monster, signaling earth, and on the right by a corn stalk upon which lord Pacal stands. This same composition occurs in the Temple of the Sun on the border of the right-hand jamb (Schele 1976: fig. 12). Here a polymorphic head descends upside down from the mouth of a *cauac* monster, and from its head, in turn, emerges a corn plant. However, in this instance the glyph the polymorph carries is not *kan* but fire (Schele 1976: 26).

Logically, corn plants grow from earth and water rather than from earth and fire; also logically, fire rises rather than falls. The paradox displayed in the composition of the Temple of the Sun jamb makes sense if, as hypothesized above, fire can substitute for blood because both are categorized as red, hence the falling fire; and blood is a transformation of water, hence the sprouting corn plant. The visual contradiction would thus embody the essential mystery of the generic category of volatile substances. It seems likely that *kan* and *yax* somehow pertain to that aspect of the cycle which transforms water into blood through growing things consumed, but that they are also qualifications of "states" of liquids in the cycle.

THE DEVELOPMENT OF THE CATEGORY OF LIQUIDS

Following the Late Preclassic florescence of polychromy on monumental art, there is a general trend towards simplified color schemes, and it becomes increasingly difficult to document the color coding of "states" within the generic category of volatile liquids. It is possible, however, to illustrate the continued existence of the category through an examination of visual dynamics, such as falling and rising. The Hauberg stela, which stylistically dates to the Protoclassic period (Schele n.d.a), shows this contrast quite clearly. Here the ruler holds out his hand in the "casting" gesture, and out of his mouth and down over his hand flows the dotted scroll of blood. Over the same hand rises the blood vision-serpent, whose upturned snout is the dotted scroll seen on Structure 6B at Cerros (Pl. 1). The identification of the serpent as a vision is a reasonable one, but, more practically, the composition also contrasts the "falling" liquids, blood and water, with the "rising" liquids, fire and smoke. The ruler is clearly carrying out sacrifice, as noted in the accompanying text (Schele n.d.a),

and the iconographic interpretation here is that he is not merely witnessing a vision but displaying himself as the source of the cycle of liquids through blood-letting.

The lintels at Yaxchilan also illustrate this contrast. On Lintel 24, as mentioned above, a female practices auto-sacrifice by drawing through her tongue a rope which falls back down towards a bowl of blood-spattered paper. The standing male above her carries a torch aloft, from which flame or smoke rises in the form of a series of dot-decorated bifurcated scrolls. While the bifurcated scroll carries the original connotation of orifice, already in the Late Preclassic it occurs as a detached motif signaling flowing liquid, as on Structure 5D-Sub. 10-1st at Tikal.

On Lintel 25 at Yaxchilan (Robertson, Rands, and Graham 1972), a kneeling female holds a bowl of blood-spattered paper in one hand and holds her other hand in the casting gesture over a second bowl of blood-spattered paper. Below her hand falls one head of a double-headed polymorph, with both head and body marked with dots. Above her hand rises the rest of the double-headed serpent, and the rising body and upper head are also marked with dots. Here, as on the Hauberg Stela, falling and rising of liquid substance are simultaneously displayed in the act of auto-sacrifice.

On Lintel 15 at Yaxchilan, the kneeling female watches the vision-serpent rise out of the bowl of blood-spattered paper. The rising serpent is marked with dots, and off of its body fall dotted scrolls and bifurcated scrolls. A corn plant appears to grow from the back of the serpent's head, perhaps an allusion to the iconography of the Temple of the Foliated Cross and the Temple of the Sun at Palenque, as discussed above. Again, there is the contrast between falling and rising liquids.

A number of stelae at Tikal (Stelae 11, 22; Jones 1982: figs. 16, 33) and Ixlu (Stelae 1, 2; Jones 1982: figs. 80, 81) also display this contrast. Here rulers are shown making the "casting" gesture, and, as identified by Stuart (n.d.), cascading dots of blood fall from the hand. Above the rulers float dotted scrolls containing various figures. As at Yaxchilan, these floating scrolls may be metaphorically interpreted as the vision, but graphically they may be read as rising smoke and fire.

Finally, the contrast in question is explicitly displayed in the Temple of the Cross at Palenque (Schele 1976: fig. 6). On the left-hand jamb, Chan Bahlum holds the Quadrapartite Badge blood-letter from which flow downwards bifurcated scrolls marked with dots, "bone" signs, the *kan* glyph, and completion signs, all identified by Stuart (n.d.) with blood, here postulated to represent both blood and water. On the right-hand jamb, God L smokes a great cigar, from which flows another bifurcated

scroll. This scrollwork clearly signals smoke and fire. The divine ruler is the immediate source of blood and the ultimate source of water, his counterpart, the god, is the source of smoke and fire, the means to transform blood into water.

CONCLUSIONS

If the foregoing speculation proves worthwhile, then colors for the Maya carried central symbolic significance and aided the conceptualization of a cycle of causality in which humans, particularly rulers, were the interlocutors through sacrifice. The primary importance of black and red are documented in their temporal priority on decorated architecture. The directional associations of these colors with the east-west axis are sensible, as this is the path of the sun and Venus, displayed as the double-headed sky serpent and its Classic analog, the Celestial Monster (Schele, in Freidel and Schele n.d.). The sun and Venus are the primary icons of sacrifice and regeneration in Maya theology (Freidel and Schele n.d.), and their paths are personified as these monsters carry the diagnostic elements of the generic category of volatile liquids as discussed above and in Stuart (n.d. *passim*). These forms are graphic displays of the transformations linking blood, fire, smoke, and water. Red and black together comprise the spectrum of this spatial axis and this cycle.

While color-coding is explicit in Late Preclassic architecture and flowers into full polychromy, the ensuing Classic period witnesses a simplification of color schemes generally (Schele, this volume). The range of colors remains as broad, but red/blue bichromy prevails, and the same elements in compositions are repainted in several different colors in the course of use. On the one hand, it is clear that colors are being signaled glyphically in the Classic period; on the other hand, it seems possible that colors in the Classic period carry symbolic references clearly and generally understood by observers. Hence a given element might be sequentially painted different colors denoting different "states" of the cycle of volatile liquids, depending upon what the users wished to emphasize at the time of repainting.

When the Spanish arrived in Maya territory, color-coding was primarily associated with the spatial organization of the cosmos: red = east, north = white, west = black, yellow = south, and blue-green = center. It seems likely, however, that Mayanists have barely scratched the surface of the subject of color in Maya theology. Even in the association with directions, the principle pursued in this essay is evident: colors were used to group unlike powers such as the red Chac, red Pauahtun, and red Bacab (rain deity, wind deity, and earth bearer) and to contrast aspects of the same power (red, white, black, and yellow Chac). More than simply a spatial

framework, color in Postclassic Maya theology was a means of structuring sameness, difference, and the transformations linking these qualities.

Soon after the florescence of polychromy on Late Preclassic architecture, the appropriate technology for the decoration of pottery with fired poly-chrome paint was developed in the lowlands. A major impetus for this achievement may well have been the central importance of color-coding in the theological program innovated in the Late Preclassic period. In this regard, it is not surprising that a major image on the Early Classic poly-chrome painted vessels is the profile polymorph, the personification of volatile liquids, with its snout decorated with lines of dots, "shiny" ele-ments, or the J-scroll-and-bracket motif (cf. Merwin and Vaillant 1932: pls. 18, 19, 20).

BIBLIOGRAPHY

ADAMS, R.E.W. (ED.)

1977 *The Origins of Maya Civilization.* A School of American Research
 Book, University of New Mexico Press, Albuquerque.

COE, WILLIAM R.

1965a Tikal, Guatemala, and Emergent Maya Civilization. *Science* 147:
 1401–1423.

1965b Tikal: Ten Years of Study of a Maya Ruin in the Lowlands of Guate-
 mala. *Expedition* 8 (1): 5–56.

FREIDEL, DAVID A.

1981 Civilization as a State of Mind: the Cultural Evolution of the
 Lowland Maya. In *The Transition to Statehood in the New World* (Grant
 Jones and Robert Kautz, eds.): 188–277. Cambridge University
 Press, Cambridge.

FREIDEL, DAVID A., and LINDA SCHELE

n.d. Symbol and Power: A History of the Lowland Maya Cosmogram.
 Paper presented at the Princeton Conference, The Beginnings of
 Maya Iconography, October 1982.

HAMMOND, NORMAN

1980 Early Maya Ceremonial at Cuello, Belize. *Antiquity* 54: 176–190.

JONES, CHRISTOPHER, and LINTON SATTERTHWAITE

1982 *The Monuments and Inscriptions of Tikal: the Carved Monuments.* Uni-
 versity Museum Monograph 44, Tikal Report No. 33, Part A. The
 University Museum, University of Pennsylvania, Philadelphia.

KELLEY, DAVID H.

1976 *Deciphering the Maya Script.* University of Texas Press, Austin and
 London.

MAUDSLAY, ALFRED PERCIVAL

1889–1902 *Archaeology.* 5 vols. Biologia Centrali-Americana: or Contributions to
 the Knowledge of the Fauna and Flora of Mexico and Central Amer-
 ica (F. Ducane Godman and Osbert Salvin, eds.). R. H. Porter and
 Dulau and Co., London.

MERWIN, RAYMOND E., and GEORGE C. VAILLANT

1932 *The Ruins of Holmul, Guatemala.* Memoirs of the Peabody Museum of
 American Archaeology and Ethnology 3 (2). Harvard University,
 Cambridge.

NORMAN, V. GARTH

1976 *Izapa Sculpture, Part 2: text.* Papers of the New World Archaeological
 Foundation, 30. Brigham Young University, Provo, Utah.

PENDERGAST, DAVID M.
 1981 Lamanai, Belize: Summary of Excavation Results, 1974–1980. *Journal of Field Archaeology* 8: 29–53.

RICKETSON, OLIVER G., and EDITH B. RICKETSON
 1937 *Uaxactun, Guatemala: Group E, 1926–1931.* Carnegie Institution of Washington, Publication 477. Washington.

ROBERTSON, MERLE GREENE, L. RANDS, and JOHN A. GRAHAM
 1972 *Maya Sculpture from the Southern Lowlands, the Highlands, and Pacific Piedmont, Guatemala, Mexico, Honduras.* Lederer, Street and Zeus, Berkeley.

ROBISCEK, FRANCIS
 1978 *The Smoking Gods: Tobacco in Maya Art, History and Religion.* University of Oklahoma Press, Norman.

SCARBOROUGH, VERNON L.
 n.d. The Settlement System in a Late Preclassic Maya Community: Cerros, Northern Belize. PhD dissertation, Department of Anthropology, Southern Methodist University, 1980.

SCHELE, LINDA
 1976 Accession Iconography of Chan-Bahlum in the Group of the Cross at Palenque. In *The Art, Iconography and Dynastic History of Palenque, Part III. Segunda Mesa Redonda de Palenque* (Merle Greene Robertson, ed.): 9–34. Pre-Columbian Art Research, The Robert Louis Stevenson School, Pebble Beach, California.
 1979 Genealogical Documentation in the Tri-Figure Panels at Palenque. In *Tercera Mesa Redonda de Palenque, 1978* (Merle Greene Robertson and Donnan Call Jeffers, eds.) 4: 41–70. Pre-Columbian Art Research Center, Palenque, Chiapas, Mexico.
 1982 *Maya Glyphs: the Verbs.* University of Texas Press, Austin.
 n.d.a The Hauberg Stela: Blood-Letting and the Mythos of Maya Rulership. Paper presented at the Quinta Mesa Redonda de Palenque, Chiapas, Mexico, 1983.
 n.d.b The Puleston Hypothesis: the Water-lily Complex in Classic Maya Art and Writing. Manuscript, 1979.

SCHELE, LINDA, and JEFFREY H. MILLER
 1983 *The Mirror, The Rabbit and the Bundle: "Accession" Expressions from the Classic Maya Inscriptions.* Studies in Pre-Columbian Art and Archaeology 23. Dumbarton Oaks, Washington.

SIMPSON, JON ERIK
 1976 The New York Relief Panel — and Some Associations with Reliefs at Palenque and Elsewhere, Part I. In *The Art, Iconography and Dynastic History of Palenque, Part III. Segunda Mesa Redonda de Palenque* (Merle Greene Robertson, ed.): 95–105. Pre-Columbian

Art Research, The Robert Louis Stevenson School, Pebble Beach, California.

STUART, DAVID

n.d. Blood Symbolism in Maya Iconography. Paper presented at the Princeton Conference, The Beginnings of Maya Iconography, October 1982.

Color on Classic Architecture and Monumental Sculpture of the Southern Maya Lowlands

LINDA SCHELE

UNIVERSITY OF TEXAS AT AUSTIN

INTRODUCTION

A S WITH THE ART of other major cultures of the past, Maya architecture, architectural sculpture, and monumental art is seen today in the neutral colors of the stone and plaster from which it was formed, rather than in the intense polychrome splendor intended by its creators and users. Of the early explorers who had occasion to see architecture and monuments freshly exposed, only Teobert Maler (1901–03, 1908–10, and 1911) systematically and carefully recorded the color he observed. The fragility of color when exposed to sun and climate is amply illustrated by a comparison of the color notation published by Maler to those made by Ian Graham in the last two decades (in the *Corpus of Maya Hieroglyphic Inscriptions*) of the same monuments. Merle Robertson (personal communication, 1974–1980), who has to date made the most comprehensive study of color at any one site, has observed during the last decade serious and continuous deterioration of color on the stucco sculptures of Palenque.

During the Classic period, color was used throughout Maya cities and can be documented as having been used as follows:

1) Murals were painted on interior walls of buildings and tombs. Early Classic murals now known were rendered in line, using red and/or black as the color (examples are known at Uaxactun, Rio Azul, Palenque, and Tikal), and flat color along with line was used in the early mural of Structure A at Uaxactun. This linear style survived into the Late Classic and is found in the cave painting of Nah Tunich (Stuart 1981), in painted glyphic panels in the Palace at Palenque, and painted capstones of the Campeche region

(Jones 1975). This style may be related to the linear-polychrome of the Late Preclassic at Cerros (Freidel, this volume), or it may have developed in conjunction with the incised style of ceramic decoration of the Early Classic. The other style of interior mural painting is the fully polychromatic one known at Bonampak, Yaxchilan, La Pasadita, and Palenque.

2) The interiors of buildings, if not decorated with murals or relief sculptures, were with rare exception left the white, gray, or cream of the finished plaster surface, or were painted solid red or in patterns of red and white.

3) Interior relief panels, thrones, benches, and lintels, both of wood and stone, were either stuccoed white, or painted red or in a polychrome scheme (Pl. 2).

4) Free-standing stelae were also stuccoed white, or painted red or polychromatically.

5) Exterior relief sculpture on architecture, usually of modeled stucco, was painted a solid red, polychromed, or left the cream or white of the stucco surface.

6) The unsculptured exterior surfaces of buildings and substructures could only be the white of stucco or painted red. The two exceptions to this white and/or red pattern are found on the west wall of House E at Palenque, a building for which Merle Robertson (n.d.) has demonstrated a very specialized function, and on Structure 6 at Bonampak.

Before entering discussions of a more detailed kind, it should be noted that the sample available for the study of color during the Classic period is of necessity biased. Unless buildings and monuments were buried during the Classic period, the survival of color was dependent on protection from the destructive effects of the environment. Buried or collapsed structures retain much more color information than exposed stelae. Because of this differential survival, Maler was able to record extensive color data on the lintels and stelae of Yaxchilan, La Mar, and Piedras Negras, but almost none at Tikal. However, the lack of color data from any one site or period at a site should not be construed as evidence that color was not used.

THE CHEMISTRY AND HUE OF MAYA COLOR

The hues of Maya color have been most carefully catalogued by Merle Greene Robertson (1977: 325, n.d.). Her studies and my observations of the application of pigment on murals at Palenque, Bonampak, and Yaxchilan suggest that intensity and tones of a hue were more often manipulated by varying the amount of pigment used in the vehicle (dilution) than by adding white or black to achieve tints and shades. Robertson (1977)

reports a pink color at Palenque that may be a tint rather than a wash, and Gordon Willey (n.d.) reports a green resulting from the application of a thin yellow wash over blue. Documented information on the chemistry of pigments is as follows:

White: The lime of stucco apparently provided white, but the quality of white was altered by the purity of the lime source and by the mixing of additional material into the plaster. Ledyard Smith (1950: 64–65) reports a bluish-gray stucco resulting from the admix of charcoal, and Robertson (1977: 308) has suggested that high-fired lime was used as the final coat and as the priming surface for color. Edwin Littman (1960: 594) and Merle Robertson (1977) have also suggested that the creaminess of the white characteristic of the final stucco surfaces at Palenque (and presumably elsewhere) resulted from the addition of bark extracts to retard the curing of the plaster. Landa (Tozzer 1941: 176) reported the use of a polishing solution of bark extract that caused a plaster surface to turn bright red.

Black: Willey (n.d.) reports that the black of the Seibal Structure A-3 stucco relief is a carbon black. Carbon can be obtained from many sources, including charcoal and burnt bone, and it is a permanent and stable pigment. Except at Seibal and on House C, pier b at Palenque, black does not appear to have been used in polychrome color schemes, although it remains prominent in the linear style and as a color for the initial drawings followed by relief sculptors. (The working drawings surviving on the sarcophagus sides at Palenque are black.)

Red: Willey (n.d.) reports that all red pigments used in the Seibal stucco relief are iron-based pigments. The dark reds, reds, and pinks are the anhydrous form of iron oxide, hematite. Wayne Isphording, a geologist at the University of South Alabama, has done extensive analyses of the clays available in both the northern and southern lowlands. He has informed me that hematites and other iron-based minerals are found in abundance throughout the region, and produce colors from dark orange-browns through bright reds (personal communication, 1981). The coloration properties of these iron-based pigments are very high, with minute amounts causing intense coloration. They are stable chemically, and require virtually no processing before use. The more rare and expensive specular hematite, imported from volcanic regions, may have been reserved for smaller, particularly important works.

Yellow: Willey (n.d.) reports that the yellow used at Seibal is the hydrated form of iron oxide. Isphording (personal communication, 1981) says that minerals yielding a yellow color are very rare in the Maya region, and the restricted use of yellow may reflect its scarcity.

Blue: Dean Arnold and Bruce Bohor (1975) and Gordon Willey (n.d.) report that Maya blue is part of the indigo-attapulgite clay complex. In his notes to *Landa's Relación de las Cosas de Yucatan,* Tozzer (1941: 117–118) calls attention to descriptions of indigo as follows:

> There is a wood or plant from which indigo is made, which the natives of these provinces formerly employed for a blue dye or paint, hence the Spaniards availed themselves of it and started large plantations, so that they have come to make large quantities in the provinces. Eight years ago it was carried to Spain, from which His Majesty derived great profit. . . . These Indians, it is understood, have diminished in number because of a certain profitable business in indigo which has been discovered in this land.

Attapulgite clay is now known to have been mined at Sacalum (Arnold and Bohor 1975) in Pre-Columbian times, but the extent of indigo farming and trade is not known. Ronald Bishop (personal communication, 1981) has informed me that scientists at Brookhaven National Laboratories have created permanent Maya blue by freeze-drying attapulgite clay. Although this chemical alteration was not achieved with the more primitive technology available to the Classic Maya, these experiments have shown that Maya blue can be generated in a permanent, stable form without the addition of pigment to attapulgite clay.

Green: Willey (n.d.) reports that Seibal green is Maya blue glazed over with yellow iron oxide. It should be noted that green was rarely used in polychrome schemes. Robertson (1977: 308) reports it on House C, pier b at Palenque; it is found in the Structure A-3 relief at Seibal (Willey n.d.), at Bonampak in the murals of Room 2 and on the Structure 1 lintels (Mary Miller, personal communication, 1981), and on fragments of a destroyed stucco relief at San Jose (Thompson 1939: 43). Maler reported both blue and green, but it cannot be determined from his descriptions if he saw a mixed green or various dilutions (i.e., transparent versus opaque layers) of Maya blue.

TECHNIQUES OF PAINTING

Merle Greene Robertson (1977, n.d.) has given detailed and thorough attention to the techniques of painting. Her observations at Palenque generally hold true at other sites. All color is applied flatly on any one shape with no attempt to vary color through either pigment change or dilution. The application of color is always within the boundary of the shape covered, and I know of no example where color is used to signal a shape or mass change that deviates from the sculpted surface. In other words, color was contained

within the shapes of the relief sculpture much as it should be in a modern coloring book. Except for the very late Seibal stucco relief on Structure A-3, line was never used at the boundaries of color as found in the Late Preclassic polychrome system at Cerros and Lamanai. Information about detail within any large block of color, such as a headdress with feathers, is conveyed solely by the shadows cast upon the relief.

There is some contrast in the painting technique used on stucco versus stone sculpture. Robertson (1977: 301–304) reports the application of several thin coatings of stucco, high in lime content, to the surface of stucco reliefs; these coats were burnished and covered by a thin wash of diluted red, also reported at Seibal (Willey n.d.). This same thin coat of red was used between layers of stucco applique, and once the final relief surface was completed, color was added applying first red, then blue, then yellow (Robertson 1979: 160–161). Willey (n.d.) reports that the very late Seibal reliefs consisted of stone armatures covered by modeled stucco with a final layer (one centimeter or less) of much finer plaster. Color was applied to this final surface. At present, not enough information is known of practices at other Classic sites to determine if the more complicated preparation techniques found at Palenque were used at other sites.

Two techniques were used on stone sculpture. Paint was applied directly to the surface of the stone, or a thin layer of stucco was applied, followed by the paint. The latter technique had the disadvantage of filling in the relief as the sculpture was repainted, but it yielded a much more vibrant color because light bounces off a brilliant subsurface better than off the more dull stone. Maya colors, unless painted in very thick coats, are not totally opaque, so that a pure white surface under the color not only produces more brilliant color, but it can cause changes in hue and value. Palenque provides ample evidence that buildings and sculptures were frequently repainted, often with color changes; the stucco coats so often found between color layers not only produced a surface with better adhesive qualities, but also restored a light-reflective undercoating for successive layers of color.

Robertson (1977) has discussed the repainting of stucco sculpture at Palenque, commenting that the entire city seems to have been painted a deep red in the latter stage of its history. Paint layers found in grooves on Copan Temple 22 and fragments in the Palenque *bodega* suggest that repainting was frequently done. Hundreds of stucco fragments in the *bodega* had three and more layers of color with extreme and frequent color changes, e.g., from blue to red to orange to blue, etc. One example will illustrate the kind of repainting found. Fragment 1430, a feather, had the following observable layers:

top: red/yellow/blue/stucco/red/stucco/blue/stucco/red/stucco/
red/stucco/red/stucco/blue
side: blue/red/stucco/red/stucco/red/stucco/red/stucco/red/stucco/
red/stucco/red/stucco/blue

This number of layers has not survived on exposed stucco still adhering to buildings at Palenque, and therefore it is not possible to determine whether the red layers represent an alternation of monochrome red with polychrome for an entire building, or merely a change of the feathers from blue to red.

THE FUNCTION AND MEANING OF COLOR

Three color treatments can be documented for Classic Maya architecture and monumental sculpture: monochrome white, monochrome red, and polychrome. In the polychrome systems that have been documented, various hues of red and blue are the principal components, with yellow and green rarely used, and white and black eliminated from use. The function and meaning of these colors can be discussed from several viewpoints: 1) the economic cost and availability of stable pigments; 2) the perceptual effect of color within large plaza spaces or within buildings; 3) the function of color as a means of identifying the material from which pictured objects are made (quetzal feathers are blue and Maya flesh is red); and 4) the metaphysical identity of objects.

Robertson (1979: 166) has identified blue as the "color for all things divine, sacred, precious—gods, beads, serpents' bodies, feathers, thrones, gods' staffs, mirror cartouches, axes of God K, mat motifs, and the *le* motif pertaining to accession, as well as divine infants, . . . and superhuman persons such as the dwarf on the south side of pier c, House C." Although variations of the use of blue and the color of sacred things is notable in the color on *bodega* fragments at Palenque as well as other sites, similar color conventions are detectable at sites where information on the polychrome scheme is available.

Monochrome white, cream, or gray occurred at many sites, and is particularly notable on the Foot Pyramid at Lamanai, which has stucco masks on the substructure terraces. Both the interior and exterior of buildings were left white, and Maler (1908–10: 103, 107) reports that Naranjo Stelae 19 and 21 had traces of plaster without color. A finished coat of plaster was the most economical treatment since it required no pigment at all and was part of the building process. In terms of distance perception, a pure white surface would produce the highest light and dark contrast with

cast light on relief surfaces. In Mayan languages, the word for "white" (*zac*) also means "resplendent"; white buildings and stelae certainly would have been resplendent in the tropical sun of the Maya region. Mary Miller (personal communication, 1981) has suggested that the white buildings reported at Yaxchilan by Maler may once have had black linear drawings and/or inscriptions on the outer walls as did Structure 1 at Bonampak.

Monochrome red had wide distribution throughout Maya history and geography. Red-painted buildings are documented at almost every Maya site and from the Late Preclassic period until Structure A-3 at Seibal, which Willey (n.d.) says was painted a deep red on both the building and substructure. Red-painted sculpture is also widely distributed and reported at almost every site on free-standing stelae, wall-mounted panels, and lintels. Reports of paint on the stelae of Naranjo (Maler 1908–10: 82–118), Tikal (Maler 1911), Seibal (Maler 1908–10: 13–25), and Copan (personal observation) suggest that they were exclusively painted monochrome red. The numerous hematites and other red pigments that can be derived from local clay and mineral sources make red an economical color to use in very large areas such as buildings and substructures. Specular hematite, however, was imported from volcanic regions and must have been used more sparingly. In contrast to white, red surfaces greatly reduce light reflectivity and, therefore, glare in public spaces. While red reduces the contrast of light and dark patterns on relief sculpture, it may have been used to reduce levels of reflected light, and perhaps reflected heat within Maya plaza spaces.

Chac, the Maya word for red, also means "great," yet while red is the color of east, the distribution of red buildings seems to have little to do with directional placement. However, David Stuart (personal communication, 1981) has recently discovered a pattern of symbols widely used in Maya iconography that may be related to the meaning of red in architectural contexts. He has identified the water-group prefix, the material depicted as being scattered on the stelae at Yaxchilan, the liquid emerging from the heads of the Celestial Monster at Palenque, the dotted scrolls in the upper section of late stelae at Tikal and Ixlu, and the S-shapes of the body of the Celestial Monster in Copan Temple 22, as blood. His identifications of this blood complex include the framing elements on the piers of House D at Palenque, so that it is becoming apparent that the Maya conceived of the Middle World as infused with blood, perhaps with connotations of both sacrifice and lineage. The red so prominently used on buildings and monumental sculptures may be part of the blood complex.

Polychrome functioned as a means of highlighting particularly important regions of a building facade by contrasting a multi-colored field to the

solid white or red of the facade proper. Since we now know that poly-chrome treatment of architectural sculpture developed during the Late Preclassic period and was later transferred to lintels, stelae, and other formats, it is evident that the use of color evolved within the context of public rather than semi-private or private usage. Both the Late Preclassic and Early Classic masked facades were great public stage fronts displaying the cosmogram within which ritual and dynastic activity occurred. Poly-chrome treatment of these exterior surfaces expanded the distance from which information could be read. The extension of this distance may well explain why the Late Preclassic use of line with flat color was abandoned in favor of the exclusive use of solid, flat color in large-shaped zones. Line requires a close proximity to be read, while large areas of solid and highly contrasting color make information readable from longer distances. The colors favored in polychrome—red hematites and blue—are split-comple-ments, and the proximity of one enhances the intensity of the other.

THE USE OF COLOR

Stone Monuments

Stone monuments, whether free-standing or mounted in architecture, could be colored in three ways. Maler (1908–10: 92, 107) reported that Naranjo Stelae 19 and 21 had stucco coatings without any evidence of color. Assuming that he examined the surfaces of both monuments care-fully, his is the only report of solid white stelae that I have been able to find in the literature. The most sustained and popular treatment of sculp-ture during the Classic period was to paint the surface a solid red. This pattern of solid red is found at every site from which color information is known, and several sites appear to have used this pattern exclusively. With the exception of the two white stelae, Maler reported only traces of red, or stucco covered with red, at Naranjo. Information in the literature, begin-ning with John Lloyd Stephens and Frederick Catherwood (1969: 130–160), reports only red on Copan stelae, and the same is true of the stelae of Tikal. Maler (1908–10: 25) reported that all traces of color detectable on Seibal stelae were also red. Karl Ruppert and John Dennison (1943: 103, 111, 114) report traces of red, but no other color, at Calakmul.

Red-painted monuments also occur at sites that utilized polychrome. At Yaxchilan, six of the seven Early Classic lintels of Structure 12 (Lintels 34, 35, 37, 47, 48, and 49), were painted solid red, and the seventh (Lintel 36) is too badly eroded to retain color. Structure 22, which combines Early and Late Classic lintels, appears also to have used this pattern of solid red. Maler (1901–03: 149–150) said that the Early Classic Lintels 18 and 22 had traces of red over the entire surface or within grooves, and the Late Classic

Lintel 21 also had traces of red paint. Of the three lintels in Structure 13, Lintels 32 and 50 had lost all traces of color by the time of discovery, but Maler (1901–03: 133) found traces of red on the entire surface of Lintel 33, perhaps indicating that the other two lintels were also red.

At Piedras Negras, Maler (1901–03: 72–74) reports red in the stelae group associated with Structure R-5. No color had survived on Stelae 32 and 37, but Stelae 33 and 36 had polished stucco surfaces painted red, and on Stelae 34 and 35, only traces of red were found. Since red was found on objects such as kneelets, which would normally have been blue, it is likely that this group of monuments was painted monochromatically red. Tatiana Proskouriakoff (1960: 458) associated this monument group with Ruler 2. All other Piedras Negras monuments with color information have explicit evidence of polychrome, or red occurs on objects known to have been red in polychrome systems and not elsewhere. This group of stelae appears to have been treated as a unit; all were dedicated to Ruler 2 (Proskouriakoff 1960: 458).

The color treatment of stone sculpture is problematic at Palenque because exposure has destroyed all traces of color on most of the major tablets. However, material in the *bodega* and on several monuments shows that the solid red scheme was also frequently used at Palenque. The sarcophagus lid (but not the sides) and the Palace Tablet were painted red, and many of the fragmentary panels from the Palace were red with a blue border that did not correspond to the border cut in the relief. We found three tablets (Nos. 39, 40, and 44) in the *bodega* (Schele and Mathews 1979) with this pattern. I suspect that many of the interior panels at Palenque were painted red, with the polychrome system more rarely used on the interior but dominant on the exterior. Another usage of red at Palenque is unusual. A brilliant red, perhaps cinnabar, was used in the grooves of at least one incised relief (Bodega No. 37) in much the same manner that red was used in the grooves of incised jades.

The polychrome treatment of stone monuments seems to have been particularly prevalent in the western region of the Classic Maya zone. All evidence from the literature suggests that in the majority of examples only various shades of blue and red were used. Since Palenque did not favor free-standing stelae, but instead utilized wall-mounted panels and stucco relief to impart the same kinds of information, I will discuss the stucco reliefs of Palenque in conjunction with stone polychrome at other sites.

Maler documented the extensive use of polychrome on the stelae of Piedras Negras and La Mar, and on lintels and wall-mounted panels at Yaxchilan and Chico Zapote. In general, the patterns of color are the same at these sites and Palenque. Flesh is red, feathers and jade are various

shades of blue, attire and accoutrements are blue, or red, or blue and red. Maler reported both blue and green on the feathers and jade, but Merle Robertson's work at Palenque, and my observations of the color remaining on Piedras Negras monuments, suggests that Maler's "green" was in many cases a transparent Maya blue. While the color schemes used at various sites seem to follow the same general conventions, there are nevertheless also differences. For example, at Palenque God K scepters were often painted blue, but on Yaxchilan Lintel 3, they were red. Furthermore, Robertson's (1977, 1979) work on the stucco of Palenque as well as evidence from color notations from the *bodega* at Palenque (Schele and Mathews 1979, n.d.) suggest that color usage was not rigidly controlled by symbolism or convention. In reviewing color data from the original *bodega* catalogs, I found that, except for the flesh of historical humans in non-supernatural contexts, all objects could be blue or red, sometimes orange, and the layers of paint on these stucco fragments suggest that color was changed often and dramatically. The multiple layers of color are not found as frequently on stone sculpture as on stucco, but after built-up paint began to obscure relief surfaces, the harder stone monuments may have been cleaned before repainting.

One of the major differences in treatment occurred in the color used for the background and its effect upon the colors used on the positive shapes. Three background colors are documented—dark red, red or red-orange, and blue. Good examples of the dark red survive on La Pasadita Lintel 2 and Dos Pilas Stela 16. Assuming that Maler's "dark red" was similar to the Dos Pilas red, it was used as a ground color on La Mar Stela 2, Chico Zapote Lintel 3, and on many monuments at Piedras Negras and Yaxchilan. The advantage of dark red is its contrast to brighter reds used for flesh and other positive shapes, as well as its contrast to blue. Merle Robertson (1977: 317) reports the use of a dark red (but one less bluish than the Dos Pilas red) on the earlier stucco reliefs at Palenque; this red was later replaced by a light pink-red. Red grounds on other Maya monuments range from blood reds to orange-reds. The disadvantage of using the same red in the ground and figure was that contrast between red positive shapes and the ground could be distinguished only by the shadows cast on the relief. Blue grounds were relatively rare with the best-known examples being Bonampak Lintels 1, 2, and 3. Maler (1901–03: 153) documented blue on the ground of Yaxchilan Lintel 26 and suggested that it was painted entirely blue, but the blue he mentioned occurred on objects normally blue in polychrome systems, so that I suspect the lintel was polychrome with a blue ground. There is only one monochromatic blue relief sculpture known—the west subterranean stucco of the Palace at

Palenque (Robertson 1979: pl. 9-5), and there the use of blue may have been determined iconographically. The scene shows the Maize God diving into an area marked as water, which was painted blue not only here but on the lower register of the tablet from Temple XIV.

The choice of ground color may have been based on symbolic function, such as the use of red grounds for interior scenes and blue for exterior scenes, as seems the case in the Bonampak murals. But since one of the rare blue grounds is found on the Kimbell Museum wall panel, which is clearly an interior scene by reason of the curtains, blue was not exclusively associated with exterior scenes. Red, as a reference to blood, may well have signaled that the pictured activity was occurring in the Middle World. However, there are important perceptual motivations that may also have played a part in the choice. Since red and blue are split-complements, the ground color grays other hues similar to it and enhances the brilliance of its opposites. The use of reds of any hue in the background would dull the reds of flesh while enhancing the blues of feathers, capes, jade. On the other hand, blue grounds work in the opposite way, enhancing shapes of red. The choice of ground color may have been controlled by convention, and also by which color pattern (i.e., the reds of flesh and accoutrements, or the blue of feathers and accoutrements) was to be featured.

Glyphic texts were treated in a variety of ways. On La Mar Stela 2 they were painted the color of the ground, de-emphasizing their importance by merging them with the ground color. On La Pasadita Lintel 2 the glyphs were painted the same dark red as the ground, but the frames around them were painted bright blue. At Yaxchilan, texts on many lintels were painted the bright red of the flesh and stood in contrast to the dark ground; Maler's data from Piedras Negras suggests that the glyphs were also painted bright red. On the Kimbell Museum panel and in many instances at Palenque, glyphs were painted a color opposite of the ground. At Palenque, glyphs could be painted red on a blue ground, or blue on a red ground, but perhaps the most dramatic and amusing use of polychrome occurred in the text of the Temple XVIII stucco relief. With one exception, the glyphs of the entire text were painted blue, while the ground was a bright blood red. A single sign in the glyph that Blom (1926: 176) found engaged to the wall at J2 was painted red. That sign is a stingray spine, appropriately red because it is a blood-letter.

ARCHITECTURE AND ARCHITECTURAL SCULPTURE

Color, in terms of architecture and architectural sculpture, is particularly important, since the themes and functions of Classic architectural sculpture can now be linked in an unbroken sequence from the critical Late Preclas-

sic traditions now documented at Cerros, Lamanai, Tikal, and other sites. The major Late Preclassic contribution to Maya public art was the masked facade to which a vaulted, stone building with roof comb was added in the Classic period.

During the Classic period, unsculpted architectural surfaces could be colored white or solid red, with other colors rarely present except in murals. Maler (1901–03: 114–192) reports three patterns of color at Yaxchilan—solid white (Structures 19, 39, 40, and 41), solid red with white interiors (Structures 2 and 6), and solid white with a wide red band below the cornice (Structures 20, 30, and 33). With the exception of Palenque where the sculpted piers functioned much like stelae at other sites, relief sculpture on building exteriors usually was limited to the following zones: the substructure or basal platform, the entablature, and the roof comb. Vertical bearing walls, except at Palenque, were rarely sculpted. Exceptions are known at Yaxchilan where two buildings have stucco glyphs in a band below the cornice, at Copan in Structures 11, 18, and 22, and at Tikal in Temple 5D-33-2nd.

Perhaps the most unusual color scheme on unsculpted surfaces was reported at Copan by Gordon Willey, Richard Leventhal, and William Fash (1978: 38). They describe the outlying Mound A of CV-43 as follows:

> The large Mound A had a stair leading up to its summit on which there was a well-constructed masonry building consisting of three rooms. The center room faced out over the plaza, and the room at each end faced east and west, respectively. The upper walls and what had been vaulted roofs of these rooms had collapsed, and the interior walls of all three chambers were painted. The east room was appropriately—in the sense of Maya directional colors—painted the color of the east, red; the west room was black, the color of the night; and the central room was green, the Maya legendary color of the center of the world.

To my knowledge this is the only building from the Classic period with different rooms painted according to the directional symbolism of color.

As with other kinds of sculpture, architectural sculpture could be solid white, solid red, or polychrome. Data from Palenque (Robertson 1977; Schele and Mathews 1979) suggests that color schemes were changed from polychrome to monochrome and back again. Different construction techniques were used in roof comb constructions at different sites. At Tikal, roof combs were carved in stone and covered with a thin layer of stucco (Miller 1973: 177), while at Palenque large stone armatures were constructed to which modeled stucco was attached. Fragments in the *bodega*

show that the Palencanos, like the Greeks, often modeled oversized figures fully in the round to be inserted into roof comb niches. The same technique was used at Yaxchilan, but stone figures as well as stucco were used. Information on the coloration of roof comb and entablature sculpture outside of Palenque and Seibal is scant. Ledyard Smith (1950: 83) reports that at Uaxactun "the traces of red paint on many buildings make it not unlikely that many were partially if not completely painted red, except where different colors were used to pick out designs in the stucco." Many polychrome stucco fragments were apparently found in the fill of the North Acropolis at Tikal, and William Coe (1967: 28) said that cream and red were found on the roof comb of Temple I. Arthur Miller (1973: 177) reports a personal communication from Coe that Aubrey Trik found evidence of blue, red, yellow, and black paint on the same roof comb. J. Eric S. Thompson (1939: 43) says that "with one or two exceptions all facades [at San Jose, Belize] appear to have been coated with undecorated cream-white stucco," although he did find stucco fragments with yellow, green, and blue paint.

The most complete evidence of polychrome is found at Palenque and Seibal. Willey (n.d.) says that the Structure A-3 relief occurred above the red-painted substructure and vertical wall of the temple. Red also seems to have been the most commonly used color, with other colors being a lighter red, yellow-brown, Maya blue, green, pink, and various shades of purple. In a unique and probably non–Maya usage, the lips of some figures were painted black, and black glyphs were drawn on some faces. In the material from the Palenque *bodega,* we assumed that all fragments from in-the-round stucco sculpture and most three-quarter and half-round fragments were from roof combs or entablatures. The paint surviving on these fragments shows that blue and red were by far the most prevalent colors, with orange sometimes used, and that color schemes were changed not only from monochromatic to polychromatic and vice versa, but that the colors of objects were changed from blue to red and red to blue.

The masked facade is perhaps the most useful of all themes in Maya architectural sculpture because it offers us a comparative context in which to study Maya attitude toward color. Freidel (this volume; Freidel and Schele n.d.) has excavated a facade at Cerros that he has analyzed as a world view cosmogram based on the movement of the sun. This same cosmic theme occurs on architectural substructures at Lamanai, Tikal, Mirador, and possibly at Uaxactun. It is carried into the Classic period at Tikal, Kohunlich, and El Zotz, and on the looted facade, now located in the Museo Nacional de Antropología (MNA) and the north substructure of the Palace at Palenque. Freidel (this volume) has shown that in the Late

Preclassic period, color went from a system using red, black, and white to full polychrome in a very short period. Both color schemes are character-ized by the use of black and/or colored line to render internal detail and to emphasize the edges of relief shapes.

At Kohunlich, the same iconographic theme is rendered in rich red color. The white of the plaster is part of the color sequence, and both a red and black line are used to enhance detail. Photographs suggest the presence of some blue. The dating of Kohunlich is problematic, but it is generally thought to be transitional, i.e., either very late Late Preclassic or very early Early Classic. Many of the details of the Kohunlich mask (for example, the framing serpents) are identical to the Cerros mask complex, but other designs, such as the central heads and the grotesques of the earplug assem-blages, resemble more closely a Classic period style. By the time the Kohunlich masks were built, the line treatment of the Late Preclassic polychromatic transition was weakened in favor of the use of more solid color areas, perhaps because they could be read at greater distances. All shape definition, both of major masses and internal details, is transmitted in the Kohunlich facades by light and shadow cast across a uniformly red surface. Line is used to enhance sculpted detail, but not to carry informa-tion independent of it.

The masks of the Early Classic Temples 5D-22-2nd and 5D-33-2nd and 3rd at Tikal are more difficult to associate with the Cerros-Kohunlich complex, although a case can be made. Little paint remains on any of the masks, but of the 5D-33-3rd masks, Coe (1967: 47) says: "Each owes its good preservation to the fact that the Maya covered them over with new masks at the time of building 33-2nd. But at the time of building 33-1st, these masks were brutally hacked and almost completely stripped of their red and white painted decorative plaster." The removal of color, then, seems to have been one way of "killing" architectural sculpture.

The MNA facade is Early Classic in style and also displays the Cerros-Kohunlich cosmogram in its anthropomorphic version, although it has been expanded to include two aged gods typical of Classic iconography. Some areas of the MNA facade were obviously repainted by the looters, but it is clear that as at Kohunlich, it was painted a solid red, with various details in the relief over-painted in white, black, and blue. Most of the overpainted details also occur in the relief, but the pupils in the eyes of the aged gods are rendered in black paint without being delineated in the relief. This overpainting of details is known on incensario stands featuring the same iconography, but it is unusual on other architectural sculpture, such as piers. Since this is the only example of Early Classic substructure sculpture retaining so much paint, it is not possible to determine if the

technique was a local phenomenon or more widespread, and because this facade was looted and obviously "doctored" for sale, the original extent of the paint cannot be determined with certainty.

The badly looted site of El Zotz also had at least one stucco masked facade (Martin Diedrich, personal communication, 1981). Although the faces of this facade have been removed, the earplug assemblage remains, and slides of them show traces of red on the central disk. Since earplugs are normally blue in polychrome systems, we can speculate that the El Zotz facade was solid red. The late Early Classic masks of the Foot Pyramid at Lamanai are also part of the Cerros-Kohunlich complex of iconography. There the main head is fully human, but with the tau-tooth characteristic of the Sun God. David Pendergast (personal communication, 1981) informs me that this mask panel and all others on the Foot Pyramid were painted with a bluish-gray coat of stucco resulting from the addition of ground charcoal to the stucco mixture. A similar gray is also documented at Uaxactun (Smith 1950: 64–65).

The final facade to be discussed is the north facade of the Palace at Palenque. Flanking a wide processional stairway were four terraces, each with an outset panel consisting of a central head, flanking recessed panels, and framing border. Although the heads are fully human, the zoomorphic headdress and the earplug assemblage are the Classic equivalent of the Cerros complex and represent the survival, virtually unchanged, of the Late Preclassic cosmogram. Although the central panel of west terrace 5 is covered with a layer of rough white plaster, Blom (1926: 171) reported that he found traces of red paint on the lower west heads, concreted over for preservation purposes in the 1950s. Robertson (1977: 315) found a place on the upper west mask that revealed "a coat of vivid light blue-green, then a layer of white on top of this, then a deep red, a white, and finally a deep red." Robertson (1977: 315) also detected blue paint on the flanking serpent bodies, while I have found clear evidence of red. It seems at an early stage these panels were polychromed, followed by several later stages of monochrome red.

One of the most interesting features of the Palenque facade is the coating of rough plaster covering the central section of the upper west panel. Freidel (personal communication, 1981) reports that the Cerros masks were ritually killed by destroying the left eye and muzzle of each mask, after which the entire facade was carefully buried. At Tikal, the Early Classic masks of 5D-33-2nd and 3rd were killed by slashing them and removing the final coat of plaster with its red paint. The thick layer of plaster on the Palenque facade appears to have functioned also as a means of "killing" the sculpture before rebuilding. It is clearly the interfacing

layer between the painted surface of the older facade and the later un-sculpted facade built over it. And since plaster was placed only over the portrait panel, and not the flanking serpents or border, it was the portrait, not the entire sculptural panel, that required killing. Since at both Tikal and Palenque color was neutralized or removed as a part of termination rituals, we may speculate that the Classic Maya considered color to be an element that imparted "life" or "force" to architecture and sculpture.

SUMMARY

Three color schemes can be documented for Classic Maya sculpture and architecture. Stucco, either white, cream, or bluish-gray, was used as the final coat on both architecture and sculpture. The interiors of buildings were often left white, and bluish-gray finishes are documented for some Uaxactun interiors. Maler reported solid white interiors and exteriors (including frieze and roof comb sculpture) at Yaxchilan. He also reported stucco finished stelae at Naranjo. The Middle Classic facade on the Foot Pyramid at Lamanai was finished in a bluish-gray stucco resulting from the addition of charcoal dust to the plaster mixture.

Perhaps the widest spread color treatment was solid red. It is likely to have been exclusively used on the monuments of several sites, including Copan, Tikal, and Seibal. It was a favored color on the interior walls and/or floors of buildings and on the outer facades of buildings, whether sculptured or not. In fact, unsculptured portions of facades are known to have been left white or painted red; to date, no other color scheme has been reported, with the exception of Mound A of CV-43 at Copan. Red may have been used in such profusion because of its ready availability, but it also must have had symbolic meaning, perhaps of blood and, by extension, of the Middle World and lineage and dynasty.

Polychrome systems used predominately hematite reds and other iron-based pigments and the blue of the attapulgite-indigo complex. Yellow (occurring mostly on jaguar pelts) and green were also rare. In poly-chrome systems, black and white rarely occur until the Terminal Classic stuccos of Seibal Structure A-3, although black line or black-line-with-red is known to have been used in mural, burial, and cave paintings through-out the Classic period. In general, color was applied according to the material of the object portrayed; i.e., feathers, jade, and water were blue, flesh red. However, color was also used symbolically, but perhaps more within local traditions than pan-Maya ones. For example, sacred objects, especially supernaturals such as God K, tend to be painted blue at Pa-lenque. At Yaxchilan, the God K scepters were red, and at Tikal Burial 195, they were painted with a blue-tinted stucco and black line. The choice

of ground color may also have been symbolic, but there is evidence that it was chosen according to which pattern of positive color was to be emphasized. In the majority of cases, the ground was red (either a dark red or the bright red also used on flesh), which focused attention on the pattern of blue used on feathers and jade. All documented instances of blue grounds (Yaxchilan Lintel 26, Bonampak Lintels 1, 2, and 3, and the Kimbell Museum Panel) involve blood-letting rites or war-related events in which the emphasis may have been on the flesh of the actors rather than on their costumes. Color in both the solid red and polychrome systems was applied as flat, usually opaque pigments. Dilution and glazing appear to have been the means for changing hue and tone because the only examples documented for tints are where pigment (blue or black) was added to a stucco mixture before use. Line, although used on Late Preclassic and some Early Classic architectural sculpture and in Classic mural painting, is rarely found on red-painted or polychrome-painted sculpture of the Classic period. Details of figure-ground separations and internal contours were conveyed through the light and dark effect of light cast across relief surfaces. "Killed" sculptures on substructures at Tikal and Palenque suggest that part of the killing process was to remove or obscure color. This practice might explain the presence of unpainted substructure sculpture in Late Preclassic and Early Classic strata at various sites.

BIBLIOGRAPHY

ARNOLD, DEAN E., and BRUCE F. BOHOR
 1975 Attapulgite and Maya Blue. An Ancient Mine Comes to Light. *Archaeology* 28 (1): 23–29.

BLOM, FRANS, and OLIVER LA FARGE
 1926 *Tribes and Temples* 1. Tulane University, New Orleans.

COE, WILLIAM R.
 1967 *Tikal: A Handbook of Ancient Maya Ruins.* The University Museum, University of Pennsylvania, Philadelphia.

FREIDEL, DAVID, and LINDA SCHELE
 n.d. Symbol and Power: A History of the Lowland Maya Cosmogram. Paper presented at the Princeton Conference, The Beginnings of Maya Iconography, October 1982.

GRAHAM, IAN
 1975–79 *Corpus of Maya Hieroglyphic Inscriptions.* Peabody Museum of American Archaeology and Ethnology, Harvard University, Cambridge.

JONES, CHRISTOPHER
 1975 A Painted Capstone from the Maya Area. *Contributions of the University of California Archaeological Research Facility* 27: 83–110. Berkeley.

LITTMAN, EDWIN R.
 1960 Ancient Mesoamerican Mortars, Plasters, and Stuccos: The Use of Bark Extracts in Lime Plasters. *American Antiquity* 25: 593–597.

MALER, TEOBERT
 1901–03 *Researches in the Central Portion of the Usumatsintla Valley.* Memoirs of the Peabody Museum of American Archaeology and Ethnology 2 (2). Harvard University, Cambridge.
 1908–10 *Explorations of the Upper Usumatsintla and Adjacent Region.* Memoirs of the Peabody Museum of American Archaeology and Ethnology 4 (2). Harvard University, Cambridge.
 1911 *Exploration in the Department of Peten, Guatemala. Tikal.* Memoirs of the Peabody Museum of American Archaeology and Ethnology 5 (1). Harvard University, Cambridge.

MILLER, ARTHUR
 1976 *Architectural Sculpture at Tikal, Guatemala: The Roof-Comb Sculpture on Temple I and Temple IV.* Actas del XXIII Congreso Internacional de Historia del Arte España entre el Mediterraneo y el Atlántico. Granada.

PROSKOURIAKOFF, TATIANA
 1960 Historical Implications of a Pattern of Dates at Piedras Negras, Guatemala. *American Antiquity* 25: 454–475.

ROBERTSON, MERLE GREENE
 1977 Painting Practices and Their Change through Time of the Palenque Stucco Sculptors. *Social Process in Maya Prehistory, Studies in Honour of Sir Eric Thompson* (Norman Hammond, ed.): 297–326. Academic Press, New York.

 1979 A Sequence of Palenque Painting Techniques. *Maya Archaeology and Ethnohistory* (Norman Hammond and Gordon R. Willey, eds.): 149–171. University of Texas Press, Austin.

 n.d. The Early Buildings of the Palace. Manuscript, 1982, in preparation for the Princeton University Press.

RUPPERT, KARL, and JOHN H. DENISON, JR.
 1943 *Archaeological Reconnaissance in Campeche, Quintana Roo, and Peten.* Carnegie Institution of Washington, Publication 543. Washington.

SCHELE, LINDA and PETER MATHEWS
 1979 *The* Bodega *of Palenque, Chiapas, Mexico.* Dumbarton Oaks, Washington.

 n.d. The field catalogs of the *Bodega* of Palenque. Bks. I–IV. Originals in the Schele library; copies in the archives of the Instituto Nacional de Antropología e Historia, Mexico, and the Zona Arqueológica de Palenque. 1974.

SMITH, A. LEDYARD
 1950 *Uaxactun, Guatemala: Excavations of 1931–1937.* Carnegie Institution of Washington, Publication 588. Washington.

STEPHENS, JOHN LLOYD, and FREDERICK CATHERWOOD
 1969 *Incidents of Travel in Central America, Chiapas, and Yucatan.* Dover Publication, New York.

STUART, GEORGE E.
 1981 Maya Art Treasures Discovered in Cave. *National Geographic Magazine* 160: 220–236.

THOMPSON, J. ERIC S.
 1939 Excavations at San Jose, British Honduras. Carnegie Institution of Washington, Publication 506. Washington.

TOZZER, ALFRED
 1941 *Landa's Relación de las Cosas de Yucatan, a Translation.* Papers of the Peabody Museum of American Archaeology and Ethnology 18. Harvard University, Cambridge.

WILLEY, GORDON R.
 n.d. Stucco Frieze. Manuscript, 1981, to be published as a part of the Seibal Reports.

WILLEY, GORDON R., RICHARD M. LEVENTHAL, and WILLIAM L. FASH, JR.
 1978 Maya Settlement in the Copan Valley. *Archaeology* 31 (4): 32–43.

Painted Architecture in the Northern Maya Area

JEFF KARL KOWALSKI

NORTHERN ILLINOIS UNIVERSITY

WE ARE ACCUSTOMED TO JUDGE northern Maya architecture by the appearance of its finest late buildings, such as the House of the Turtles or the House of the Governor at Uxmal, where patterns of light and shadow produce brilliant chiaroscuro effects on the cut stone facades. Such edifices seem so captivatingly complete that we often forget there is abundant evidence that, like ancient Greek sacred architecture, many of these buildings were painted with a wide range of colors.[1] This paper will outline the evidence for polychromy in northern Maya architecture, which, for the purposes of the present discussion, will be confined to buildings of Preclassic through Terminal Classic date, from the Rio Bec region to the northern plain of Yucatan (Fig. 1). Postclassic architecture at Chichen Itza is mentioned when it seems probable that colored sculptures have a direct relationship with earlier northern Maya buildings. We can obtain a basic idea of how and why colors were used on these edifices from a review of the statements of early Spanish historians, records of early explorers, archaeological site reports, and a detailed examination of preserved paint on facades.

EARLY REFERENCES TO PAINTED ARCHITECTURE IN YUCATAN

The earliest reference to painted architecture in Yucatan comes from Bernal Díaz del Castillo, who described the appearance of the temples at Campeche (Ah Kin Pech) in 1517 as follows: ". . . on the walls were

[1]On the use of painting generally on northern Maya buildings, see Catherwood (1844: 5), Charnay (1978: 17), Spinden (1913: 131), Totten (1926: 36–37), Morris, Charlot, and Morris (1931, 1: 226), Thompson, Pollock, and Charlot (1932: 125–126), Hissink (1934: 13), Robertson (1963: 28–29), Pollock (1965: 409, 1980: 580), Stierlin (1964: 145), Sharp (n.d.: 21), G. Andrews (1975: 78), and Potter (1977: 82).

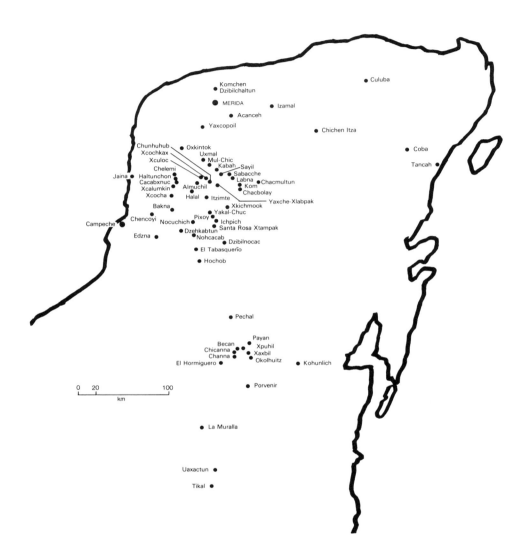

Fig. 1 Map of the northern Maya area.

figured the bodies of many great serpents and snakes and other pictures [paintings] of evil looking idols. These walls surrounded a sort of altar covered with clotted blood. On the other side of the Idols were symbols like crosses, and all were coloured" (Díaz del Castillo 1908, 1: 1).

Fray Diego de Landa, describing the house types of the Yucatec Maya at a time shortly after the Conquest, noted that "the lords have their walls painted with great elegance" (Tozzer 1941: 85–86). Landa is referring principally to interior mural painting, but the reference further suggests that buildings were painted to mark their social importance, with the houses of headmen being more lavishly decorated than those of commoners.

One of the earliest references to color on Puuc architecture comes from Fray Antonio de Ciudad Real, who described the portal vault through the South Structure of the Nunnery at Uxmal in 1588: "It would appear that this entrance had been plastered and that on the plaster paintings had been made in blue, red and yellow color, since even now some of them remain and can be seen. Nearly all the rest of the stones had been plastered but not painted" (Ciudad Real 1872, 58: 455–461).

Pedro Sánchez de Aguilar, writing in 1639, stated that on the walls of Uxmal and Chichen Itza were ". . . many figures painted in vivid colors which one may see today, of their sacrifices and dances . . ." (Sánchez de Aguilar 1937: 140).

PAINTING ON FORMATIVE AND EARLY PERIOD BUILDINGS

Painted architecture in the northern Maya area apparently dates from the Middle Formative period (c. 800–350 B.C.) during the Nabanche phase (Andrews V et al. n.d.: note 3). Structure 500 at Komchen, one of the site's largest structures which defines the north end of the Preclassic main plaza, has red-brown paint on small areas of its sloping terrace walls. Although the remaining paint does not cover the entire platform, it is not known whether this was the original appearance or whether it is due to differential weathering (Andrews V, personal communication, July 1981). At Becan the late-facet Pakluum phase Structure XXVII has an upper structure with well-preserved, red-painted plaster (Potter 1977: 12).

According to E. Wyllys Andrews IV (1965: 307–309), the major decoration of buildings during the Early period in Yucatan (c. A.D. 280–800) consisted of "panels of carved or painted stucco." Evidence for the appearance of such painted architecture is found at Acanceh, where the entire large pyramid, including the two colossal stucco masks flanking the stairway, had been painted red (Seler 1960, 5: 392).[2]

[2]The colossal size of these masks relates them to those at Izamal (Charnay 1887: 308–309) and perhaps more distantly to those of Kohunlich (Pl. 3) as well (Segovia 1969: 1–8). On the

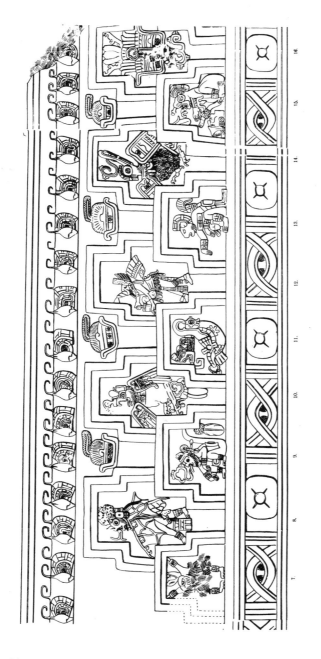

Fig. 2 Acanceh, stucco sculptures on the Temple of the Stucco Relief (after Seler 1960, 5: taf. XI).

54

A remarkable use of polychromy on an Early period building occurred on the north facade of the Temple of the Stucco Relief at Acanceh (Fig. 2).[3] The relief of the stuccoed facade was painted with a broad range of hues including red, reddish-brown, pink, beige, yellow, green, and light and dark blue. All colors were applied as flat washes, and were limited to fairly large, clearly defined areas; there was no attempt to blend colors to suggest modeling. The color treatment is reminiscent of roughly contemporary mural paintings at Teotihuacan, Monte Alban, or Uaxactun. Although the flat colors recall those of Teotihuacan, the internal detailing of the reliefs shows greater concern for organic connectedness and overlappings more characteristic of Classic Maya art.[4] The background of the relief was red to reddish-pink, while the stepped frames that enclose the figures were painted in different two-color combinations. No two adjacent frames featured exactly the same combination, so that the color effect was richly varied along the length of the facade. Whether these changes of color are primarily decorative, or have symbolic meaning, is not known.

The zoomorphic and anthropomorphic figures featured various color combinations. Some of the colors seemed to approximate natural appearances, as in a green and yellow serpent body, while others, such as the blue bodies of the rodents (squirrels?), were non-realistic and apparently were selected for decorative or symbolic purposes.

Another use of color on Early period architecture is found at Culuba, where the masonry facades of a multi-room building in Group A were plastered and painted red (Andrews V 1979: 9, figs. 1–2). Other examples of painted facades and architectural sculptures from the Formative and Early periods are known at Yaxcopoil (Andrews IV 1942: 260), Izamal (polychrome) (Fig. 3) (Charnay 1887: 311, 1978: 14–16), Ake (Roys and Shook 1966: 40, 42), Jaina (polychrome) (Piña Chan 1968: 35), Coba

Acanceh pyramid see Marquina (1964: 800–802, lám. 242) and Kubler (1975: 132, 171). The stylistic connections with Early Classic Peten structures have suggested a similar date for the Acanceh pyramid to Marquina, Kubler, and Andrews IV (1965: 298–299), but recently Andrews V (1974: 144) has suggested that the possibly contemporary Temple of the Stucco Relief at Acanceh was constructed during Tepeu 2 times, or about A.D. 700.

[3]The preservation of these painted sculptures is due to the fact that the building they decorate was later embedded in a larger pyramid of Florescent date (Seler 1960, 5: 392; Andrews IV 1942: 258). The stuccos now show little trace of color, but fortunately, shortly after the Stucco Temple was uncovered, Adela Breton (1908: 36) made quarter-scale watercolor drawings of the reliefs, now in the City Museum of Bristol, England.

[4]The relief has been described as "Mexican" influenced by Andrews V (1974: 144), who places it at about A.D. 700. Andrews IV (1965: 298–299) believed that the Temple dates to the first phase of the Early period, corresponding to Tzakol in the Peten. The nature of the correspondences, both of style and of motif, among this relief and the arts of other regions of Mesoamerica has recently been investigated by Virginia Miller (n.d.a, n.d.b).

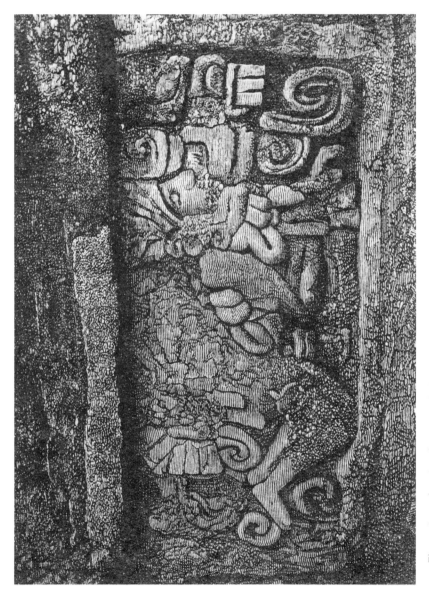

Fig. 3 Izamal, painted stucco relief on the pyramid of Kab-ul (after Charnay 1978: 14).

(Thompson, Pollock, and Charlot 1932: 70-note 1, 99, 125–126, figs. 34, 56), and Kohunlich (red) (Pl. 3) (Segovia 1969: 1–8). It is possible that Early period structures at Oxkintok (Shook 1940: 168–169), Edzna (Palacios 1928: 170; G. Andrews 1969: 74, 87), and Dzibilchaltun (Clemency Coggins, personal communication, August 1981) were painted in some cases as well. It is evident that painted buildings, either plain red or polychrome, were common during these periods. Many other structures which have lost their stucco probably were originally painted.

PAINTED ARCHITECTURE AND SCULPTURE IN THE CENTRAL YUCATAN AREA

David Potter (1976, 1977) has recently suggested that the buildings of the Rio Bec and Chenes areas share enough traits of masonry style, architectural form, and iconographic motif to incorporate them in a larger regional tradition termed the Central Yucatan Architectural Style, which flourished from about A.D. 600 to 830. At least fourteen buildings within this region have traces of painted plaster or stucco (Potter 1977: 82), but only a few of the better-documented painted facades from this region need be discussed here.

In the Rio Bec area, Chicanna Structure II (Fig. 4), a three-unit dragon-mouth building, has an elaborate stucco program with many traces of paint on the remaining plaster. Most of the walls and the original roof comb were painted red, perhaps with some blue as well. Protected areas in the central dragon-mouth facade retain traces of red, black, blue, green, yellow, and white paint (Eaton 1972: 47). Structure VI at Chicanna has large areas of plaster still covering the rear wall, some with red and blue paint (Potter 1977: 69). The masks of Structure XX also retain traces of red and blue paint (George Andrews, personal communication, August 1981), and Structure I has areas of wall covered with red-painted plaster (Eaton 1972: 44).

At Becan, the remaining stucco relief of the dragon-mouth entrance of Structure X is painted a dominant red, with traces of yellow and blue-green (Potter 1977: 56, fig. 54), and fragments of stucco from Structure IV suggest that much of the exterior of this building was also painted, primarily in red with touches of blue, green, and yellow (Potter 1977: 28, 37, 40–41, fig. 31). Two human sculptures (associated with Structure X and with Structure IV) (Fig. 5) and three faces with simian features found at Becan were painted red (Potter 1977: 26, 33–34, 56, figs. 25, 29–30, 55). Other Rio Bec sites with painting preserved on the building facades include Pechal (Ruppert and Denison 1943: 92), Channa (Ruppert and Denison 1943: 64, fig. 77, pl. 24b), La Muralla (slightly south of Rio Bec region) (Ruppert and Denison 1943: 72), Porvenir (Potter 1977: 105),

Fig. 4 Chicanna, Str. II, north wing and section of dragon-mouth doorway.

Xpuhil (Potter 1977: 93, fig. 75), and El Hormiguero (George Andrews, personal communication, August 1981).

Two of the best-known Chenes sites, Hochob and El Tabasqueño, have several examples of paint preserved on the building facades. At Hochob, Structure 2 (Fig. 6), the famous dragon-mouth building, had liberal traces of red paint on its flying facade, suggesting that the entire roof structure with its files of stucco figures was painted red (Pollock 1970: 13). The elaborate stucco facades were apparently a natural creamy color, with the exception of the eyes of the large dragon masks on the central building and east wing, which were painted a vermilion red (Pollock 1970: 13; Hissink 1934: 13). The East Temple of Structure 5 at Hochob has traces of red paint on the three-part base molding and on the upper facade. On the west facade a few patches of low relief stucco, perhaps depicting feathers, are painted red, brown, and green (Pollock 1970: 17). Maler (1895: 279) and Seler (1916: 18) suggest that virtually the entire exterior and roof comb

Fig. 5 Becan, Str. IV, red-painted stucco figure found in upper courtyard. Height, 68 cm (after Potter 1977: fig. 25).

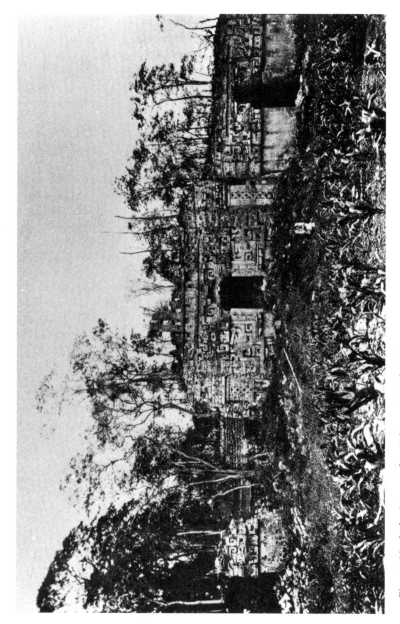

Fig. 6 Hochob, Str. 2 (after Seler 1916: taf. VI).

were painted red, and this color was carried across the doorjambs and formed a band around the inside of the doorway as well.

One of the best-preserved dragon-mouth facades is found on Structure 1 at El Tabasqueño. Apparently this entire elaborate stone and stucco portal, as well as the roof comb and its stucco human figures, was originally painted red (Pollock 1970: 21). The walls and moldings of the lower story were also covered with polychrome stucco of red, yellow, and blue color (Maler 1895: 249; Seler 1916: 40, abb. 37). Other examples of painted buildings in the Chenes style are known at Nohcacab (Pollock 1970: 38, fig. 44a; Seler 1916: 60–61), Santa Rosa Xtampak (Maler 1902: 228; Matheny and Berge 1971: 7), Dzibilnocac (Pollock 1970: 30; Nelson, Jr. 1973: 28), Dzehkabtun (Maler 1902: 230; Ruz 1945: 40), Nocuchich (Pollock 1970: 43–44, 46, figs. 52–54), and Uxmal (Pollock 1970: 80). Structure 1 at Nocuchich (Fig. 7) is a remarkable tower adorned with a colossal human head in red-painted stucco.

Painted buildings and architectural sculpture were common in the Rio Bec and Chenes areas. The predominant color was red, but multicolored sculpture often added variety.

PAINTED ARCHITECTURE AND SCULPTURE IN THE PUUC AREA

In a recent discussion of Puuc architecture, Harry E. D. Pollock (1980: 580) suggests that:

> Just as frequent as the use of stucco was the use of paint as a decorative medium. Traces of paint are found on dozens of structures, but only rarely have any sizeable areas been preserved. Painting seems to have taken a number of forms. There is evidence of overall painting of walls, possibly of whole buildings, in a single color. . . . There was undoubtedly a great deal of painting in connection with Puuc architecture, relatively little of which has been preserved.

Early Puuc architecture tended to use modeled stucco as a medium for figural or geometric sculpture, and in many instances this stucco sculpture, as well as the flat plaster covering walls, shows traces of color. Structure 6 at Itzimte is a small, one-room temple building which is an example of Proto-Puuc architecture as defined by Pollock (1980: 584, 587) and perhaps dates from A.D. 600–700 (G. Andrews n.d.: 31–34, fig. 26; Von Euw 1977: 6). Patches of reddish-orange plaster adhering to the rear wall and the medial molding suggest that the entire building was painted this color.

The Mirador Temple at Sayil (Fig. 8) was partially polychrome. The binder molding on the roof comb (carrying rosette-like reliefs on the

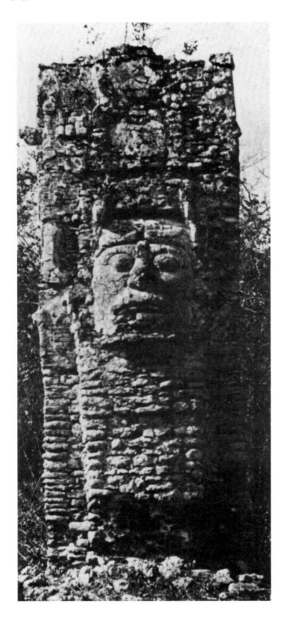

Fig. 7 Nocuchich, Str. 1, red-painted tower and colossal stucco head (after Pollock 1970: fig. 53a).

Fig. 8 Sayil, Mirador Temple.

middle member and a feather motif on the upper and lower members) had traces of red, green, and blue paint on the lower member according to Pollock (1980: 119), although George Andrews (n.d.: 14–15) reports that patches of plaster remaining on this molding show a green horizontal band with the balance in red.

Another use of polychrome on what is probably an Early Puuc building occurs at Chencoyi (George Andrews, personal communication, August 1981). Above a doorway with two round columns and square capitals is a panel of geometric stucco relief with traces of red, yellow, and blue paint.

Traces of painted plaster or stucco sculpture are also found on buildings of Early Puuc style at Uxmal, Labna, Mul-Chic, Oxkintok, Sabacche, Xkichmook, Xcocha, and Xcalumkin, among others. Some of these buildings apparently had their entire facades and/or roof combs painted red, while others had a greater variety of color.[5]

[5]Buildings with facades and/or roof combs predominantly red include Sabacche, Str. 1 (Pollock 1980: 71; Maler 1895: 248); Xcocha, Building of the Glyphic Band (Pollock 1980: 512); Bakna, Southeast Court, East Building (Pollock 1980: 537); Oxkintok, Str. 3B5 (Pollock 1980: 308); principal structure at Xkeche (Pollock 1980: 335); Xcochkax, South Range of the First Tier (Pollock 1980: 387); Cacabxnuc, North Group, North Building (Pollock 1980:

The architectural sculpture of Late Puuc buildings differs from that which preceded it in northern Yucatan and the southern Maya area. Naturalistic sculptures executed primarily in modeled stucco characterized previous architectural decoration, while the mosaic sculptures of the Puuc buildings are composed largely of pre-carved geometric elements (Fig. 9). As George Kubler (1975: 173) has noted, the sharply faceted facades of these buildings are adapted superbly to the strong sunlight of Yucatan. Yet there is much evidence that even these Late Puuc buildings would have had such chiaroscuro effects softened by the use of color.

Several Late Puuc buildings at Uxmal have traces of paint on their facades. The gabled roof comb of the House of the Pigeons (Fig. 10) formerly supported stucco sculpture, remnants of which exist with color intact. In some of the apertures of the roof comb there is red-painted plaster, while on the facade, set against a red background, are some low-relief feathers, presumably from a headdress, that show traces of green paint (Morley 1910: 9; Littman 1960b: 410; Kowalski, 1977 field notes). The range on the east side of the second court of the Pigeons Group has an upper facade composed of colonnettes between three-member moldings; apparently both the colonnettes and moldings were painted red (Morley 1910: 13, fig. 1).

The Cemetery Temple at Uxmal has traces of red-painted plaster covering the medial molding and on the lower wall, at the rear (Pollock 1980: 222; Kowalski, 1977 field notes). Seler (1917: 50) asserts that the entire building was covered with plaster and painted red. Painting was continued over the doorjambs (Pl. 4), where broad red bands frame a central blue panel.

The East Structure of the Nunnery at Uxmal (Fig. 11) also retains traces of red paint. Many of the interstices of the latticework have patches of red-painted plaster inside, while the mouths of the long-snouted masks on the corners of the building also show traces of red (Stephens 1963, 1: 183–185; Seler 1917: 42). Ciudad Real described paintings in the portal vault of the South Structure of the Nunnery, and it is probable that the Pyramid of

462); Haltunchon, Hilltop Group, West Building (Pollock 1980: 465); Chelemi, Building with Paintings (Pollock 1980: 468); Xcalumkin, Initial Series Building (Pollock 1980: 424); Xcalumkin, North Group, South Building (Pollock 1980: 452); Xcalumkin, Hieroglyphic Group, Middle Building (Pollock 1980: 441); Xcalumkin, Northwest Building (Pollock 1980: 430). My 1977 field notes state that traces of red paint occur on some of the structures at Xkichmook. Buildings that show traces of a greater variety of color include Uxmal, House of the Old Woman, Lower Temple (Pollock 1980: 256; G. Andrews n.d.: 48); Mul-Chic, Str. A (Piña Chan 1963: 101, láms, I, II; G. Andrews n.d.: 7, figs. 4–5); Labna, Mirador Temple (Stephens 1963, 2: 32; Saville 1893: 233; Pollock 1980: 38); and Xcalumkin, Blue Stucco Head (Pollock 1980: 454, fig. 762d).

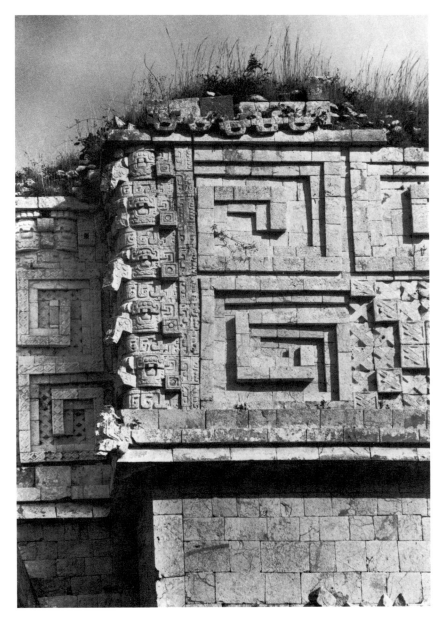

Fig. 9 Uxmal, House of the Governor, section of the west facade.

Fig. 10 Uxmal, House of the Pigeons, painted stucco featherwork on roof comb.

the Magician was lavishly painted, too (Littman 1960b: 410; Waldeck 1838: 96). On Temple V, the stone facing of lower walls and upper facade is marked with small holes in zig-zag, compound lattice, and step-fret patterns (Seler 1917: 114, abb. 100); it is likely that these patterns, which are barely visible from ground level, were the guidelines for painted designs.

Three other sites with important evidence of painting are Labna, Ichpich, and Kom. The Labna example will be discussed later. The Palace by the Waterworks at Ichpich (Fig. 12) has medial and cornice moldings decorated with sawtooth elements against a red-painted background. Maler (1902: 200) believed that the entire building was once painted red, but this is not certain. There is also a red-line figural painting on the lower surface of the medial molding of this building (Kowalski, 1977 field

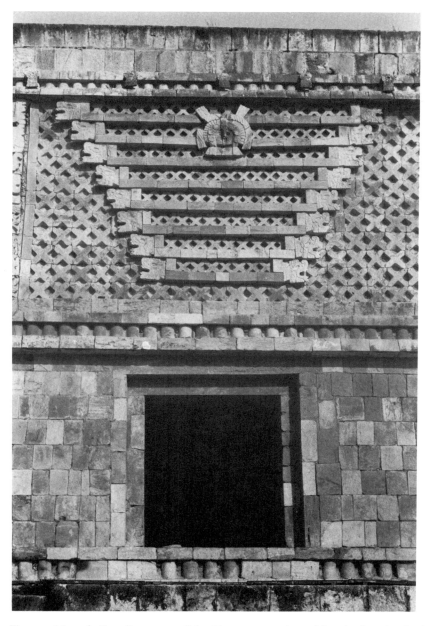

Fig. 11 Uxmal, East Structure of the Nunnery, section of facade showing lattice-work and over-doorway serpent tiers.

Fig. 12 Ichpich, Palace by the Waterworks.

notes). Another building at Ichpich was nicknamed the "Red Palace" by
Maler (1902: 200) because preserved plaster indicated that virtually its
entire exterior was painted red. My 1977 field notes state that Building D
(marked CNEP 1) had a molding with red paint, and is presumably
Maler's "Red Palace." At Kom, an extensive patch of red-painted plaster
is still visible flanking a doorway on a palace building (Kowalski, 1977
field notes).

A good indication of the original appearance of some of these Puuc
buildings is provided by the mural paintings in Edifice 3 at Chacmultun
(Fig. 13). In the lower register of the mural is a building whose facade is
painted brilliant red and green. There is a red lower wall and a mansard-
profile upper facade with a step pattern of bright green against a red
ground. Medial and cornice moldings are bordered in green with red
interiors. Edifice 3 itself was painted blue and red (E. H. Thompson 1904:

15; Marquina 1928: 69). In Room 10, the room containing the murals, there are traces of paint around the doorway, and Thompson (1904: 17) says that "not only upon the inner surfaces of the lintels, but on the outer faces as well, were painted scrollwork designs in bright red and blue." A similar painted doorway occurs in Edifice 4 at Chacmultun (E. H. Thompson 1904: pl. IX; Barrera Rubio 1979: 197, figs. 6, 6a).

In addition to the examples mentioned, there are other Pure Puuc buildings with painted facades (mostly red) at Uxmal, Kabah, Sayil, Xculoc, Chacbolay, Chunhuhub, Halal, Yaxche-Xlabpak, Yakal-Chuc, and Al-

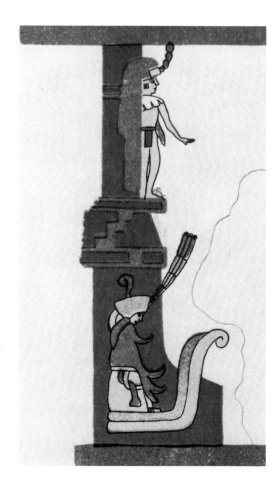

Fig. 13 Chacmultun, detail of the mural painting in Edifice 3 (after E. H. Thompson 1904: pl. VIII).

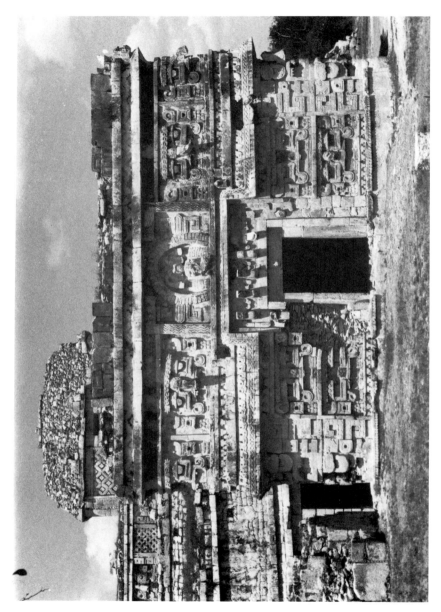

Fig. 14 Chichen Itza, Monjas, East Wing.

70

muchil.[6] Red continued to be the favored color for the covering of large areas in Puuc architecture, but much polychromy was used, particularly on sculpture.

PAINTING ON "MAYA" BUILDINGS AT CHICHEN ITZA

Several of the buildings in the southern section of Chichen Itza are closely related to Puuc architecture stylistically, and are associated with hieroglyphic or radiocarbon dates suggesting that they were constructed prior to the final "Toltec" period at the site (Thompson 1945: 8–9; Andrews V 1979: 5).[7] Buildings with known traces of color include the Red House (Seler 1960, 5: 246; Proskouriakoff 1963: 91), the Monjas (Fig. 14) (Seler 1960, 5: 233; Bolles 1977: 116, 119, 126, 136, 250), the Southeast Annex of the Monjas (Bolles 1977: 163, 250, 258), and the Iglesia (Bolles 1977: 154, 250). Many traces of paint were also found on the transitional Caracol (Stephens 1963, 2: 200; Ruppert 1935: 48–51, 107, 150, 153, 197, 203, 221). With the exception of the Red House, these buildings were partly polychrome. Several of these structures will be considered in more detail under discussions of separate motifs.

PAINTED HUMAN FIGURAL SCULPTURE

Several of the facades of northern Maya buildings carried programs of human figural sculpture. Although in many cases these have lost their original coloring due to intense weathering, enough examples exist to support the idea that many of the figures were originally painted, and to give an indication of typical colors.

Red, reddish-brown, or reddish-orange were the most common colors for the bodies of human figures. On the Early period pyramid of Kab-ul at Izamal (Fig. 3) a low relief stucco sculpture of a man had a body described as dark reddish-brown, or the color of Maya flesh (Charnay 1978: 14).

[6]These other buildings include Uxmal, The House of the Governor (Catherwood 1844: 15); Uxmal, Portal Vault (Smith and Ruppert 1954: 1, fig. 1); Kabah, Str. 2A2 (Pollock 1980: 168, fig. 331); Kabah, Str. 2C6, Codz Poop (Pollock 1980: 189); Sayil, Str. 4B2, South Palace (Pollock 1980: 128, fig. 127); Sayil, Third Story of the Main Palace (Littmann 1960b: 411); Xculoc, Building east of the Figure Palace (Maler 1902: 209); Chacbolay, Castillo (Maler 1902: 198, abb. 1); Chunhuhub, Upper range of Main Palace (Maler 1902: 211, abb. 10); Halal, Second Story, South Wing of Northwest Building of Acropolis (Pollock 1980: 548); Yaxche-Xlabpak (Maler 1902: 208); Yakal-Chuc, Building with Two Rooms (Maler 1902: 220); and Almuchil, Ball Palace (Maler 1902: 214; Ruz 1945: 45).

[7]It is here recognized that a significant influx of non-Classic and "Mexican" influences began at Chichen Itza, as well as at the Puuc sites, before the date of A.D. 968–987 (Katun 4 Ahau) traditionally associated with the arrival of the Toltecs. For some more recent discussions of Terminal Classic-Early Postclassic culture history see J. E. S. Thompson (1970), Proskouriakoff (1970), Ball (1974, 1979), and Andrews V (1979).

The naturalistic, seated stucco figure from Becan Structure IV (Fig. 5) was modeled of red-brown plaster (Potter 1977: 26, 33), while the human figure found in Structure X was covered with red-painted plaster (Potter 1977: 56, fig. 55). Red-painted stucco fragments from Xpuhil show an apparent human arm attached to a collar, and hands or feet (Potter 1977: 93, figs. 75a–c). The East Wing of the Monjas (Fig. 14) at Chichen Itza features a central human figure who was always painted red, although minor changes in color were made in the surrounding elements (Bolles 1977: 126). According to George Andrews (n.d.: 7), the flying facade of the Proto-Puuc Structure A at Mul-Chic (c. A.D. 600–700) had stucco figures that were painted, with many traces of orange paint still visible. Piña Chan (1963: 10, láms. I, II) mentions vestiges of blue, red, and yellow paint on this flying facade, however, so it is less certain that the figures were uniformly reddish-orange.

The examples mentioned above are the best documented appearances of red used as a general body color. However, there are other buildings where human figures are known to have formed part of the structural ensemble, and where the preserved color suggests that they, along with their background, were painted red. This type of treatment is characteristic of perforated roof combs and flying facades, as at Hochob Structure 2 (Fig. 6), Structure 1 at Sabacche (Pollock 1980: 71), and the Building with the Six Rooms at Dzehkabtun (Maler 1902: 230). Many traces of red paint also adhere to the stucco facing on the front, rear, and in the apertures of the flying facade of the Mirador Temple at Labna. This flying facade is known to have carried an extensive figural composition, portions of which still exist (Stephens 1963, 2: 32; Pollock 1980: 38). However, Pollock (1980: 38) also reports blue as well as red paint on the headdress of one figure above the central doorway, and Saville (1893: 233) states that traces of red, yellow, blue, and black paint could be seen in protected areas on the same figure.

More varied colors were given to faces than to the rest of the body, perhaps reflecting an interest in recording the personalized appearance of facial painting. However, in many instances the face as well as the body was painted red. At Izamal, the face of the stucco figure on the Kab-ul pyramid (Fig. 3) seems to have been red (Charnay 1978: 14), and Viollet-le-Duc (1863: 46) mentions that the larger human head of stucco on the second terrace of this pyramid had traces of paint in the mouth (presumably red) (Charnay 1887: 311). The first and second masks on the pyramid at Kohunlich (Pl. 3) retain much of their original red paint. Although they are depictions of the Sun God (Segovia 1969: 7), their appearance is basically human. Related in style to these monumental heads at Kohunlich is

the colossal red stucco head that adorned the tower at Nocuchich (Fig. 7).

Fine examples of elaborate, polychrome facial painting occur on two human heads of stucco (Pl. 3) discovered by Gann (1918: 140–142), and said to have been found at the House of the Governor at Uxmal (Saville 1921: 126–127, pls. V-VII). These heads are well modeled and convincingly naturalistic examples of Maya portraiture. Like the stuccos of Palenque (Griffin 1976: 141–143, figs. 10, 12), these sculptures were probably broken from an architectural setting. The largest and best-preserved of the heads is painted black, with brown patches on each side of the mouth (Pl. 5). The lips are red and the eyes are white with black pupils. A line of brown encircles the entire eye on the lids. Broad white bands are painted around the eyes, and the large, circular ear ornaments are painted red. The other portrait head resembles the first, but with only the right eye encircled and with two pellets above the lip rather than one (Saville 1921: 126–127, pl. VI). There is also a small, grotesque head painted black with three red discs for eyes and mouth (Saville 1921: 126–127, pl. VII).

Another example of a different facial color treatment occurs on Miscellaneous Sculpture M4 from Xcalumkin. Pollock (1980: 454, fig. 762d) describes this as a modeled stucco human head with headdress, with a tenon at the rear for insertion into a facade. The final coat of plaster on the head was painted blue.

The costumes and accoutrements of human figures provided an opportunity for a richer polychrome effect. At Izamal, the figure in relief on the Kab-ul pyramid (Fig. 3) had a blue and yellow headdress, while the large surrounding scrolls were blue, yellow, and red (Charnay 1978: 14). Remnants of low-relief stuccos on the East Temple of Structure 5 at Hochob possibly depict the feathers of a headdress and show traces of red, brown, and green paint (Pollock 1970: 18). Red and green stucco featherwork is found at Dzibilnocac (Pollock 1970: 30–34), and polychromy on the flying facade of the Mirador Temple at Labna may be associated with costume elements (Pollock 1980: 38; Saville 1893: 233). Vivid colored featherwork occurred on the east facade of the East Wing of the Monjas (Fig. 14) at Chichen Itza, where the plumes around the horseshoe-shaped nimbus framing the figure were alternately red, yellow, and green, except toward the base, where they were all red. The feathers flanking the figure had been repainted and changed from orange to red, and the long plumes of the headdress changed from blue to orange-red to red, always with red tassels at the ends. The small plumes above the headdress were originally bright yellow, but later were painted red (Bolles 1977: 126).[8]

[8]This description conflicts slightly with that of Seler (1960, 5: 233).

Some headdresses were painted entirely green, blue, or greenish-blue, the color in this case probably intended to represent the treasured plumes of the quetzal. An example appears on the Portal Vault at Labna (Fig. 15). Inside the niches formed by the doorways of the miniature huts on the west side are remnants of stucco which depict the headdresses of seated figures. The long plumes are blue and green, and the background is red (Proskouriakoff 1963: 63–64; Pollock 1980: 43, fig. 83). According to Maler (1902: 209) the building east of the Figure Palace at Xculoc had a human figure above the central door. The figure wore a high helmet with featherwork, on which traces of sky-blue paint were visible. Traces of green paint on stucco fragments on the roof comb of the House of the Pigeons at Uxmal suggest that the plumage of the headdresses was this color (Littman 1960b: 410; Morley 1910: 9). Pollock (1980: 256) also refers to traces of red and green paint on fragments of stucco on the roof comb and upper facade of the House of the Old Woman at Uxmal. Some of the green may be associated with featherwork.

In general, it seems that the conventions of color applied to human figures on the exteriors of buildings resemble those found in Maya mural paintings. The preference for red body color seems to have been the result of an approximation of the tanned color of Maya flesh. The multicolored treatment of some faces is best explained as an attempt to record the appearance of individualized face painting, and is indicative of a type of portraiture. However, as Proskouriakoff (Ruppert, Thompson, and Proskouriakoff 1955: 43) has suggested at Bonampak, although these facial colors and patterns may have had specific symbolic associations in daily use, they seem to have been painted by the artist as "data of his observation rather than as symbols."

Many of the figural sculptures on the facades of northern Maya buildings undoubtedly were intended to represent the local elite. Dynastic portraiture has been shown to exist in the architectural sculpture of Tikal (Miller 1976), Palenque (Griffin 1976), and Yaxchilan (Kowalski, n.d.a), supporting the identification of the human figure at the center of the House of the Governor (Fig. 16) as a portrait of the ruler of Uxmal (Kowalski n.d.a, n.d.b). Many, though not all, of the painted figures adorning the facades of northern Maya buildings were probably placed as similar symbols of dynastic power and were thus conceived as portraitlike depictions of local rulers. Thus the colors of flesh, faces, and costume were an attempt to make the image of the ruler as vivid and convincingly present as possible.

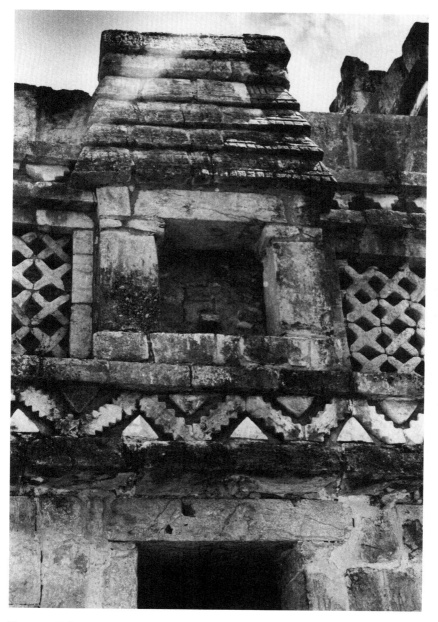

Fig. 15 Labna, Portal Vault, detail of west side showing miniature hut with painted niche, blue-green feathers against red field.

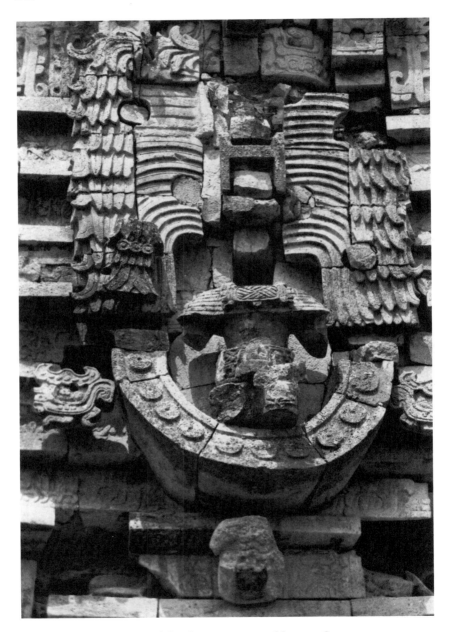

Fig. 16 Uxmal, House of the Governor, central human figure.

PAINTING ON LATTICEWORK

One of the most common designs on Puuc buildings is a geometric pattern that resembles an interwoven latticework or trellis (Figs. 9, 11). The original integrity of such lattices would have been enhanced by a finish coat of plaster that once covered the separate X-elements and concealed the joints between them. The best evidence for the painted appearance of such lattices comes from Uxmal. At the East Structure of the Nunnery, portions of the original plaster covering the lattice survive (Fig. 11). There the gaps between the lattice strips are painted a dark red, while the lattice itself seems to have been a natural plaster color (Stephens 1963, 1: 183–185; Seler 1917: 42). It is probable that this scheme of lighter lattice strips against a darker red ground was more widespread, although it was not universal.[9] The effect of the red paint at the East Structure of the Nunnery is to accentuate the contrast between the lattice and ground, thus stressing visually the connectedness of the lattice laths. In order to understand why this was important we must consider the iconography of the lattice.

Although several scholars have interpreted the Puuc lattices as having serpent associations, it seems more reasonable to view the simple lattice as a stone version of plant material, specifically of a woven mat.[10] Early versions of the lattice, twined-vine doors of modern Maya houses, and mat-weave designs that appear in the roofs of temples depicted in the Maya codices suggest that the latticework was intended to represent features of the pole-and-thatch construction of a Maya hut.

Its resemblance to Maya mat motifs, such as those on Altar 17 at Tikal (Robicsek 1975: pl. 4) or on Lintels 6 and 43 at Yaxchilan (Maler 1903: pls.

[9]Pollock (1980: 189) reports traces of red paint in the hollows of a lattice-related braid design at Kabah. Bolles (1977: 116) says that one coat of plaster on the lattice on the north side of the East Wing of the Monjas at Chichen Itza showed light red color in the recesses. The color may have been overall, or limited to the recesses. Three or four other coats of plaster on the lattice were plain. However, he (1977: 258) also reports that the entire lattice on the Southeast Annex of the Monjas was painted red-purple.

[10]On the supposed serpent associations of the lattice see J. E. S. Thompson (1966: 84, 1945: 10, 1973: 206) and Sharp (n.d.: 75). Early writers who stressed the imitative and vegetal character of the lattice include Catherwood (1844: 9–10), Viollet-le-Duc (1863: 64–69, fig. 9) and Spinden (1957: pl. 52). Although it has been suggested (Foncerrada 1965: 132) that the Puuc latticework may be related to the interlace designs on Structure D at Tajin Chico, closer parallels exist with lattice forms used in earlier Maya architecture. In the Rio Bec region, earlier versions of the lattice appear on buildings at Xaxbil and Payan, and on Structure 1 at Okolhuitz, where the latticework is treated as a plaited, mat-weave pattern (Ruppert and Denison 1943: 78, 82, 83, figs. 96, 102, 103, pls. 33a, 35b, 36b). At the Chenes site of Hochob, Structure 2 has interwoven latticework designs, perhaps related to the (x) *mak ak* woven doorways of modern Maya houses, in the doors of the miniature huts adorning the facade (Seler 1916: 13–16, abb. 27; Wauchope 1938: 42, fig. 31). For resemblances in the codices see Villacorta and Villacorta (1930: 26, 360) and Robicsek (1975: 142).

L, LXVII), however, also suggests that the latticework was an important symbol of dynastic authority, corresponding to the many references to the mat as a seat of power in Maya literature and art (Roys 1967: 72, 74, 77, 83, 92, 95, 102, 103-note 3, 133; Recinos 1950: 207–208; Morris, Charlot, and Morris 1931, 2: pls. 133–134; Jones 1977: 35–36, fig. 1). The mat was surely an emblem of rulership for the Puuc Maya. At the House of the Governor at Uxmal it appears in the medallion worn by the lord in the central motif (Fig. 16) and as a design adorning the side of his belt; it also appears on the faces of many of the square blocks of stone that form the terraced sections of the step-frets on the frieze (Fig. 9). It seems certain that for the Puuc Maya the latticework, with its obvious structural similarity to a woven mat, would have assumed that mat's regal connotations. Thus the latticework serves to identify the stone structures as edifices fit for the "Lord of the Mat." The red-painted background between the lattice strips stengthens the visual impact of the design and assures that the interwoven structure of the lattice is clear from great distances.

PAINTED MASK PANELS

Long-snouted mask panels form one of the most distinctive elements of architectural sculpture in the northern Maya area (Fig. 9). There is evidence that some of these masks were once multicolored, as at the Southeast Annex of the Monjas at Chichen Itza. There the background and the inside of the flanking frets were red–purple. Part of the square earplug was blue-green, while the lower ear ornament was banded with blue-green, yellow, and purple. The inside of the mouth was red (Bolles 1977: 250, 258). An eyebrow from a Florescent period mask (Fig. 17) of unknown provenance shows a red frame and raised scrollwork design against a blue-green background.

Perhaps the finished appearance of such masks resembled the small grotesque masks found in the upper and lower panels of Pilasters C and D from the Temple of the Chacmool at Chichen Itza (Fig. 18). The predominant color on these masks is blue-green (Morris, Charlot, and Morris 1931, 2: pls. 33–34), although two on Pilaster D are mainly pinkish-red. Such multicolored effects probably actually were applied to the masks of the Temple of the Warriors at Chichen Itza, since drops of blue, green, yellow, red, and black paint were found on the battered lower wall zone beneath the sculptural panels (Morris, Charlot, and Morris 1931, 2: 35–36). The Chacmool masks (Fig. 18) have red mouths that recall the red-painted mouths of the East Structure of the Nunnery at Uxmal, and Pollock (1980: 189) reports red paint in the mouths of the masks on the Codz Poop at Kabah as well. It is possible that these Uxmal and Kabah

Fig. 17 Florescent period mask eyebrow with green–blue background and red raised elements. Regional Museum of Anthropology, Merida, Yucatan.

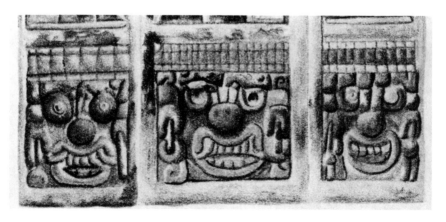

Fig. 18 Chichen Itza, Temple of the Chacmool, masks on the base of Pilaster C (after Morris, Charlot, and Morris 1931, 2: pl. 33)

examples originally were polychrome, but that only the protected red mouths have survived.

Multicolored paint also occurs on the dragon-mouth facades of Structure II at Chicanna (Fig. 4) and Structure X at Becan. Not all the masks were polychrome, however. The dragon-mouth masks at Hochob and Nohcacab apparently had red-painted eyes only, as did smaller masks at Xkichmook (Kowalski, 1977 field notes). Other masks were painted entirely red, as at El Tabasqueño, Pechal, and Pixoy (Pollock 1970: 21; Ruppert and Denison 1943: 92; George Andrews, personal communication, August 1981).

Color symbolism is known to have played an important role in the cosmology of the Maya who associated specific colors with each of the four cardinal directions (Thompson 1970: 196, 251; Roys 1967: 170–172), but it is difficult to be certain to what degree such color symbolism determined the colors of the masks. In the case of the all-red masks, as with all-red buildings or roof combs, the color was probably chosen more for economic than symbolic reasons, since red was the most readily obtainable pigment (Littmann 1960a: 172, 1960b: 409). However, red is also the color associated with the east, which was considered the preeminent cardinal direction and the home of the principal rain god (J. E. S. Thompson 1970: 196, 254; Villa Rojas 1945: 102). The dragon-mouth facades of the Chenes (Fig. 6) and Rio Bec sites are generally identified as representations of Itzamna (J. E. S. Thompson 1945, 1970: pl. 7), and the polychrome versions (e.g., Chicanna Structure II, Becan Structure X) recall the colorful depiction of that deity as a two-headed dragon in the Dresden Codex (Förstemann 1880: 4–5).

The color of the smaller polychrome masks is more problematic. Most of these masks basically seem to represent the Maya rain god, Chac, who appears in the Maya codices as the pendulous-snouted God B (Seler 1917: 12ff.).[11] It is thus tempting to interpret the arrangements of masks on Puuc buildings as reflecting the world directional symbolism attributed to the Chacs by Landa and exhibited in the Maya codices (Tozzer 1941: 137–138; Roys 1967: 170–172; Villacorta and Villacorta 1930: 70–72). Many buildings have the masks placed at their four corners (Fig. 9) or on all four facades, suggestive of directional symbolism; but many others have masks only on one facade or above a single doorway. Remaining traces of paint

[11]The principal figure represented by the masks is the Yucatec rain god, Chac, the God B of the codices. However, some masks may also incorporate aspects of God K of the codices or the manikin or flare god of the Classic monuments, the *cauac* monster, long-snouted creatures that serve as ceremonial headgear for Maya rulers, and the "frontal" head of the two-headed monster. These identifications are discussed in Kowalski (n.d.b).

are so scarce that it is not possible to show that different masks were painted different colors—red, white, black, or yellow—which would connect them with specific cardinal points (Hissink 1934: 65; Bolles 1977: 250).

It seems more likely that the dominant blue-green color of the small masks of the Chacmool Pilasters (Fig. 18), or of the larger mask eyebrow (Fig. 17), had a more definite symbolic meaning. Blue or blue-green was a color commonly associated with long-snouted figures in Maya art, appearing on the stucco manikin figures from Tikal (W. R. Coe 1967: 57), on the headdress masks of God B and God K impersonators at Chichen Itza (Morris, Charlot, and Morris 1931, 2: pls. 36, 37, 127, 129, 132, 157), and on the Chacs who appear in the mural of Structure 12 at Tancah (A. G. Miller 1972: 467, fig. 1). In the Dresden Codex, blue-green is the color of water or rain, in which the Chacs appear striding or sitting (Förstemann 1880: 33–41, 65–68, 74). During the Classic period, liquids that have been identified as water are often marked with *yax* or *kan*-cross glyphs, perhaps signifying the green or blue-green color of the water, or perhaps marking the flow as a precious liquid (Rands 1955: 355–357, figs. 18d, 19a–c, 20c, 22a, 22c; J. E. S. Thompson 1960: 252, 276–277). Landa associates the color blue with priests and sacrifices, and also mentions an altar with blue steps in connection with a festival dedicated to the Chacs and Itzamna (Tozzer 1941: 117–119, 155, 162–164). Thus when the color blue or blue-green was used it probably served to connect the masks with concepts of preciousness, water, rain, and perhaps the sky as well.[12]

CONCLUSIONS

Color contributed significantly to the aesthetic impact and symbolic meaning of northern Maya architecture. Traces of paint are found on numerous structures throughout this area from Preclassic through Terminal Classic times, and indicate treatments ranging from single-color painting of entire buildings, most often in red, to varied polychrome effects on some motifs such as human figures, costume elements, scrollwork, and mask panels. Thus through hypothetical reconstructions it is even possible to envision the effect that color would have had on grandiose edifices such as the House of the Governor at Uxmal (Fig. 9).[13]

[12]For other references to the ceremonial use of the color blue in Landa, see Tozzer (1941: 155, 158, 164). Tozzer (1941: 117-note 537), citing Genet, connects blue with the god of the heavens, Itzamna. See also Seler (1960, 5: 237) and Hissink (1934: 10) on the identification of certain motifs on the masks as *chalchihuitls,* symbols of jade, water, rain or preciousness.

[13]Such reconstructions appear in Totten (1926: pls. LXXXIV, LXXXVII) and Marquina (1928: between 63–64). A color painting of the House of the Governor, by a staff artist of the National Geographic Society, has also recently been published (Bennett 1982: 66–67).

Color undoubtedly was applied for a variety of reasons, none of which are mutually exclusive. Buildings were probably painted for decorative purposes and as a mark of social prestige, as is suggested by Landa. Color enhanced the lifelike qualities of human figural sculpture, and in some instances, as on the stucco heads from Uxmal, was used to create portraits emphasizing personal facial painting. The color of the all-red mask panels seems to be based on the ready availability of pigment, while the poly-chrome and blue-green color of some other masks may be symbolic, based on their associations with deities such as Itzamna and Chac. In late Puuc architecture the cut-stone mosaic technique emphasizes the sharp contours of the motifs, but also tends to obscure them by creating a unified texture of light and shadow. When used as polychrome, color lent greater clarity and distinctness to the separate images on the facades. For example, the cream-on-red treatment of some Puuc lattices stressed their interwoven, mat-weave structure.

Despite their aesthetic power, the facades of Yucatan are not merely decorative, but are assemblages of symbolic and iconic forms. Color pro-vided a greater sense of completeness. Like the Gothic cathedrals, whose stained glass windows transformed them into visions of the "Celestial City," many northern Maya buildings were bathed in strong colors that literally "enlivened" their figures, masks, and other sculptural motifs, en-dowed them with a more profound existence, and increased their potency as emblems of supernatural legitimacy and dynastic dominion.

BIBLIOGRAPHY

ANDREWS, E. WYLLYS, IV

 1942 Yucatan: Architecture. *Carnegie Institution of Washington, Year Book* 41: 257–263. Washington.

 1961 Preliminary report on the 1959–60 field season, National Geographic-Tulane University Dzibilchaltun program. *Tulane University, Middle American Research Institute, Miscellaneous Series,* 11: 1–27. New Orleans.

 1965 Archaeology and Prehistory in the Northern Maya Lowlands: An Introduction. In *Handbook of Middle American Indians* (Robert Wauchope and Gordon R. Willey, eds.) 2: 288–330. University of Texas Press, Austin.

ANDREWS, E. WYLLYS, V

 1974 Some Architectural Similarities between Dzibilchaltun and Palenque. In *Primera Mesa Redonda de Palenque, Part I* (Merle Greene Robertson, ed.): 137–147. The Robert Louis Stevenson School, Pebble Beach, California.

 1979 Some Comments on Puuc Architecture of the Northern Yucatan Peninsula. In *The Puuc: New Perspectives. Papers presented at the Puuc Symposium, Central College, May 1977* (Lawrence Mills, ed.): 1–17. Central College, Pella, Iowa.

ANDREWS, E. WYLLYS, V, W. R. RINGLE III, P. J. BARNES, ALFREDO BARRERA RUBIO, and TOMAS GALLARETA N.

 n.d. Komchen: An Early Maya Community in Northwest Yucatan. Paper presented at the Sociedad Mexicana de Antropología meeting, San Cristobal, Chiapas, June 21–27, 1981.

ANDREWS, GEORGE

 1969 *Edzna, Campeche, Mexico. Settlement Patterns and Monumental Architecture.* University of Oregon Press, Eugene.

 1975 *Maya Cities, Placemaking and Urbanization.* University of Oklahoma Press, Norman.

 n.d. Early Puuc Architecture. Paper presented at the 43rd International Congress of Americanists, Vancouver, British Columbia, August 1979.

BALL, JOSEPH W.

 1974 A Coordinate Approach to Northern Maya Prehistory: A.D. 700–1200. *American Antiquity* 39: 85–93.

 1979 The 1977 Central College Symposium on Puuc Archaeology: A Summary View. In *The Puuc: New Perspectives. Papers presented at the Puuc Symposium, Central College, May 1977* (Lawrence Mills, ed.): 46–51. Central College, Pella, Iowa.

BARRERA RUBIO, ALFREDO
1979 Las pinturas murales del area Maya del Norte. *Enciclopedia Yucatanense* 10: 189–222. Edición Oficial del Gobierno de Yucatan, Merida.

BENNETT, ROSS S. (ED.)
1982 *Lost Empires, Living Tribes.* National Geographic Society, Washington.

BOLLES, JOHN
1977 *Las Monjas, A Major Pre-Mexican Architectural Complex at Chichen Itza.* University of Oklahoma Press, Norman.

BRETON, ADELA
1908 Archaeology in Mexico. *Man* 8 (17): 34–37.

CATHERWOOD, FREDERICK
1844 *Views of Ancient Monuments in Central America, Chiapas, and Yucatan.* Bartlett and Welford, New York.

CHARNAY, DÉSIRÉ
1863 *Cités et ruines américaines.* Paris.
1887 *The Ancient Cities of the New World* (J. Gonino and Helen S. Conant, trans.). Harper and Brothers, New York.
1978 *Viaje a Yucatan a fines de 1886.* Fondo Editorial de Yucatán, Cuadernos Tres. Mexico.

CIUDAD REAL, ANTONIO DE
1872 *Relación breve y verdadera de algunas cosas de las muchas que sucedieron al Padre Fray Alonso Ponce en las provincias de la Nueva España.* Colección de Documentos Ineditos para la Historia de España 52–53. Madrid.

COE, WILLIAM R.
1967 *Tikal, A Handbook of the Ancient Maya Ruins.* The University Museum, University of Pennsylvania, Philadelphia.

DÍAZ DEL CASTILLO, BERNAL
1908 *The True History of the Conquest of New Spain* (A. P. Maudslay, trans.). Hakluyt Society, London.

EATON, JACK D.
1972 A Report on Excavations at Chicanna, Campeche, Mexico. *Cerámica de Cultura Maya* 8: 42–61. Temple University, Philadelphia.

FONCERRADA DE MOLINA, MARTA
1965 *La escultura arquitectónica de Uxmal.* Imprenta Universitaria, Mexico.

FÖRSTEMANN, ERNST
1880 *Die Maya-Handschrift der Königlichen Öffentlichen Bibliothek zu Dresden.* A. Naumann, Leipzig.

GANN, THOMAS
1918 *The Maya Indians of Southern Yucatan and Northern British Honduras.* Smithsonian Institution, Bureau of American Ethnology, Bulletin 64. Washington.

GRIFFIN, GILLETT
 1976 Portraiture at Palenque. In *The Art, Iconography and Dynastic History of Palenque, Part III* (Merle Greene Robertson, ed.): 137–147. The Robert Louis Stevenson School, Pebble Beach, California.

HISSINK, KARIN
 1934 *Masken als Fassadenschmuck. Untersucht an den alten Bauten der Halbinsel Yukatan.* Akademische Abhandlungen zur Kulturgeschichte, reihe 3, 2. Sammlung Heitz, Strassburg.

JONES, CHRISTOPHER
 1977 Inauguration Dates of Three Late Classic Rulers of Tikal, Guatemala. *American Antiquity* 42: 28–60.

KELEMEN, PAL
 1943 *Medieval American Art.* 2 vols. Macmillan, New York.

KOWALSKI, JEFF KARL
 n.d.a The House of the Governor, a Maya Palace at Uxmal, Yucatan, Mexico. PhD dissertation, Department of the History of Art, Yale University, 1981.
 n.d.b A Historical Interpretation of the Inscriptions of Uxmal. *Fourth Palenque Round Table Conference.* University of Texas Press, Austin. (In press.)

KUBLER, GEORGE
 1975 *The Art and Architecture of Ancient America.* 2nd ed. rev. Penguin Books, Harmondsworth, England.

LITTMANN, EDWIN R.
 1960a Ancient Mesoamerican Mortars, Plasters, and Stuccos: The Composition and Origin of *Sascab. American Antiquity* 24: 172–176.
 1960b Ancient Mesoamerican Mortars, Plasters, and Stuccos: The Puuc Area. *American Antiquity* 25: 407–412.

MALER, TEOBERT
 1895 Yukatekische Forschungen. *Globus* 68: 247–260, 277–292. Braunschweig.
 1902 Yukatekische Forschungen. *Globus* 82: 197–230. Braunschweig.
 1901–03 *Researches in the Central Portion of the Usumacinta Valley.* Memoirs of the Peabody Museum of American Archaeology and Ethnology 2 (2). Harvard University, Cambridge.

MARQUINA, IGNACIO
 1928 *Estudio arquitectónico comparativo de los monumentos arqueológicos de México.* Secretaría de Educación Pública, Mexico.
 1964 *Arquitectura prehispánica.* 2nd ed. Instituto Nacional de Antropología e Historia, Mexico.

MATHENY, RAY T., and D. L. BERGE
 1971 Investigations in Campeche, Mexico. *Cerámica de Cultura Maya* 7: 1–15. Temple University, Philadelphia.

MILLER, ARTHUR G.

1972 The Mural Painting in Structure 12 at Tancah and in Structure 4 at Tulum, Quintana Roo, Mexico: Implications of Their Style and Iconography (1). *Atti del XL Congresso Internazionale degli Americanisti, Roma-Genova:* 465–471. Tilgher, Genova.

1976 The Roof-Comb Sculpture and Doubled Portrait Lintels of Temples I and IV. *Actas del XXIII Congreso Internacional de Historia del Arte España entre el Mediterraneo y el Atlántico* 1: 177–184. Granada.

MILLER, VIRGINIA

n.d.a Teotihuacan Influence at the Palace of the Stuccoes, Acanceh, Yucatan, Mexico. Paper presented at the 44th International Congress of Americanists, Manchester, 1982.

n.d.b The Palace of the Stuccoes at Acanceh: Style and Iconography. Paper presented at the Quinta Mesa Redonda de Palenque, 1983.

MORLEY, SYLVANUS G.

1910 A Group of Related Structures at Uxmal, Mexico. *American Journal of Archaeology,* second series 14: 1–18.

1937–38 *The Inscriptions of the Peten.* 5 vols. Carnegie Institution of Washington, Publication 437. Washington.

MORRIS, EARL H., JEAN CHARLOT, and ANN AXTELL MORRIS

1931 *The Temple of the Warriors at Chichen Itza, Yucatan.* 2 vols. Carnegie Institution of Washington, Publication 406. Washington.

NELSON, FRED, JR.

1973 *Archaeological Investigations at Dzibilnocac, Campeche, Mexico.* Papers of the New World Archaeological Foundation 33. Brigham Young University, Provo, Utah.

PALACIOS, ENRIQUE JUAN

1928 Monumentos de Etzna-Tixmucuy. In *Estado actual de los principales edificios arqueológicos de México.* Contribución de México al XXIII Congreso de Americanistas. Mexico.

PIÑA CHAN, ROMÁN

1963 Informe preliminar sobre Mul-Chic, Yucatan. *Anales del Instituto Nacional de Antropología e Historia* 15: 99–118. Mexico.

1968 *Jaina, La Casa en el Agua.* Instituto Nacional de Antropología e Historia, Mexico.

POLLOCK, H. E. D.

1965 Architecture of the Maya Lowlands. In *Handbook of Middle American Indians* (Robert Wauchope and Gordon R. Willey, eds.) 2: 378–440. University of Texas Press, Austin.

1970 Architectural Notes on Some Chenes Ruins. In *Monographs and Papers in Maya Archaeology* (William R. Bullard, Jr., ed.). Papers of the Peabody Museum of Archaeology and Ethnology 61. Harvard University, Cambridge.

1980 *The Puuc: An Architectural Survey of the Hill Country of Yucatan and Northern Campeche, Mexico.* Memoirs of the Peabody Museum of Archaeology and Ethnology 19. Harvard University, Cambridge.

POTTER, DAVID F.
 1976 Prehispanic Architecture and Sculpture in Central Yucatan. *American Antiquity* 41: 430–448.
 1977 *Maya Architecture of the Central Yucatan Peninsula, Mexico.* Tulane University, Middle American Research Institute, Publication 44. New Orleans.

PROSKOURIAKOFF, TATIANA
 1960 Historical Implications of a Pattern of Dates at Piedras Negras, Guatemala. *American Antiquity* 25: 454–475.
 1963 *An Album of Maya Architecture.* University of Oklahoma Press, Norman.
 1970 On Two Inscriptions at Chichen Itza. In *Monographs and Papers in Maya Archaeology* (William R. Bullard, Jr., ed.): 457–467. Papers of the Peabody Museum of Archaeology and Ethnology 61. Harvard University, Cambridge.

RANDS, ROBERT L.
 1955 *Some Manifestations of Water in Mesoamerican Art.* Smithsonian Institution, Bureau of American Ethnology, Bulletin 157. Washington.

RECINOS, ADRIÁN
 1950 *The Popol Vuh: The Sacred Book of the Ancient Quiché Maya* (Sylvanus G. Morley and Delia Goetz, trans.). University of Oklahoma Press, Norman.

ROBERTSON, DONALD
 1963 *Pre-Columbian Architecture.* Braziller, New York.

ROBICSEK, FRANCIS
 1975 *A Study in Maya Art and History: The Mat Symbol.* Museum of the American Indian, Heye Foundation, New York.

ROYS, LAWRENCE, and EDWIN M. SHOOK
 1966 *Preliminary Report on the Ruins of Ake, Yucatan.* Memoirs of the Society for American Archaeology 20. Salt Lake City.

ROYS, RALPH L.
 1952 *Conquest Sites and the Subsequent Destruction of Maya Architecture in the Interior of Northern Yucatan.* Contributions to American Anthropology and History 11 (54). Carnegie Institution of Washington, Publication 596. Washington.
 1967 *The Book of Chilam Balam of Chumayel.* University of Oklahoma Press, Norman.

RUPPERT, KARL
 1935 *The Caracol at Chichen Itza, Yucatan, Mexico.* Carnegie Institution of Washington, Publication 454. Washington.

RUPPERT, KARL, and JOHN H. DENISON, JR.

1943 *Archaeological Reconnaissance in Campeche, Quintana Roo, and Peten.* Carnegie Institution of Washington, Publication 543. Washington.

RUPPERT, KARL, J. ERIC S. THOMPSON, and TATIANA PROSKOURIAKOFF

1955 *Bonampak, Chiapas, Mexico.* Carnegie Institution of Washington, Publication 602. Washington.

RUZ LHUILLIER, ALBERTO

1945 Campeche en la arqueológia maya. *Acta Antropológica* 1 (2–3). Mexico.

SÁNCHEZ DE AGUILAR, PEDRO

1937 *Informe contra idolorum cultores del Obispado de Yucatan.* 3rd ed. Triay e hijos, Merida.

SAVILLE, MARSHALL

1893 The Ruins of Labna, Yucatan. *The Archaeologist* 1: 229–235. Ohio Archaeological and Historical Society, Waterloo, Indiana.

1921 Bibliographic Notes on Uxmal, Yucatan. *Museum of the American Indian, Heye Foundation, Indian Notes and Monographs* 9 (2). New York.

SEGOVIA, VICTOR

1969 Kohunlich. *Boletín del Instituto Nacional de Antropología e Historia* 37: 1–8. Mexico.

SELER, EDUARD

1916 *Die Quetzalcouatl-Fassaden Yukatekischer Bauten.* Abhandlungen der königlich preussischen Akademie der Wissenschaften, Phil.-hist. Klasse 2. Berlin.

1917 *Die Ruinen von Uxmal.* Abhandlungen der königlich preussischen Akademie der Wissenschaften, Phil.-hist. Klasse 3. Berlin.

1960 *Gesammelte Abhandlungen zur Amerikanischen Sprach- und Altertumskunde.* 5 vols. Akademische Druck- u. Verlagsanstalt, Graz, Austria.

SHARP, ROSEMARY

n.d. Greca: An Exploratory Study of Relationships between Art, Society, and Personality. PhD dissertation, University of North Carolina at Chapel Hill, 1972. University Microfilms, Ann Arbor.

SHOOK, EDWIN M.

1940 Exploration in the Ruins of Oxkintok, Yucatan. *Revista Mexicana de Estudios Antropológicos* 4: 165–171. Mexico.

SMITH, A. L., and KARL RUPPERT

1954 Ceremonial or Formal Archway, Uxmal. *Carnegie Institution of Washington, Notes on Middle American Archaeology and Ethnology* 5 (116): 1–3. Washington.

SPINDEN, HERBERT J.
 1913 *A Study of Maya Art.* Memoirs of the Peabody Museum of American Archaeology and Ethnology 6. Harvard University, Cambridge.
 1957 *Maya Art and Civilization.* The Falcon's Wing Press, Indian Hills, Colorado.

STEPHENS, JOHN LLOYD
 1963 *Incidents of Travel in Yucatan.* 2 vols. Dover, New York.

STIERLIN, HENRI
 1964 *Living Architecture: Mayan.* Grosset and Dunlap, New York.

THOMPSON, E. H.
 1904 *Archaeological Researches in Yucatan.* Memoirs of the Peabody Museum of American Archaeology and Ethnology 3 (1). Harvard University, Cambridge.

THOMPSON, J. ERIC S.
 1939 Las llamadas "Fachadas de Quetzalcouatl." *Actas de la Primera Sesion del XXVII Congreso Internacional de Americanistas, Mexico* 1: 391–400. Mexico.
 1945 A Survey of the Northern Maya Area. *American Antiquity* 11: 2–24.
 1960 *Maya Hieroglyphic Writing: An Introduction.* University of Oklahoma Press, Norman.
 1966 *The Rise and Fall of Maya Civilization.* 2nd ed. University of Oklahoma Press, Norman.
 1970 *Maya History and Religion.* University of Oklahoma Press, Norman.
 1973 The Maya glyphs for capture or conquest and an iconographic representation of Itzam Na on Yucatecan Facades. *Contributions of the University of California Archaeological Research Facility* 18: 203–207. Berkeley.

THOMPSON, J. ERIC S., H. E. D. POLLOCK, and J. CHARLOT
 1932 *A Preliminary Study of the Ruins of Cobá.* Carnegie Institution of Washington, Publication 424. Washington.

TOTTEN, GEORGE OAKLEY
 1926 *Maya Architecture.* The Maya Press, Washington.

TOZZER, ALFRED M. (ED.)
 1941 *Landa's Relación de las cosas de Yucatan, a Translation.* Papers of the Peabody Museum of Archaeology and Ethnology 18. Harvard University, Cambridge.

VILLA ROJAS, ALFONSO
 1945 *The Maya of East Central Quintana Roo.* Carnegie Institution of Washington, Publication 559. Washington.

VILLACORTA C., J. ANTONIO, and CARLOS A. VILLACORTA
 1930 *Códices mayas.* Typografía Nacional, Guatemala.

Jeff Karl Kowalski

VIOLLET-LE-DUC, EUGÈNE
1863 Antiquités américaines. In Désiré Charnay, 1963.

VON EUW, ERIC
1977 *Itzimte, Pixoy, Tzum. Corpus of Maya Hieroglyphic Inscriptions.* Peabody Museum of Archaeology and Ethnology 4, part 1. Harvard University, Cambridge.

WALDECK, JEAN FREDERIC M. DE
1838 *Voyage pittoresque et archéologique dans la province d'Yucatan (Amérique Central) pendant les années 1834 et 1836.* B. Defour, Paris.

WAUCHOPE, ROBERT
1938 *Modern Maya Houses: A Study of their Archaeological Significance.* Carnegie Institution of Washington, Publication 502. Washington.

Painted Architecture and Sculpture in Ancient Oaxaca

John Paddock

INSTITUTO DE ESTUDIOS OAXAQUEÑOS

PAINTED ARCHITECTURE

THE IMPORTANCE OF ARCHITECTURAL POLYCHROMY in Pre-Columbian Oaxaca is well illustrated by a negative example. Tilantongo ruling families were considered noblest among the noble Mixtecs: when a dynasty elsewhere ended, a new ruler was brought from Tilantongo. In the Pre-Hispanic Mixtec histories that record these matters, a rectangular panel of *grecas* often stands for the concept of city; and Tilantongo is easy to recognize among them all because its *grecas* are black and white, whereas the others are almost always polychrome (Fig. 1).

Such panels or *tableros* are normal parts of highland buildings, but only parts. The question remains whether polychromy was the practice on other parts of the buildings. Until such buildings are examined for polychrome by archaeologists in the Mixtec region, one must rely on the testimony of the scribes, who were eyewitnesses to at least some of what they recorded.

Evidence from the Codices

A quick survey of seven principal Mixtec codices (see the table) reveals 444 polychrome *greca* panels and 53 bichrome panels (i.e., black and white, red and white, black and gray, yellow and red, and yellow and white); polychrome is thus the norm at 89%. When the painter had to represent a temple at reduced size for the year- or day-sign House, polychrome often would seem clumsy or over-elaborate, and 146 of the 186 examples of the day-sign House (78%) are bichrome, most commonly red and white (Fig. 2). (Usually their dark interiors are indicated in blue.)

Excluding mountains bent to one side to resemble curvilinear temples in profile, and excluding also the many ballcourts, walled precincts, and

Painted Greca Friezes, House-signs, and Buildings in Seven Mixtec Codices

The table indicates the range of painted architecture depicted in the codices in a general sense, but the numbers are not necessarily absolute, because there are several ambiguous representations. Slightly variant results could be produced in a recount, but the variations would be too small to affect the inferences made here.

CODEX	GRECA FRIEZES			HOUSE SIGNS		BUILDINGS*		
	poly-chrome	bichrome	unfinished poly-chrome	poly-chrome	bichrome	poly-chrome	red & white with black outline	red & white with dark interior
Selden	40	9	0	4	24	25	0	0
Bodley	149	7	0	0	56	41	0	0
Colombino–Becker I	60	0	0	7	0	54	0	0
Nuttall	100	18	2	16	30	41	8	19
Vindobonensis Obverse	62	19	0	4	27	174	19	16
Vindobonensis Reverse	3	0	0	4	9	3	0	0
Sánchez Solís	30	0	0	5	0	44	0	0
TOTALS	444	53	2	40	146	382	27	35

*When the building itself is bichrome but has in or on it an identifying figure or object that is polychrome, the building is counted as bichrome.

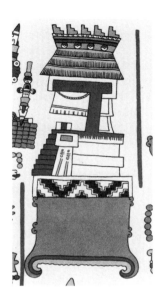

Fig. 1 *right* The place sign of Tilantongo, a polychrome temple atop a black and white *greca* panel. Codex Nuttall 68 (after Codex Nuttall 1902).

Fig. 2 *below* The day-sign 6 House with a bichrome House sign. Codex Nuttall 27 (after Codex Nuttall 1902).

Fig. 3 *below right* A bichrome (red and white) temple with its dark interior indicated in blue. Codex Nuttall 8 (after Codex Nuttall 1902).

flat-top pyramids, the seven codices contain 444 roofed buildings presented frontally, in profile, or in a combined view. Of these, 382 or 86% are polychrome (Fig. 1), 8% are red and white with dark interiors indicated in blue (Fig. 3), and 6% are red and white only. All have black outlines. The Codices Nuttall and Vindobonensis Obverse, which give the impression of being the most colorful manuscripts (perhaps because of their unfaded colors), nevertheless have nearly all the bichrome buildings.

Archaeological Evidence

All the surviving Mixtec codices are very late, having been painted from about A.D. 1300 to 1556, when a last marriage of Mixtec nobles was added to the Codex Selden (Caso 1964: 94), but these manuscripts were based on earlier versions. Representations of Mixtec buildings in other media confirm that both *greca* panels and polychromy are many centuries older. Polychromy and *greca* panels appear on an urn dating from perhaps A.D. 700, from the Ñuiñe culture of the Mixteca Baja (Fig. 4).[1]

Older representations of painted architecture in Oaxaca appear at Monte Alban. Alfonso Caso's excavations there produced a ceramic model of a temple with a bird inside (Fig. 5); the mansard roof has a simple red-painted decoration on the orange ceramic, a combination diagnostic of Monte Alban II, about 200 to 0 B.C. Although the building represented is unusual in many ways (i.e., the center is unroofed) and may never have existed precisely as the model suggests, its decoration is similar to red-and-white designs seen on buildings in the codices. The decoration also differs from the motifs used in ornamenting dishes made of the same ware, called A-9; the dishes usually have *grecas*—the earliest ones in Mesoamerica.[2]

Still earlier, and still stranger, is a pottery brazier of Monte Alban I, about 600 to 200 B.C. (Fig. 6). The painted decoration is again limited to red lines on the light gray background of the ware. The building represented is a stepped pyramid, and the red lines form a radically simplified version of an enormous "Olmec" face that occupies the entire front of the building. The drawing is so schematic that, quite possibly by intention, the same lines may be seen as indicating parts of the building such as stairs and a doorway.

If these pottery models of buildings from Monte Alban I and II are true in principle to the reality, painted decoration at this time was limited to red lines on white plaster.[3] Red and white probably were the overwhelmingly predominant colors at Monte Alban, even in later times. The poly-

[1]For the archaeological traits of the Ñuiñe culture see Moser (1977), Paddock (1966b: 174–200, 1970a, 1970b), and Winter et al. (1976).

[2]Step designs, quite possibly ancestral to the *greca,* occur in Monte Alban I, but they lack the hook that would make them into what the Aztecs called the *xicalcoliuhqui.* I am indebted to Marcus C. Winter for this observation and a number of others, some incorporated into the text. Donald L. Brockington, Horst Hartung, and Charles R. Wicke also contributed valuable comments that have been used in the same ways.

[3]The stone building models of periods III and IV, which have been studied by Hartung (1970, 1977), are far from fanciful, as comparisons with actual buildings show. They are not to scale, however, and tend to show little more than the facades of the buildings they represent. Hartung believes traces of color occur on some of them.

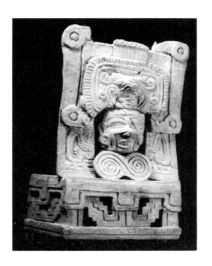

Fig. 4 *above* A polychrome Ñuiñe "urn" with *greca* panels, from Huajuapan, painted green, yellow, red, and white. Height 32 cm. Museo Frissell Mitla.

Fig. 5 *above right* Bichrome ceramic temple model of Monte Alban II, from Monte Alban, after a watercolor by Alejandro Caso (after Caso and Bernal 1952: fig. 502 bis). Museo Nacional de Antropología, Mexico.

Fig. 6 *right* Bichrome ceramic temple model of Monte Alban I, from Monte Alban, after a watercolor by Alejandro Caso (after Caso and Bernal 1952: fig. 308). Museo Nacional de Antropología, Mexico.

chromy of the codices does not necessarily contradict this, because the only people shown in the manuscripts are politically significant nobles, and the only buildings are those that are symbolic of their station. Varied colors were a luxury, and they were painted on the buildings in the codices to show high status. The surfaces of actual buildings were vastly larger, however, and I would question whether there was enough polychrome paint available to cover them, even presuming that the sides and rear were painted more plainly and cheaply than the facades.

Those who work in tropical forests assert that, even though the temperature is commonly just below that of the human body and the humidity just below 100%, the deep green shadow of the forest is consoling if not comfortable. In any clearing, however, the fiery sun of the tropics dominates all; Colin Turnbull (1962: 270–272) believes it is fatal to the Mbuti pygmies if they stay in it too long. Some Peten Maya cities constituted large cleared, paved areas in a tropical rain forest. Neither the bare earth of a central African clearing nor the rough gray streets and buildings of a modern city can reflect the sun's rays in a manner comparable to the glare thrown back in one's face by a smooth white surface. The Maya and other Mesoamerican peoples must therefore have protected themselves from the sun, never far from the zenith at midday. Eskimos, who never felt a strong or a high sun, invented a form of sunglasses to prevent blindness from the combination of sun and reflection on snow (Murdock 1934: 198). Mesoamerican Indians, while better defended by nature against brilliant light than are blue-eyed people, were no better endowed than Eskimos in this respect.

It should not be surprising, then, to note that in at least some ancient Mesoamerican cities the paved plazas and patios were not left white but painted dark red. The central plaza of Monte Alban, paved before the time of Christ, presented some ten to twelve acres (four to five hectares) of flat surface to a sun never low in the sky except near sunrise and sunset. It therefore seems likely to have been painted.[4] Later, cities in the Valley of Oaxaca definitely did have Indian-red floors, as I have noted in excavations; the Teotihuacan palaces also had them.[5]

The choice of red might initially seem strange, for red is considered a "hot" color, and a "cool" blue-green would seem a better choice. But blue-green floors would have been costly, perhaps impossible at any cost. Only the Maya had significant amounts of blue pigment suitable for such

[4]In a number of small excavations at Monte Alban, including several in the great plaza, Marcus Winter has found no traces of paint on surviving floors (personal communication, January 1982). Perhaps a microscopic examination of a sample would be worthwhile.
[5]"Plain red paint is commonly found on exterior walls, temple platforms, stairs, and even streets" (Miller 1973: 36).

places; not even the wealthiest non-Maya cities had much blue on buildings. Blue and green and their combinations were highly prized by Mesoamericans, but this hue, the color of jade and turquoise and Maya blue and quetzal feathers, was the least frequently used. Perhaps it was the most precious color partly because it was so scarce.

In the volcanic highlands, at least, the iron-oxide red used on floors was almost the only choice.[6] There are large deposits of it at many places. Yellow ochre was available, less commonly, but it would not be as effective against glare as dark red. Cinnabar was scarce. Carbon black was used for many purposes, but the amount required to blacken an acre of pavement might have been prohibitive to people who had already burnt a considerable piece of forest to make lime cement, and perhaps carbon black would not work as a floor paint. (Of course black would absorb more heat than a lighter color, and even dark red floors would be hotter to the foot than white ones.)[7] The red may have been "chosen" by elimination.

It is not only on floors that we find red. Red-on-buff is the most common color combination in simple pottery, principally because most pottery clays turn buff with the easiest firing methods, and red iron oxide is the first pigment discovered almost everywhere that resists firing. The color of blood—determined by its own red iron oxide—has been used since Paleolithic times to deny death on burying the dead (Wrechsner et al. 1980; Marshack 1981; Wrechsner 1981). In ancient Oaxaca, offerings commonly included a cloud of powdered red pigment, cast over an entire cache or on the front of an effigy vase or thrown against a tomb door.

Far from all floors were painted red; white may have been preferred for interiors, for obvious reasons, but some patio floors are recorded as also being brilliantly white (Torquemada 1943, 1: 251), and carefully polished besides (at Cempoala, in 1519). A thousand years earlier, in Teotihuacan the prevalence of multicolored murals in the palaces made white interior floors almost inevitable as a contrast to the walls, where iron-oxide red was usually the background color and prominent in the murals as well. The variety of colors and designs in earlier Teotihuacan murals gave way later to repetition in red and white (Millon 1972). White floors helped also to illuminate the murals. There were places where one could see a dividing line: a patio floor and the step up to the interior dark red, the red extending over the top of the step and about as far back from the edge as the step

[6]The red is said to be mostly hematite, Fe_2O_3. Studies of Teotihuacan pigments include Acosta (1964: 50), Torres Montes (1972), and Littman (1973).

[7]No doubt a rather simple experiment would show just how much hotter a sample of ancient red floor becomes under the Oaxaca sun than a piece of unpainted or white-painted flooring. Unshod feet develop their own thick soles; and ancient Valley of Oaxaca figures often are shown wearing sandals.

was high (Acosta 1964: lám. 7; Séjourné 1966: 42, lám. XXXVI). The unpleasantness of a glaring-white floor might be tolerated where the reflected light was needed on the interior murals or polychrome stone reliefs.

Comparison of Monte Alban with Teotihuacan is often fruitful, for their circumstances would seem to dictate far more similarity than in fact we find between them. One interesting difference is in painted architecure. If we define our terms so generally as to emphasize similarities, we may say that Monte Alban and Teotihuacan share the *talud-tablero* system of decorating facades. But if we look more closely, we see that their battered bases differ, the *tableros* above differ, and the proportions vary one to the other. More to the point here, the decoration differs, too.

The Teotihuacan *tablero* is an extremely plain rectangle, a closed frame.[8] The space it surrounds is commonly decorated with simple geometric reliefs painted in polychrome or bichrome. The painted sculptures of the early Temple of Quetzalcoatl were covered up; after that, the most complex *tablero* decoration was of painted Tajin-style volutes in red and white.

Compared to Maya forms, the Monte Alban *tablero,* too, is severely plain and angular. Compared to the Teotihuacan form, however, it is dynamic and complex—open at the bottom, the frame stepped to give it a double line of light and shadow around top and sides (Hartung 1970; Sharp 1970). Relief sculpture has been found in a few *tableros* at Monte Alban: a standing jaguar, some inverted T shapes, early *grecas* at Atzompa. Apparently no traces of painted decoration have been found (Margáin 1971: 75). Unless some still unknown factor has resulted in complete destruction of a large amount of painting at Monte Alban, it seems to have been the rule that the facade *tableros* were left plain at Monte Alban and were painted with geometric figures at Teotihuacan.

While excavating at Lambityeco, we noted some unfamiliar motifs painted in red on a white-plastered wall. Lambityeco is a site of early Monte Alban IV; we were digging in rather pretentious but shoddily constructed elite houses of a time, around A.D. 650, when Monte Alban no longer dominated much of the Valley of Oaxaca. The outward forms of Monte Alban architecture were closely imitated, but a new style of figurines and some other signs indicated an interesting divergence from the ways of the old capital. Therefore we strove vigorously to make new evidence of the strange painted motifs. Failing, we realized that they were

[8]In earlier phases at Teotihuacan, at least some very large frames were themselves decorated. For example, the ornate first Temple of Quetzalcoatl had painted blue-green circles (representing jade) on the frames that enclosed its painted sculptures. Especially in early periods, the general aspect of considerable parts of Teotihuacan was almost gaudy. Later it was much more sober.

simple squiggles made by a house-painter trying out his brush before painting the wall solid red. While he doodled with the brush, the plaster was still fresh. When he applied the coat of solid red paint it was less so, and the solid color came off while the squiggles stayed for posterity.

Lambityeco provides other novelties. An extraordinarily durable mud plaster, more resistant than the usual lime plaster, was used on some interior walls and showed traces of having been painted yellow.[9] On the other hand, excavation of a long-buried house, which had been preserved to a highly unusual degree by being buried under new construction, gave us many hitherto unknown architectural details, but painting was limited to red and white even though sculptural decoration clearly indicated that resources were ample (Rabin 1970). Lambityeco patios were small enough so that leaving them white would not result in painful glare except near midday, for the buildings that enclosed them were almost as high as the patios were wide.

A different logic must be sought in the situations at Yagul and Mitla. The late palaces at these sites surround relatively much larger patios (Bernal 1965, 1966; Bernal and Gamio 1974). The extremely long, narrow palace rooms, especially those having only single doorways to admit light, were dark all day long (Fig. 7)—yet their finely polished floors, like those of the patios, were dark red. Wall decoration was repetitive: geometric designs in stone mosaic of high relief. Thus even a single torch would create a striking spectacle, showing one design that repeated itself as it extended into increasing shadow and finally was lost in the darkness, while different designs higher up remained less sharply defined. Proportions of some rooms in these palaces are more moderate, meaning the ends were less dark; and some rooms have triple doorways that illuminated them rather well if their curtains were pulled aside.

At some places in the Mitla palaces, only a few years ago one could see where the red paint on some walls ended; it extended almost exactly one meter up from the floor. However, in doorways and passages the color was used all the way up to the lintel or roof stones, and on the undersides of them as well.

Unlike the *greca* panels of the codices, the stone mosaics of Mitla seem not to have been polychrome.[10] Where plaster remains over the stones, it is in many places painted red, ranging in hue from a deep orange to a strong hematite red. The black that is often mistaken for paint seems to be fungus. In some places one can still see that outer surfaces were painted

[9]The yellow was presumably made with clay and some organic material that acted as a binder; lore, which is not necessarily wrong, says this binder is sap.

[10]This is in contrast to Margáin (1971: 78), who says the Mitla *grecas* were polychrome.

Fig. 7 The west salon of the Hall of Columns palace, Mitla, after its roof was restored.

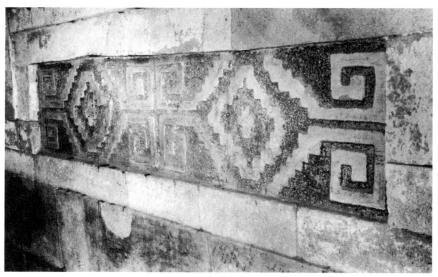

Fig. 8 Panel of *grecas* in the Xaaga tomb, Mitla. The smooth outer surface of the stone is plastered white; the rough engraved background is red.

white for contrast with the red inset ones (Fig. 8). This would greatly increase visibility of the designs at times when shadows are not intense.

At the turn of the century, Eduard Seler (1904) recorded much more of the Mitla palace murals than now exist, but all of them were red and white. The extremely long, narrow panels where the murals occur have dimensions similar to those of an extended Mixtec codex, and the content and style are equally similar, but the murals are not colored like a codex. The fading of some codices suggests (and tests confirm) that some vegetable colors were used in them, and it may be that other pigments suitable for outdoor use were not available in Mitla at the time.

Thus in ancient Oaxaca walls and floors were commonly colored red, but the painting was plain, so far as is known, except for a few tomb murals and the representations of buildings in miniature.[11] The desire for painted surfaces may be linked to the need to lessen the glare of stuccoed surfaces, and red seems to have been the prevalent color simply because it was the most readily available.

PAINTED MONUMENTAL SCULPTURE

Beginning perhaps even before the founding of Monte Alban in about 600 B.C., the figures usually called Danzantes—some of them bearing calendrical and other glyphs—were being carved (Paddock 1966b: figs. 31–47, 54–59; Scott 1978). They may have been painted too, although on carvings of such antiquity we do not expect and do not get evidence of that. Delineated with single grooves on the flat stone, the Danzantes would invite the use of a contrasting color in the grooves. However, the large flat areas would be inviting, too, and probably they were covered with white plaster that made them even more tempting for the addition of some painted details. Brockington and Hartung (personal communications, December and October 1981) see the Danzantes as very likely to have been painted. Details are carved on some (glyphs, for example), and other details may have been painted. As Brockington observes, at Monte Alban there occur some carved Danzante hands like the hands of Dainzu ball players, but lacking the ball—which may have been painted in. Polychromy was definitely known and used in this period, as shown by a superb *brasero* in the Howard Leigh Collection (Fig. 9).

What may be said of the Monte Alban I Danzantes pertains equally to those of Period II. A larger ceramic figure of a feline, life-size or more unless it represents a jaguar, surely must have been made for a temple

[11]At least a few Monte Alban tombs also had painted decoration on their facades. Caso (1965) mentions facade painting on Tombs 10, 50, 103, 104, and 123.

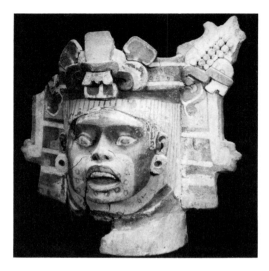

Fig. 9 Polychrome brazier of Monte Alban I style. Height 31 cm. Howard Leigh Collection, Museo Frissell, Mitla.

platform at Monte Alban, and it is polychrome. In this period, many images, often on braziers, were made at life-size or larger, most of them polychrome (Paddock 1966b: figs. 80–88). And polychrome ceramics took on a new dimension with the appearance, in the Valley of Oaxaca, of the so-called fresco ware, which several centuries later came into use at Teotihuacan and in the Maya region (Caso, Bernal, and Acosta 1967: 61–67).

Some Valley of Oaxaca pyramids had friezes in deep relief carving, made by assembling blocks of ceramic tile. One example in the Leigh Collection (Fig. 10) has areas of white, pink, and gray paint. Whether these colors are successive monochrome layers or the remains of a polychrome decoration, I cannot say. The friezes are handsome and of interesting content, but unhappily all known examples are from looting, so our data are limited and less than totally reliable. Some friezes come from Santa Ines Yatzechi, some twenty kilometers south of Monte Alban, where they are said to have been torn from the faces of pyramids (probably from inside *tableros*). They are of Monte Alban IIIA style, and surface survey has indicated that the area was a major population center of that period (Blanton et al. 1979).[12]

Monte Alban dominated the valley at that time, however, and a number of stelae were placed at the capital. We can only speculate as to whether they were painted. If they were, the murals in some Monte Alban tombs

[12]Salvage excavations at Yatzechi in 1980–81 by the Centro Regional of the Instituto Nacional de Antropología e Historia confirmed this, reports Marcus Winter.

Fig. 10 Ceramic tile representing a jaguar. Height 24.5 cm. Howard Leigh Collection, Museo Frissell, Mitla.

of roughly the same period probably are similar in the use of colors (Caso 1938: 86–92).

The carved face of the Estela Lisa (Fig. 11) (Acosta 1959: 12–21, figs. 9–17; Caso 1965: fig. 15) was red when it was uncovered,[13] although we should not be misled by this. The application of red pigment was the usual last step in making an offering, such as the placement of several Period IIIA pottery vessels that were cached below the Estela Lisa, and the stela's carving thus was covered with red almost by accident. The color was from loose pigment, not from paint in a binder or vehicle, because a few summer rains sufficed to remove the red after the carved face was exposed.

During Monte Alban IIIB, two effigy vases show that some use of polychrome continued. One vessel in the Leigh Collection is unusual in more than its polychromy: both the posture and the iconographic details would make it distinctive even in monochrome, though the piece probably is from the Valley of Oaxaca (Fig. 12). The second vessel is said to be from the Mixteca Alta (Bernal 1968: 33 and color plate). If it had turned up in the Valley of Oaxaca, it would have been classed as rather strange

[13]It is called the Estela Lisa because, while it resembled a number of other South Platform Monte Alban stelae in all else, the visible face was uncarved. Repairs to the pyramid in 1958 forced its removal, and the bottom edge was then found to be carved (as are the edges of several stelae that have figures also on their large visible sides).

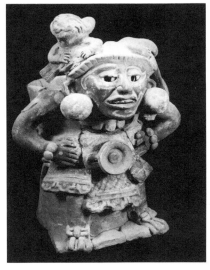

Fig. 11 *above* The Estela Lisa ("uncarved stela"), at Monte Alban. Originally part of the northwest corner of the South Platform (visible with its *talud* and *tablero* in the background), it was later moved to the Museo Nacional de Antropología, Mexico City.

Fig. 12 *left* Polychrome figure in the style of Monte Alban IIIB, but said to have come from the Mixteca Alta. Height 36 cm. Howard Leigh Collection, Museo Frissell, Mitla.

even aside from its polychromy. Both have traits of Monte Alban IIIB, about A.D. 400–800.

Plainly monumental in both function and size are some plaster sculptures of early Monte Alban IV at Lambityeco, dated close to A.D. 700. Although their material is extremely fragile, the sculptures were preserved because new houses were built over them without their being demolished. Paint was visible on the sculptures when they were found. The pair of striking heads adorning the *tableros* of Tomb 6 were painted white; the *tableros* behind them were solid red (Figs. 13, 14, 15). They are slightly over life-size. The pair of enormous Cociyo busts in the house adjoining were white also, with red only on their chest pendants (Fig. 16).

In Monte Alban IV a general decline in workmanship is accompanied by

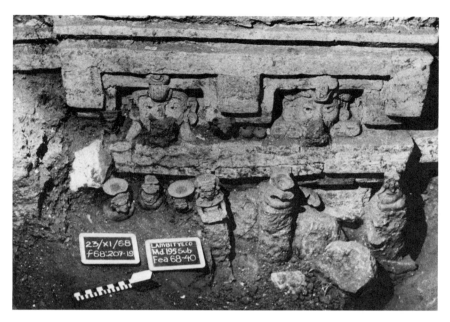

Fig. 13 Facade of Tomb 6, Lambityeco, showing details of an original Monte Alban style *tablero* without restoration or reconstruction.

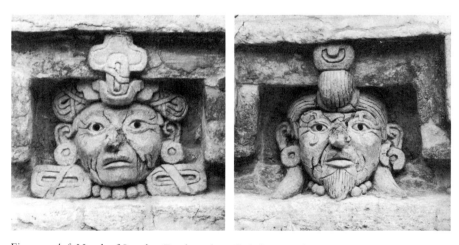

Fig. 14 *left* Head of Lord 1 Earthquake, slightly over life-size, facade of Tomb 6, Lambityeco. Photograph by John O'Leary.

Fig. 15 *right* Head of Lady 10 J, slightly over life-size, facade of Tomb 6, Lambityeco. Photograph by John O'Leary.

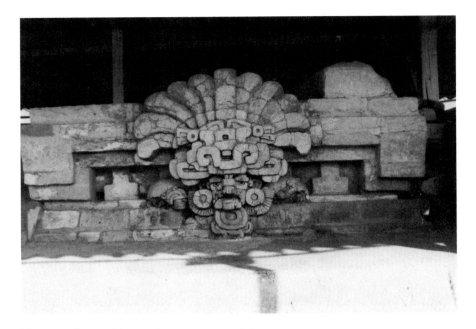

Fig. 16 Plastered bust of Cociyo, over life-size. It is on the Monte Alban style
tablero, not reconstructed, of a raised room in an elite residence, Lambityeco.

a decline in the use of polychrome. A tomb at Lambityeco (Paddock,
Mogor, and Lind 1969; Winter, Deraga, and Fernández 1977) had clear
traces of finely drawn murals in white, red, black, and gray-blue paint—
but the flimsiness of the tomb's construction assured the loss of all but a
few fragments. From this period also are a small polychrome "urn" in the
Museo Frissell at Mitla (Fig. 17) and a large alligator mask from Yagul,
which was unplastered but painted red (Fig. 18),[14] but one otherwise sees a
near absence of polychromy on sculpture.

Polychromy is conspicuous in Monte Alban V, but the familiar ex-
amples are small in scale: polychrome pottery and painted manuscripts.
There is, however, a polychrome stone monument at Yagul from this

[14]The wearer, identifiable only by a crudely carved arm and hand of normal size, seems to
be human. The stone was found in a wall of the ball court where it had been used as an
ordinary construction stone, plastered over and invisible. It obviously had been made for a
conspicuous place, perhaps at one end of a balustrade, about A.D. 800. This monument was
called "the serpent stone" by Oliver (1955: 65–67), by Wicke (1955: 68), and by me in 1955
and later. However, since the creature clearly lacks the bifid tongue that would identify it as a
serpent, I now call it an alligator.

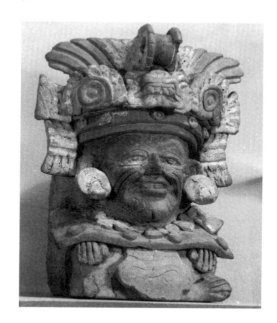

Fig. 17 Polychrome "urn" of Monte Alban IV style (red, yellow, white). Height 26 cm. Museo Frissell, Mitla.

Fig. 18 The Yagul "alligator" stone. Museo Regional de Oaxaca.

Fig. 19 The Yagul "toad-jaguar" monster, in front of Mound 4-E.

period to suggest that other monumental sculptures were painted (Fig. 19; Paddock 1955: 42, 45). Only bits of plaster, in red and (probably) black over white, remain in sheltered pits around the head, and the creature is not identifiable without its painted details, for the plaster and paint helped to define the forms,[15] and they were gone when we found it.

[15]The creature has features of a toad and a jaguar, and Donald Brockington reminds me that in 1955 we compared it with the "frog altars" reported by Thomas Gann (1929) in Honduras; Peter Furst (1981) has recently surveyed a closely related question in a highly stimulating way. The animal, however, may not be identifiable, for it is a mythical monster.

CONCLUSION

Although polychrome elements predominate on buildings depicted in the Mixtec codices, most of the actual buildings in ancient Oaxaca that show traces of paint were apparently colored simply in places with red on the white of the plaster. At Mitla the stone mosaic panels were often colored red, sometimes with the outer surfaces left white to bring out the contrast of the designs, and the murals at Mitla, too, were painted only in red and white. Iron-oxide red was often used to color paved patios and plazas and the floors of buildings in Oaxaca, and at Mitla it continued up part of the interior walls and delineated the door frames of the palaces. Paint seems to have been used in these instances to emphasize some of the architectural elements and especially to diminish the glare of the bright sun; the red of iron-oxide was the most readily available pigment.

On sculptures, there is some evidence of polychrome as early as Monte Alban I and continuing through Monte Alban V, although the surviving polychrome is found principally on ceramic pieces. Other sculptures, such as the plaster busts from Lambityeco, seem to have been left largely the color of the white plaster, with only a few details painted in red.

BIBLIOGRAPHY

ACOSTA, JORGE R.
 1959 Exploraciones arqueológicas en Monte Albán. XVIII temporada,
 1958. *Revista Mexicana de Estudios Antropológicos* 15: 7–32.
 1964 *El palacio del Quetzalpapalotl.* Instituto Nacional de Antropología e
 Historia, Mexico.

BERNAL, IGNACIO
 1965 Architecture in Oaxaca after the End of Monte Alban. In *Handbook of
 Middle American Indians* (Robert Wauchope and Gordon R. Willey,
 eds.) 3: 837–848. University of Texas Press, Austin.
 1966 The Mixtecs in the Archeology of the Valley of Oaxaca. In *Ancient
 Oaxaca* (John Paddock, ed.): 345–366. Stanford University Press,
 Stanford, California.
 1968 Urna mixteca. *Boletín del Instituto Nacional de Antropología e Historia*
 32: 33 and color plate.

BERNAL, IGNACIO, and LORENZO GAMIO
 1974 *Yagul: el Palacio de los Seis Patios.* Instituto de Investigaciones
 Antropológicas, Universidad Nacional Autónoma de México, Mexico.

BLANTON, RICHARD E.
 1978 *Monte Albán: Settlement Patterns at the Ancient Zapotec Capital.* Aca-
 demic Press, New York.

BLANTON, RICHARD E., JILL APPEL, LAURA FINSTEN, STEVE KOWALEWSKI, GARY
FEINMAN, and EVA FISCH
 1979 Regional Evolution in the Valley of Oaxaca, Mexico. *Journal of Field
 Archaeology* 6: 369–390.

CASO, ALFONSO
 1938 *Exploraciones en Oaxaca, quinta y sexta temporadas 1936–1937.* Instituto
 Panamericano de Geografía e Historia, Mexico.
 1964 *Interpretation of the Codex Selden 3135 (A. 2)* (Jacinto Quirarte and John
 Paddock, trans.). Sociedad Mexicana de Antropología, Mexico.
 1965 Sculpture and Mural Painting of Oaxaca. In *Handbook of Middle
 American Indians* (Robert Wauchope and Gordon R. Willey, eds.) 3:
 849–870.

CASO, ALFONSO, and IGNACIO BERNAL
 1952 *Urnas de Oaxaca.* Instituto Nacional de Antropología e Historia,
 Mexico.

CASO, ALFONSO, IGNACIO BERNAL, and JORGE R. ACOSTA
 1967 *La cerámica de Monte Albán.* Instituto Nacional de Antropología e
 Historia, Mexico.

CODEX NUTTALL
 1902 *Codex Nuttall. Facsimile of an Ancient Mexican Codex belonging to Lord Zouche of Harynworth, England* (Zelia Nuttall, ed.). Peabody Museum of American Archaeology and Ethnology, Harvard University, Cambridge.

FURST, PETER T.
 1981 Jaguar Baby or Toad Mother: A New Look at an Old Problem in Olmec Iconography. In *The Olmec and Their Neighbors* (Elizabeth P. Benson, ed.): 149–162. Dumbarton Oaks, Washington.

GANN, THOMAS
 1929 *Discoveries and Adventures in Central America.* Duckworth, London.

HARTUNG, HORST
 1970 Notes on the Oaxaca Tablero. *Boletín de Estudios Oaxaqueños* 27.
 1977 Maquetas arquitectónicas precolombinas de Oaxaca. *Baessler-Archiv* 25: 387–400.

LITTMAN, EDWIN R.
 1973 The Physical Aspects of Some Teotihuacán Murals. In Miller 1973: 175–186.

MARGAIN, CARLOS R.
 1971 Pre-Columbian Architecture of Central Mexico. In *Handbook of Middle American Indians* (Gordon F. Ekholm and Ignacio Bernal, eds.) 10: 45–91. University of Texas Press, Austin.

MARSHACK, ALEXANDER
 1981 On Paleolithic Ochre and the Early Uses of Color and Symbol. *Current Anthropology* 22: 188–191.

MILLER, ARTHUR G.
 1973 *The Mural Painting of Teotihuacán.* Dumbarton Oaks, Washington.

MILLON, CLARA
 1972 The History of Mural Art at Teotihuacán. In *Teotihuacán. XI Mesa Redonda* (vol. 2, not marked as such): 1–16. Sociedad Mexicana de Antropología, Mexico.

MOSER, CHRISTOPHER L.
 1977 The Head–Effigies of the Mixteca Baja. *Katunob* 10 (2): 1–18.

MURDOCK, GEORGE PETER
 1934 The Polar Eskimos. In *Our Primitive Contemporaries* (George Peter Murdock, ed.): 192–220. Macmillan, New York.

OLIVER, JAMES P.
 1955 Architectural Similarities of Mitla and Yagul. *Mesoamerican Notes* 4: 49–67.

PADDOCK, JOHN
 1955 The First Three Seasons at Yagul. *Mesoamerican Notes* 4: 25–47.

John Paddock

 1966a Mixtec Ethnohistory and Monte Albán V. In *Ancient Oaxaca* (John Paddock, ed.): 367–385. Stanford University Press, Stanford, California.

 1966b Oaxaca in Ancient Mesoamerica. In *Ancient Oaxaca* (John Paddock, ed.): 83–242. Stanford University Press, Stanford, California.

 1970a A Beginning in the Ñuiñe: Salvage Excavations at Ñuyoo, Huajuapan. *Boletín de Estudios Oaxaqueños* 26. Mitla.

 1970b More Ñuiñe Materials. *Boletín de Estudios Oaxaqueños* 28. Mitla.

 1978 The Middle Classic Period in Oaxaca. In *Middle Classic Mesoamerica, A.D. 400–700* (Esther Pasztory, ed.): 45–62. Columbia University Press, New York.

PADDOCK, JOHN, JOSEPH R. MOGOR, and MICHAEL D. LIND

 1969 Lambityeco Tomb 2. *Boletín de Estudios Oaxaqueños* 25. Mitla.

PARSONS, LEE A.

 1967–69 *Bilbao, Guatemala*. 2 vols. Milwaukee Public Museum, Milwaukee.

RABIN, EMILY

 1970 The Lambityeco Friezes: Notes on Their Content. *Boletín de Estudios Oaxaqueños* 33. Mitla.

SCOTT, JOHN F.

 1978 *The Danzantes of Monte Albán*. Studies in Pre-Columbian Art and Archaeology 19. Dumbarton Oaks, Washington.

SEJOURNE, LAURETTE

 1966 *Arquitectura y pintura en Teotihuacan*. Siglo XXI Editores, Mexico.

SELER, EDUARD

 1904 The Wall Paintings of Mitla. In *Mexican and Central American Antiquities, Calendar Systems, and History:* 243–324. Smithsonian Institution, Bureau of American Ethnology, Bulletin 28. Washington.

SHARP, ROSEMARY

 1970 Early Architectural Grecas in the Valley of Oaxaca. *Boletín de Estudios Oaxaqueños* 32. Mitla.

TORQUEMADA, JUAN DE

 1943 *Monarquía indiana*. 3 vols. Editorial Salvador Chávez Hayhoe, Mexico.

TORRES MONTES, LUÍS

 1972 Materiales y técnicas de la pintura mural de Teotihuacán. In *Teotihuacán. XI Mesa Redonda* (vol. 2, not marked as such): 17–42. Sociedad Mexicana de Antropología, Mexico.

TURNBULL, COLIN M.

 1962 *The Forest People*. Anchor, New York.

WICKE, CHARLES R.
 1955 The Ball Court at Yagul: A Comparative Study. *Mesoamerican Notes* 5: 37–74.

WINTER, MARCUS C., DARIA DERAGA, and RODOLFO FERNÁNDEZ
 1976 Cerro de la Codorniz: una zona arqueológica Ñuiñe en Chilixtlahuaca, Huajuapan, Oaxaca. *Boletín del Instituto Nacional de Antropología e Historia,* ép. 2, 17: 29–40.
 1977 La Tumba 77-11 de Lambityeco, Tlacolula, Oaxaca. In *Procesos de Cambio. XV Mesa Redonda* 1: 425–429. Sociedad Mexicana de Antropología, Mexico.

WRECHSNER, ERNST E.
 1981 More on Palaeolithic Ochre. *Current Anthropology* 22: 705–706.

WRECHSNER, ERNST E., and respondents
 1980 Red Ochre and Human Evolution: A Case for Discussion. *Current Anthropology* 21: 631–644. (Includes comments by fourteen others and a reply by Wrechsner.)

Naturalistic and Symbolic Color at Tula, Hidalgo

ELLEN TAYLOR BAIRD

UNIVERSITY OF NEBRASKA AT LINCOLN

T HE USE OF COLOR AT TULA, HIDALGO, the Postclassic Toltec capital, was first noted by the nineteenth-century explorer Désiré Charnay. He reported that the floors were red in the inner rooms of a house he excavated to the southwest of the main plaza (Charnay 1887: 105). In the same house, he also noted that "the walls are covered with rosettes, palms, red, white, and gray geometrical figures on a black ground" (Charnay 1887: 108).

Many years later, Jorge Acosta's excavations in the 1940s and 1950s brought to light a large number of polychrome sculptures, most of them architectural. Acosta's discoveries indicate that painted architecture and architectural sculpture are not only common but important aspects of Toltec art (Acosta 1964: 46). Acosta's work is invaluable and indispensable for the study of color at Tula.

Polychrome at Tula is used, essentially, in two ways—naturalistically and symbolically. The six colors most frequently employed are red, blue, yellow, pinkish ochre, white, and black; black was used only to outline motifs (Acosta 1956–57: 83).

Naturalistic colors are used on two types of sculptures, both of them low relief: 1) male figures in procession and 2) reclining male figures. The processional figures are found on the lower face of numerous banquettes and altars. The Palacio Quemado polychrome figures are found on the altars of Sala 1, the altars and banquettes of Sala 2, and the banquette of Room 4. In addition, painted processional figures are depicted on the banquette and altar of the Great Vestibule, which fronts Pyramid B, and on the East Altar (Fig. 1).

PROCESSIONAL FRIEZES

According to Acosta, the colors of certain processional friezes were in an excellent state of preservation when they were discovered in the early

Fig. 1 Plan of the Palacio Quemado, Pyramid B, and Building 1 at Tula (drawing by the author after Acosta 1964: fig. 2).

1940s (Acosta 1945: 41). Unfortunately the colors have faded considerably since their discovery. Undoubtedly the original colors served not only to enliven the appearance of the friezes, but also to clarify and identify the motifs of this very low-relief sculpture. In the northwest corner of the Great Vestibule, some of the colors are visible. A reconstruction of the frieze of the Great Vestibule, drawn by Hugo Moedano, reveals the following color scheme: red is used for the background and some ornaments; blue indicates feathers and jade and turquoise ornaments; yellow denotes other feathers, weapons, and jewels; white also indicates feathers as well as eyes, teeth, and cotton clothing; skin is pinkish-ochre; and black is used to outline motifs and to make them stand out (Pl. 6; Acosta 1945: 41, 1956–57: 83). Moedano characterizes the figures in the frieze as *caciques* (chieftains) on the basis of their elaborate and varied regalia, processional attitude, and lack of weapons (Moedano 1947: 133); the men carry shields and staffs but do not have typical Toltec weapons such as the *atlatl*. The figures are depicted in profile and march toward the central staircase of Pyramid B. On the cornice of the banquette are low-relief, feathered serpents against a red background. In contrast to the naturalistic colors of the processional figures, the feathered serpents are painted red and blue. The color sequence of the six remaining serpents is two blue serpents, one red serpent, two blue serpents, one red serpent. As the colors are clearly not naturalistic, one might assume that they are symbolic.

The figures and serpents of the East Altar (Fig. 1) are treated in much the same manner, although the skin color of the figures is red, not pinkish-ochre, and black outlines are not used. In the Palacio Quemado, fragmentary remains indicate that the altars of Sala 1 were polychrome and probably had processional figures, but the banquette in this room is plain and undecorated.

The banquette and altar reliefs in Sala 2 of the Palacio Quemado are comparable to those of the Great Vestibule in color, in length, and in the rich and varied attire of the figures who march toward the southern door of the sala. The only difference in the use of color on the processional figures is that, with the exception of white adornments, black is not used to outline motifs (Acosta 1957: 133). On the east end of the north banquette, the cornice serpents have appendages of different colors. The easternmost serpent is red and has small white volutes, which Acosta suggests make this a cloud serpent. The next three serpents are dark blue and have long, dark blue-gray curving appendages, which Acosta interprets as feathers; each serpent has three rattles painted blue (Acosta 1957: 132). Based on the average size of the remaining serpents, Acosta estimates that there were originally 212 processional figures and 104 serpents (Acosta

1964: 74). The estimated number of serpents is, of course, equal to two Mesoamerican 52-year calendar rounds.

On the east side of Sala 2, a Chacmool was discovered in front of the altar. The upper floor level on the east side is painted red, as is the vertical wall behind it. A red, cylindrical stone box was found within the east altar (Acosta 1957: 152). A similar red box was also discovered in the south altar of Sala 1; among other items, it contained a jade plaque with traces of red on it (Acosta 1954: 104).

Room 4, immediately behind Sala 2, also had a polychrome banquette or altar with processional figures. The remaining stones indicate the use of the standard color patterns. These figures, however, are armed with weapons. Connected to Room 4 are Rooms 2 and 3. The clay walls of Room 2 have remains of red paint on them.

The Coatepantli, or serpent wall, which parallels the north side of Pyramid B, has as its central motif a frieze of serpents, as do the banquette cornices (Pl. 7). Each Coatepantli serpent is, however, intertwined with the body of a partially fleshed, skeletal figure. The serpents have rattles and plumes on their tails but do not appear to be feathered as are the banquette serpents. The background is again red, as is the flesh of the skeletal figure. The serpents are blue and yellow with yellow undersides; they are arranged so that there are two blue serpents, one yellow one, two blue, one yellow, and so on. The banquette serpents in the Great Vestibule follow a pattern of two blue and one red (Acosta 1945: 41). On the Coatepantli, the volutes are yellow, and the serpents' teeth and men's bones are white. A stepped motif flanks both sides of the frieze (Acosta 1944: 142–143). Acosta interprets the theme of the Coatepantli as a serpent devouring Tlahuizcalpantecuhtli, Venus as the Morning Star (Acosta 1944: 142). George Kubler has suggested that "the theme alludes to the souls of dead warriors" (Kubler 1962: 45). There were originally two standard-bearers atop the Coatepantli; the two small standing figures wore different clothing of different colors, but in both figures, the bodies were red (Acosta 1944: 145; Dutton 1955: 210).

Certain coloristic patterns begin to emerge at Tula, above all the use of red. Red is consistently used as a background color, for skin (although faded it may appear to be pink- or orange-ochre), on floors and walls, on stone offering receptacles found in altars, and on at least one jade plaque found in an offering cache. It is difficult to determine if the use of red has consistent meaning, whether it follows a symbolic or artistic convention when it is not used naturalistically. Red is clearly related in some instances to things sacred, as its use in and on offerings indicates.

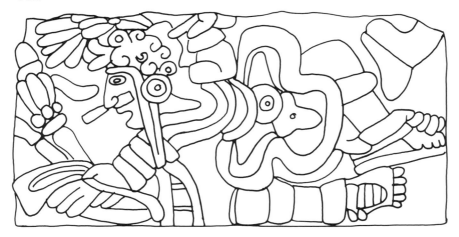

Fig. 2 Reclining figure from Sala 1, Palacio Quemado, Tula (drawing by the author after Acosta 1954: pl. 39).

RECLINING FIGURES

Naturalistic, descriptive color is also used on other relief panels such as the reclining figures from Sala 1 of the Palacio Quemado (Fig. 2). These figures are thought to have formed a major part of a polychrome, sculptural frieze on the roof-level facade that encircled the inner, open patio of Sala 1 (Acosta 1961a: 33). The figures are dressed and armed as warriors; the position of their bodies suggests that they have fallen or are falling. The undulant bodies of feathered serpents are seen behind the warriors in some panels; in one relief, the warrior holds a serpent staff. Several warriors wear skirts in the shape of the symbol for Venus. The colors are consistent with those applied to the processional figures—the background and bodies are red; ornaments such as earspools, nosebars, pendants, and some feathers are blue; weapons, such as *atlatls,* are yellow; and eyes, serpents' teeth, and some articles of clothing are white (Acosta 1957: 127).

Similar relief panels depicting falling or fallen warriors were also found in Sala 2 of the Palacio Quemado. Like those in Sala 1, they originally covered the inner roof-level facade of the open patio. Yet the colors used in the Sala 2 figures are much more restricted; they are almost completely red except for a few yellow ornaments (Acosta 1957: 155–156). The use of color borders on the non-naturalistic.

Associated with these reclining figures from Salas 1 and 2 of the Palacio Quemado are other painted stones with representational or decorative motifs. A frequent motif is a large blue disk on a red background (Fig. 3);

Fig. 3 *Tezcacuitlapilli,* Sala 1, Palacio Quemado, Tula (drawing by the author after Acosta 1954: fig. 16).

a circle forms the center of the disk from which four to eight raylike divisions extend. The outer edge of the disk is dentated with the number of divisions ranging from 14 to 18 (Acosta 1957: 127). Acosta identifies the disk as a *tezcacuitlapilli,* a sacred disk worn on the belts of the great lords (Acosta 1954: 113). Another common motif is a bowl piled high with ovoid shapes and having three arrow shafts or reeds protruding from the top (Fig. 4). The background and bowl are red, the reeds are blue, and the ovoid objects (and occassional volutes) are yellow. Acosta identifies the bowl as a *cuauhxicalli,* a heart receptacle (Acosta 1954: 98).

Found with the reliefs of blue disks and red bowls were a number of decorative, polychrome stones. (Similar ornamental stones were found in the rubble of the south colonnade of the Palacio Quemado.) They include white, G-shaped merlons representing cross-sections of shells; blue and red rectangular stones, probably cornices; blue and red circular stones; and small blue, red, and yellow columnlike stones (Acosta 1954: 48, 50, 98, 102, 103, 112; 1960: 71). Red and blue dominate the colors on the ornamental stones. The stones are thought to have originally formed a polychrome, roof-level frieze.

Non-naturalistic color is used on a third group of reclining relief figures found at El Corral, Tula, located approximately a mile north of the main plaza. At El Corral, a small altar is attached to the east side of the circular pyramid. The wall of the altar is divided into three registers. The two upper registers are vertical; the topmost register has reliefs of a procession

Fig. 4 *Cuauhxicalli,* Sala 1, Palacio Quemado, Tula (drawing by the author after Acosta 1954: fig. 16).

of warriors, and the second register has skulls alternating with crossed bones. The third and lowest register is a *talud* with reliefs of reclining figures. The figures carry weapons, and some are depicted with feathered serpents. One of the warriors is accompanied by a glyph that may be that of the reptile's eye (Acosta 1974: 35). The warriors on the north and south sides of the altar face east. The remaining figure on the northeast corner of the east facade faces south and is unique in wearing a skeletal mask on his face (Acosta 1974: 37). Acosta points out that the altar was periodically painted white, but that in places where the paint had fallen, he could see traces of colored paint (Acosta 1974: 39).

The fourth group of reclining figures comes from the south side of the Southeast Platform which is next to, and slightly south of, Pyramid C. These figures are not armed but carry ornamented ceremonial staffs (Fig. 5; Acosta 1960: 69). On the opposite sides of many of the stones are relief images of the rain god (Fig. 6), several of which hold serpents in their hands. All have goggled eyes and elongated, curving upper lips, the latter more typical of the Yucatec rain god, Chac, than of the Central Mexican Tlaloc (Acosta 1960: 69). The glyph 9 Hand accompanies one of the reclining figures (Fig. 5; Acosta 1960: 63); the rain god on the opposite side (Fig. 6) carries a ceremonial bag and has a serpent beneath him. Several other stones are associated with this group of reclining figures, the most notable being two that form a relief of a jaguar-bird-serpent creature in whose open mouth a face appears. Acosta thinks these relief panels "without a

Fig. 5 Reclining figure from the Southeast Platform, Tula (drawing by the author after Acosta 1960: pl. XXI).

Fig. 6 Rain god from the opposite side of Fig. 5 (drawing by the author after Acosta 1960: pl. XXII).

Fig. 7 Reclining figure from the Temple of the Warriors, Chichen Itza (after Morris, Charlot, and Morris 1931: fig. 25).

doubt" were *tableros* on the south side of the Southeast Platform (Acosta 1960: 68). All of these stones are completely painted white (Acosta 1960: 63).

Reclining warriors similar to those at Tula are depicted on the *tableros* of the Temple of the Warriors at Chichen Itza (Fig. 7). J. Eric S. Thompson (1943: 118–119) has identified them as representations of the deity Tlalchitonatiuh, "Sun near the earth/horizon," who is generally regarded as representing the sun just after having set or just before rising. The images of Tlalchitonatiuh at Chichen Itza combine the jade-studded golden hair of Tonatiuh, the sun god, with the goggled eyes of Tlaloc. At Chichen, the reclining figures are painted in varied colors: "the background is red; the warriors have head-dresses of green, red and blue, and dresses of green, yellow, red and blue" (Morris, Charlot, and Morris 1931: 42).

Although the reclining pose of the Chichen and Tula figures is similar, as are some of the adornments and items of clothing, it is obvious that the Tula figures lack the identifying attributes (i.e., goggled eyes, flowing yellow hair studded with green) of the deity. Furthermore, the Tula reliefs of reclining figures may be divided into four groups on the basis of color and location: 1) naturalistically varied color, probably from a roof-level

frieze around the open, interior patio, Palacio Quemado, Sala 1; 2) red and yellow, again probably from a roof-level frieze around the open, interior patio, Palacio Quemado, Sala 2; 3) white over various colors (naturalistic?), on the lowest of three registers of the altar at El Corral; 4) white, from *tableros* on walls of the Southeast Platform. Surely the use of different colors, and especially the use of non-naturalistic colors on the reclining figures, is significant and lends added meaning to those figures even though that meaning is not readily apparent.

NON-REPRESENTATIONAL WALL PAINTINGS

Non-representational wall paintings were also discovered by Acosta. The interior walls of the Great Vestibule were found to have been painted with horizontal bands of color (Dutton 1955: 219). Similar, although better preserved, examples of wall painting are also to be found on the walls of the north-south passageway immediately to the west of Pyramid B and on a wall to the east of Building 1.

The horizontal bands in the passageway extend the full length of the walls from north to south (Pl. 8a). From bottom to top the colors and widths of the bands are 1) white, 79 cm; 2) black, 10 cm; 3) red, 9 cm; 4) blue, 9 cm; 5) yellow, 10 cm; 6) red, 29 cm. The blue band is outlined in black. Acosta suggests that the uppermost red band may have been the lower part of an area that had representational painting on it, the red serving as a background (Acosta 1954: 44).

The top of the mural on the east face of the wall slightly to the east of Building I is clearly a representational scene, as men's sandal-clad feet are seen (Pl. 8b). Beginning at the bottom, the bands of color beneath the scene are 1) lowest band again white, 46 cm; 2) second band yellow, 7 cm; 3) third band blue, 7 cm. Red motifs on a yellow background are used in the uppermost area (Acosta 1964: 60–61).

In both murals, white is the lowermost color and covers the largest area although the sequence of the following colors is not the same. It is not known whether the bands of color are significant and meaningful or merely decorative.

Color Symbolism

Pre-Conquest color symbolism seems to have been standardized only among the Maya where it is associated with the four world directions. According to Thompson (1934: 211), who derives his information from Landa, east is associated with red, north with white, west with black, and south with yellow. In Central Mexico there does not seem to have been a standardized pattern of color association, for the colors assigned to the

world directions vary from source to source. However, in book 10 of the Florentine Codex, Sahagún describes Tula and the Toltecs and two sets of four "houses" placed in accordance with the cardinal directions. The first group of four "houses" constituted the "place of worship of their [the Toltecs] priest, whose name was Quetzalcoatl" (Sahagún 1950–71, bk. 10: 166). Facing east was the house of gold; west, the house of green stone; south, the house of shells, of silver; and north, the house of red shells. The House of Feathers was also a group of four structures oriented toward the cardinal directions, and, significantly, the same colors are associated with the same directions. The walls of the house that faced east were covered with yellow feathers, such as parrot feathers; the house that faced west was called the "house of precious feathers," and its walls were covered with quetzal feathers and blue cotinga feathers; white feathers such as eagle feathers covered the walls of the house facing south; and red feathers, such as those of the red spoonbill or red arara, covered the walls of the house facing north (Sahagún 1950–71, bk. 10: 166). Sahagún's description of these houses tentatively provides us with a set of colors and the cardinal directions with which they were associated at Tula. East is aligned with yellow, west with blue-green, south with white, and north with red. Although Sahagún does seem to be referring to the cardinal directions in the same sense that we use the words east, west, north, and south, con-temporary scholars, most notably Gordon Brotherston, have questioned the application of Western concepts of space to those of Pre-Conquest Mesoamerica. Brotherston suggests that the Maya words *xaman* and *nohol,* usually translated as "north" and "south," do not always or exclusively refer to our north and south respectively but "sometimes must mean above and below" (Brotherston 1976: 59). In a recent article on the shape of time, Clemency Coggins has stated this concept quite succinctly:

> The shape of time may thus, in one way, be conceptualized as a vertical four-point diagram within the ecliptic band (including a fourth point below). These points or places are: where the sun rises; where it reaches the top; where the sun sets; and where it reaches the bottom.[1] (Coggins 1980: 731)

Drawing on the work of Gary Gossen, she goes on to add:

> Evidence for continuity in Maya cosmology is found in modern Chamula beliefs concerning the organization of space. The Chamula describe their cosmos in terms of the path of the sun,

[1]Cecelia F. Klein (1975: 81, 1976a: 218–222, esp. note 2, p. 221) has also forwarded the hypothesis that "north" refers to the sun at its zenith (i.e., noon) and "south," the sun at its nadir (i.e., midnight).

with east the primary direction while north connotes the position of the sun at zenith, or up, and together these two directions are hot, light, right hand, and male; whereas west and south connote the position of the sun in the underworld, or down, and are together cool, dark, left hand and female. (1980: 731).

If we accept these ideas and Sahagún's color-direction associations, we are left with the following color symbolism: yellow—place and point in time of the sun's rising on the horizon, east; red—place and point in time of the sun at its zenith, above, north; blue-green—place and point in time of the sun's setting, west; white—place and point in time of the sun at its nadir in the underworld, below, south. The colors that refer to the points in the sun's path when it is at its most intense, or on its way to its greatest intensity at sunrise and zenith, are the warmest colors, yellow and red. The two directions associated with sunrise and zenith, east and north, are traditionally linked, as are west and south, sunset and nadir. The colors associated with the descent and demise of the sun, blue and white, are appropriately cool colors.

It would be naive and overly simplistic, I think, to assume that each and every time a color was used it had one and only one meaning. Blue, for instance, is commonly used throughout Mesoamerica (and the world) to represent water. The Nahuatl word *xihuitl* not only means turquoise, which is of course blue, but also year, and the glyph for turquoise is used to represent "year." In the same sense, I think it highly likely that at Tula blue may have indicated not only west but also water or turquoise, depending on the context, and red not only the sun at its diurnal height but also blood.

At this point, the color symbolism I have proposed for Tula, although based on Sahagún, is purely hypothetical; nonetheless it does provide a starting point for the analysis of symbolic color at Tula.

The broad white areas at the lowermost level of the passageway murals to the west of Pyramid B and the east wall of Building I do seem to reinforce the idea that white symbolically represents the south, the sun's position beneath the earth, or the underworld (Pl. 8a, b). The juxtaposition of blue (W) and yellow (E) in the bands above might possibly be a reference to the rising and setting of the sun. Overall, the colors above the white areas do not fall into a pattern that is easily associated with the path of the sun, but may nevertheless refer to diurnal points in time.

The Coatepantli north of Pyramid B also has polychrome non-representational motifs (Pl. 7). Stepped motifs fill the panels above and below the central panel. The raised stepped band is red, as are the rectangular shapes set within the stepped forms. The background color is divided. One part

Fig. 8 East wall of Pyramid B, Tula (after Acosta 1945: fig. 19).

is yellow, the other blue. It is possible, but not provable, that the yellow
and blue symbolize horizons, east and west, that the red rectangular shapes
indicate the rising and setting of the sun, and that the raised stepped bands
refer to the diurnal path of the sun rising and falling from east to west. In
addition, the different colors of the reclining warriors might refer to their
roles in the cosmic scheme of things. The white reclining warriors might
then be the fallen warriors who accompany the sun in the underworld, the
red and yellow warriors would be those of the sun rising from the east to
its zenith, and the naturalistically colored warriors would be those of the
earthly realm.

PYRAMID B

If we apply this color symbolism to Pyramid B and its related sculp-
tures, the outcome is intriguing. Contrary to almost all published descrip-
tions, Pyramid B was not painted in different colors. According to Acosta
(1943: 142), Pyramid B was white and heavily stuccoed. The stucco was
so thick that it obscured (and obscures) the outline of the reliefs (Acosta
1942: 128). The wall treatment is a modified version of the *talud-tablero*.

Tablero Reliefs

The *tablero* is divided into two registers; the lower of the two registers
has two planes, one that is level with the upper *tablero* register and the
other recessed (Fig. 8). Coyotes and jaguars proceed along the upper regis-
ter. On the lower register, two birds are depicted eating objects usually
identified as hearts dripping blood.

On the north side of the pyramid one bird is a vulture, the other an
eagle; one faces east, the other west. Acosta says that these relief panels are
from the last of three building stages at Pyramid B. The east wall of the

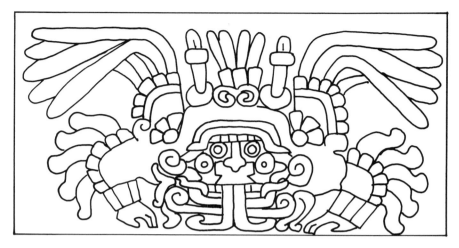

Fig. 9 Jaguar-bird-serpent, Pyramid B, Tula (drawing by the author).

pyramid has similar motifs that Acosta says are from the second building stage (Acosta 1954: 59). The east reliefs differ only in that eagles are paired with eagles, and vultures with vultures; all the birds face south.

A crouching monster with a face in its open jaws is depicted in the recessed panels between the bird reliefs (Fig. 9). The monster has a jaguar-like mouth, crocodilianlike forelegs, and is feathered. The face in its mouth has goggled eyes, a human nose, and a nose pendant which is often in a shape like a *talud-tablero*. A bifurcated tongue hangs out of the feathered monster's mouth, but the ownership of the tongue is uncertain.

At Chichen Itza a very similar motif with face in open monster jaws occurs with great frequency. Sometimes it is unclear to whom the bifurcated tongue belongs (Fig. 10). In other reliefs it belongs quite clearly to the face within the gaping jaws of the feather monster (Fig. 11). This creature is usually identified as Tlahuizcalpantecuhtli, Venus the Morning Star, on the basis of Seler's identification of a similar motif at Mausoleum III, Chichen (Fig. 10). The Chichen monster is accompanied by a date that combines the Venus glyph with the 52-year bundle accompanied by eight dots (Fig. 10). Seler concludes that the date glyph refers to a "Great Venus Cycle" and that the monster therefore represents Venus the Morning Star (Seler 1960–61, 1: 693–694). Cecelia Klein (1976a: 87) disagrees slightly with Seler and identifies the motif as Venus the Evening, rather than Morning, Star and the end of the Venus cycle. The date glyph on Mausoleum III, provided it has been correctly interpreted, refers not only to the

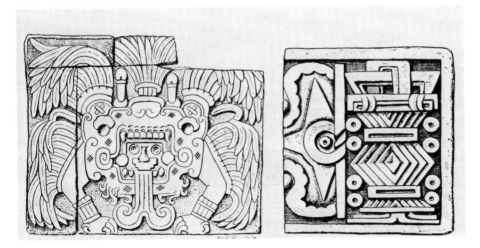

Fig. 10 Jaguar-bird-serpent, Mausoleum III, Chichen Itza (after Seler 1960–61, 5: figs. 242, 243).

Fig. 11 Jaguar-bird-serpent, base of Column 6 (west side), northwest colonnade, Temple of the Warriors, Chichen Itza (after Morris, Charlot, and Morris 1931: pl. 46).

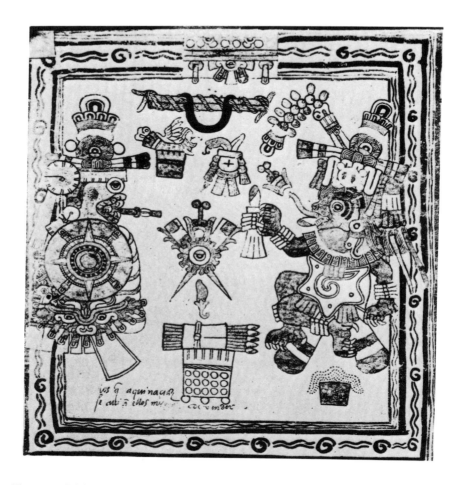

Fig. 12 Tlalchitonatiuh (*left*) and Xolotl (*right*), Codex Borbonicus, page 16, detail (after Vaillant 1940: pl. XXXIV).

completion of a "Great Venus Cycle" of 260 Venus cycles but also to 416 years or four complete Venus-solar cycles. It is significant and important that the completion of both Venus and solar cycles coincides.

I have previously suggested (Baird n.d.) that it is Tlaloc who is represented in the jaws of the earth—specifically the so-called Tlaloc B or Jaguar Tlaloc as identified by Esther Pasztory (1974). At Teotihuacan, Tlaloc B is associated with net jaguars, water, warfare, and possibly a sacrificial warrior cult. According to Pasztory, the "net jaguar is shown in water and fertility contexts in mural painting, which suggests the under-world during the rainy season. . . . the net design is similar to, and possibly derived from, the glyph 'movement' (*ollin*) associated with the descending aspect of the sun deity in Postclassic iconography" (Pasztory 1978: 132).

These identifications essentially agree on the nature of the feathered monster: it represents the earth. Its recessed position in the lower *tablero* register enhances its earthly significance. I would suggest that the use of white on the pyramid further indicates that the feathered monster not only represents the earth, but more specifically the underworld, as does the pyramid itself.

I would also like to suggest yet a different identification of the face within the monster's mouth, the little-known deity Tlalchitonatiuh (Fig. 12). Thompson says that "Tlalchitonatiuh, 'Sun near the earth,' . . . represents the sun at the horizon, and his picture combines the attributes of Tonatiuh and Tlaloc," specifically the goggled eyes of Tlaloc (Thompson 1943: 119). Thompson goes on to suggest that the blending of features might refer to the frequent cloudiness of sunrise. In book 10 of the Floren-tine Codex, with reference to the feast day Nahui Ollin (4 Ollin), the text says that the sun at sunrise was sometimes "quite pale, white-faced, pallid, because of the clouds—a mist, a heavy pall, or clouds of many colors which were spread before his face" (Sahagún 1950–71, bk. 7: 1–2). Klein links Tlalchitonatiuh to other aspects of the dead sun in the underworld such as Yoaltonatiuh, "Night Sun," and Yohualtecuhtli, "Lord of the Night" (Klein 1976b: 4). She goes on to say that "Yohualtecuhtli . . . represented not only the dead night sun in the underworld, but the 'dead' planet Venus as well" (Klein 1976b: 10) and suggests that "at anytime in which the sun and Venus simultaneously completed a cycle, the two celes-tial bodies were believed to engage in mortal nocturnal combat and ulti-mately to fuse in the dark bowels of the . . . earth monster" (Klein 1976b: 11). The face in the monster's mouth may represent this hybrid Venus-sun creature and is most probably some aspect of Tlalchitonatiuh or some other underworld sun who partakes of his attributes.

Of the other creatures on Pyramid B, the jaguar and the coyote are often associated with the underworld. The jaguar's associations with the underworld and the sun in the underworld are well known. I have already mentioned the Teotihuacan net jaguar; there is also the Aztec jaguar god of the interior of the earth, Tepeyollotl, and the Maya Jaguar-Sun, the night sun in the underworld. In the Leyenda de los Soles, the First Sun was the jaguar sun, 4 Jaguar, or Ocelotonatiuh (sun jaguar). Another name given this jaguar sun is Tlalchitonatiuh (Nicholson 1968: 226). It may be worth mentioning that the date 4 Ollin, the day on which ceremonies and sacrifices honoring the sun were held, falls within the week that begins on 1 Jaguar (Sahagún 1950–71, bk. 5: 6). The jaguar was also a major participant in the birth of the Fifth Sun, the sun of the present era. The jaguar and the eagle were both singed by the fire out of which the sun was created. In commemoration of these acts of self-sacrifice, the Aztec orders of the jaguar and eagle warriors were created (Sahagún 1950–71, bk. 7: 6). Valiant warriors were called *quauhtlocelotl,* "eagle-ocelot or jaguar," according to Sahagún (1950–71, bk. 7: 6).

The coyote is also associated with the underworld. David Kelley (1955: 397–416) links the coyote to Xolotl, Venus as Evening Star, an aspect of Quetzalcoatl. Xolotl is depicted as doglike in appearance (Fig. 12); he is closely connected to the underworld, as he is credited with taking the bone from the underworld from which mankind was made (Thompson 1950: 78). "Seler regards Xolotl as the canine god who conducts the sun each evening to the underworld. There is strong support for this idea in the fact that Xolotl shares with Tlalchitonatiuh [or 4 Ollin] the patronage of the week 1 Cozcaquauhtli [1 Vulture]" (Thompson 1950: 78). We also find that a close relationship between Xolotl and Nanahuatzin exists. Nanahuatzin was the syphilitic god who threw himself into the flames and became the Fifth Sun (Sahagún 1950–71, bk. 7: 6). Thompson says that Xolotl and Nanahuatzin are interchangeable "in the series of days and weeks, and the two are confused in mythology" (Thompson 1950: 79). If so, Xolotl might also be considered the sun as well as Venus. An Aztec greenstone sculpture of Xolotl depicts him as wearing a sun disk on his back (Fig. 13). I am inclined to regard Xolotl not only as Venus the Evening Star but more specifically as Venus in the underworld.

Of the two birds represented, the vulture is more readily associated with the underworld. As I have previously mentioned, Xolotl and Tlalchitonatiuh or 4 Ollin are patrons of the week 1 Vulture or Cozcaquauhtli. The fact that vultures eat carrion would also clearly link the bird with death and consequently the underworld.

Eagles are closely associated with the sun. In the Florentine Codex the sun is referred to as "the soaring eagle" (Sahagún 1950–71, bk. 7: 1). The

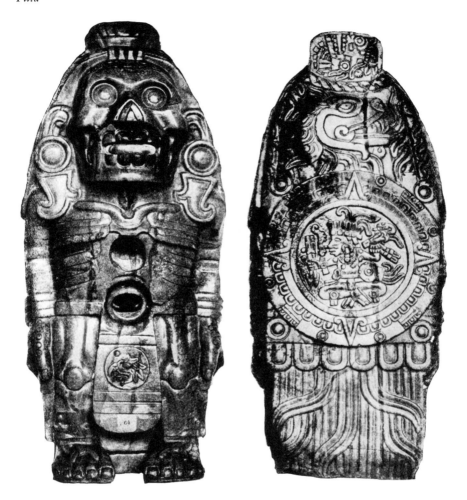

Fig. 13 Front and rear view of Xolotl. Greenstone, red shell, and bone; height 29.7 cm. Würtembergisches Landesmuseum, Stuttgart (after Seler 1960–61, 3: pl. 1, figs. 1, 3, op. p. 392).

eagle not only symbolizes the sun but seems to have "functioned as an intermediary between man and that divinity" (Thompson 1950: 82). The eagle is definitely connected to the diurnal sun, but its placement beneath the jaguars and coyotes quite literally puts it, on Pyramid B, in a below-ground position. Thompson tenuously links the eagle to the night with his suggestion that the aged Maya moon goddess, Men, was paralleled in Mexican religion by Ilamatecutli-Ciuacoatl, the "eagle-woman" (Thomp-

son 1950: 84). Another possible link between the eagle and the underworld is provided by the Aztec greenstone sculpture of Xolotl (Fig. 13), which has the glyph 1 Eagle on his breech-cloth. One can also assume that the sun in the underworld was as much, if not more, in need of nourishment (blood sacrifice) brought to it by the eagle than the diurnal sun.

The motifs on the *tableros* of Pyramid B thus have strong connections with the underworld, Venus, and the sun in the underworld. The use of the color white and its associations with the south and consequently the underworld reinforce these ideas. Thompson (1950: 252) translates the word *zac* in Yucatec as "white" but goes on to say that the word also means "artificial or not what a thing seems." The same sort of meaning seems to be attached to the use of white at Tula. Animals and birds that normally prowl the earth and fly through the sky are painted white to indicate that they are not what they appear at first to be; they are not above the ground but below it.

Pyramid B Temple

As one moves up the staircase of Pyramid B one also moves northward—connecting once again the concepts of up and north quite obviously and simply. The exterior appearance of Pyramid B's temple is now highly speculative. It probably had decorative features similar to those of the south colonnade of the Palacio Quemado: small columns, circular stones, cornices, etc., although this is somewhat uncertain. Acosta (1943: 143) thinks that reliefs of feathered serpents were also used.

Feathered serpents were used, apparently, as columns supporting the lintel of the main doorway (Fig. 14). Traces of paint reveal that they were painted red and blue (Acosta 1945: 28). Sahagún refers to serpent columns in his description of Tula: "The so-called serpent column, the round stone pillar made into a serpent. Its head rests on the ground; its tail, its rattles are above" (Sahagún 1950–71, bk. 10: 165). George Kubler suggests that this orientation of the serpents "may have served the purpose of connecting upper and lower zones of the universe. . . . the Toltec serpent-column descends from the skies to spread celestial gifts upon the earth" (Kubler 1962: 47). According to Sahagún (1950–71, bk. 6: 163), the women who died in childbirth met the sun daily at its zenith and "they carried it, they brought down the sun. They carried it [to the earth's horizon, to sunset] with a litter of quetzal feathers, it traveled in quetzal feathers." The women then gave the sun to the people of Mictlan, the underworld. The colors, red and blue, of the serpent columns' feathers seem to correspond to the movement of the sun from its zenith (red) to setting (blue, the place where the sun sets) according to the color symbolism I have suggested.

Fig. 14 Serpent Column, Pyra-mid B, Tula (drawing by the author).

At the rear of the temple stand four piers. Carved in relief on the four sides of each pier are four warriors and four bundles of weapons (Fig. 15). The piers are painted completely in red (Acosta 1956–57: 79). According to my hypothetical color symbolism scheme, red signifies up or north, the place of the sun at its height in the sky. Sahagún, in describing the red Toltec houses, refers to the north (toward which the red houses face) as "the plains, the spearhouse" (Sahagún 1950–71, bk. 10: 166). In book 2, the song of Uitznauac, Yoatl says, "My seasoned warrior's in the spear house . . . it is my home as lord" (Sahagún 1981, bk. 2: 223). The spear house is thus in the north and is the house of the warriors. According to Horcasitas and Heyden, sacrificial victims and warriors killed in battle went to the house of the warriors in the north (Durán 1971: fn. p. 438).

The sun was the primary patron of the warriors; they escorted the sun from rising to zenith each day. In book 6, chapter 3, of the Florentine Codex, prayers to Tezcatlipoca "to request aid when war was waged . . . make it quite apparent . . . [that] they really believed that all those who died in war went there to the house of the sun, there to rejoice forever"

Fig. 15 Pier, Pyramid B, Tula (after Acosta 1945: fig. 11).

(Sahagún 1950–71, bk. 6: 11). Throughout this chapter, the land where the dead warriors reside is frequently referred to as "above us, in the land of the dead, in the heavens" (Sahagún 1950–71, bk. 6: 11). Again the concepts of north and up or above are linked not only with each other, but also with the sun at its zenith.

The colossal atlantids are perhaps the most intriguing of the temple sculptures (Pl. 9). They are dressed and armed as warriors and in all probability had obsidian-inlaid eyes. Acosta has reconstructed much of the polychrome (1961b). From the top down, the headdress of each atlantid has long yellow and short red feathers. The band holding the feathers is composed of white, irregular shapes. The feathers have been called eagle feathers (Acosta 1943: 140–141), but clearly their color precludes such an identification. The red and yellow feathers are more closely associated with the parrot or red arara. The raised shapes of the headband suggest a mosaic; the white color may indicate the use of shell. The outer edge of the ear bars is red and the hair yellow.

The facial coloring is difficult to determine with accuracy. In a 1943 publication, Acosta says that the face was red and blue (1943: 141). The polychrome reconstruction depicts the outer edges of the face as red and the inner area of the face bounded by eyes and mouth as blue.

The stylized butterfly pectoral is yellow; the ribbons tied to the pectoral are red. The fringed material behind and slightly below the pectoral is also red, as are the ribbons that tie the *tezcacuitlapilli* (sacred disk) to the figure. The color of the *tezcacuitlapilli* is not given by Acosta, but it is compared to the turquoise and pyrite mosaic disks from Chichen. The triangular skirt is yellow with red fringes. The leg bands are yellow, and traces of red, yellow, and blue remain on the sandals, which have a feathered serpent on the heel-piece. The bracelets and armbands that the atlantids wear are yellow. Probably the best-known aspect of the atlantids is the red and white striping of their legs. Hugo Moedano, who worked with Acosta at Tula in the 1940s, identified the atlantids as images of Tlahuizcalpante-cuhtli, primarily on the basis of the red and white striped legs. Unfortunately Moedano's study seems never to have been published although Acosta reported Moedano's conclusions in 1943 and 1944 publications (1943: 143, 1944: 159–160).

Red and white striping of the legs is closely associated with Tlahuizcal-pantecuhtli, but is found on other figures as well. It is found on Camaxtli and Mixcoatl, hunting deities who are essentially interchangeable. Thompson has identified a striped warrior from the northwest colonnade of the Temple of the Warriors at Chichen as Tezcatlipoca, but the association of striping with this deity seems to be extremely rare (Thompson 1942: 49).

Red and white stripes are found on paper ornaments associated with Xipe Totec and the captives to be sacrificed in Tlacaxipehualiztli rites sacred to Xipe. The striping of victims' bodies is also associated with the major feast day of the sun, Nahui Ollin (4 Ollin), which is the name of the present sun.

Accounts of the striping of sacrificial victims in the works of Durán and Sahagún make it clear that the victims' legs were painted with white stripes (Durán 1971: 188; Sahagún 1981, bk. 2: 45). In describing the striping of victims, Sahagún says, "they name the captor 'sun', 'chalk', 'feather', because he was as one whitened with chalk" (Sahagún 1981, bk. 2: 49). Elsewhere in discussing the prayers of eagle and jaguar warriors, Sahagún says, "they wish for death: concede them the little that they desire, that they long for, the chalk, the down feathers. Assign them to the mother of the sun, the father of the sun that they may provide drink, provide food, provide offerings to those above us, those in the land of the dead, in the heavens" (Sahagún 1950–71, bk. 6: 13). It is significant that white is applied; this implies that the red is the natural color of the skin. White, as we have seen at Tula, is associated with the south, the under-world, and, most important, with death. To stripe one with chalk was to mark that person for death. The red and white, side by side, may refer not only to the coming death by sacrifice but also to the ultimate destination of the sacrificed warrior—the spear house, the home of the warriors, north, above, up, the sun at its zenith, which red appears to symbolize at Tula.

The yellow, stylized butterfly pectoral reinforces the solar aspect of the atlantids. The butterfly's association with the sun and with warriors is a strong one. Sahagún says that warriors who died in battle or were sacri-ficed went to the home of the sun; after four years, they were transformed into birds and butterflies (1950–71, bk. 3: 47–48). Seler has compiled considerable evidence that butterflies were symbols of fire and were asso-ciated with dead warriors and the sun at its zenith (Seler 1960–61, 4: 713–715). In connection with the Aztec feast of Nahui Ollin, Durán says that an image of the sun was hung on one side of the courtyard of the Temple of the Sun; "this image was in the form of a butterfly" (Durán 1971: 188). He also says that the sign *ollin* was "in the form of a butterfly" (Durán 1971: 187). He further indicates that the warriors and knights of the sun celebrate Nahui Ollin and "the symbol venerated was shown in the form of a butterfly" (Durán 1971: 414). Sahagún's description of the butterfly provides some insight into its association with *ollin,* movement, and the sun. Sahagún says of the butterfly: "It is a flyer, a constant flyer, a flut-terer, a sucker of the different flowers and a sucker of liquid. It trembles, it

Fig. 16 Itzpapalotl, El Corral (drawing by the author after Acosta 1956–57: fig. 21, no. 2).

beats its wings together, it constantly flies. It sucks, it sucks liquid" (Sahagún 1950–71, bk. 11: 94). The characteristics of the butterfly which are repeated are the movement of the butterfly and its constant need for liquid which appear to be paralleled in the sun's ceaseless rising and falling and seemingly insatiable thirst for liquid refreshment.

The butterfly deity associated with sacrifice is Itzpapalotl, Obsidian Butterfly, whose image is found at El Corral (Fig. 16) according to Acosta (1974: 47, fig. 22). Itzpapalotl in some legends was the first war victim and closely associated with human sacrifice in order to feed and nourish the earth and the sun. Furthermore, Itzpapalotl is the patron of the day 1 Vulture. The patrons of the week 1 Vulture are Xolotl and Tlalchitonatiuh or 4 Ollin (Nahui Ollin).

The butterfly pectoral and the striped legs of the atlantids are both associated with sacrifice to the sun and particularly the feast of Nahui

Ollin. Red and yellow clearly predominate in the colors applied to the atlantids and symbolically tie them to the sun, if, as I have suggested, red is the color of the sun at its zenith and yellow the color of the eastern sun at the horizon. Red and white stripes are characteristic of images of the deity Tlahuizcalpantecuhtli, Venus as Morning Star. Several warriors depicted on Pyramid B's piers and some of the reclining warriors wear skirts in the shape of the Venus glyph. At Tula, Venus and Venus warriors seem to play the role of sacrificial victims. Venus as Morning Star daily goes down in defeat before the blinding light of the rising sun. This suggests that the defeated Venus, the worthy adversary of the sun, may have been thought of as a sacrificial victim par excellence.

The application of Sahagún's directional colors (white for south or down, yellow for east, red for north or up, and blue for west), to Tula's polychrome architecture and related sculpture produces some interesting results. The use of three distinct color schemes for a large group of very similar motifs, the reclining figures, suggests that non-naturalistic color does have symbolic significance. Not all sculptures were painted in symbolic colors; the processional scenes, for example, are naturalistically painted. However, the consistent use of red for the backgrounds of these scenes may be a convention, a tradition with no inherent meaning—or it may also be related to the nourishment of the sun through death in warfare or the sacrifice of others.

If the hypothetical color symbolism I have suggested is applied to Pyramid B and its sculpture, we get some unusual results. The pyramid itself is white, which would indicate a reference to the underworld. This is in accordance with traditional interpretations; however, I think that the jaguar-bird-serpent image (Fig. 9) usually identified as Tlahuizcalpantecuhtli, Venus as Morning Star, has as many, if not more, associations with the sun in the underworld. The colors used on the Pyramid B temple sculptures, particularly the atlantids, further suggest that Pyramid B was dedicated to a solar cult in addition to, or perhaps instead of, a Venus cult. Not only the colors but the motifs themselves suggest that Pyramid B was devoted to the cult of Nahui Ollin and more generally to the institution of warfare and human sacrifice.

ACKNOWLEDGMENTS: I would like to acknowledge the support of the Research Council, University of Nebraska at Lincoln (summer 1980), that enabled me to begin my research on Toltec sculpture. I also wish to thank Carmen M. King for her assistance with the photographs used in this article.

BIBLIOGRAPHY

ACOSTA, JORGE R.

1940 Exploraciones en Tula, Hidalgo. *Revista Mexicana de Estudios Antropológicos* 4 (3): 172–194.

1941 Los últimos descubrimientos arqueológicos en Tula, Hgo., 1941. *Revista Mexicana de Estudios Antropológicos* 5 (2–3): 239–248.

1942 La ciudad de Quetzalcoatl, exploraciones arqueológicos en Tula, Hgo. *Cuadernos Americanos,* año 2, 2 (2): 121–131.

1943 Los colosos de Tula. *Cuadernos Americanos,* año 2, 12 (6): 138–146.

1944 La tercera temporada de exploraciones en Tula, Hgo., 1942. *Revista Mexicana de Estudios Antropológicos* 6 (3); 125–164.

1945 La cuarta y quinta temporada de exploraciones en Tula, Hgo., 1943–44. *Revista Mexicana de Estudios Antropológicos* 7 (1–3): 23–64.

1954 Resúmen de las exploraciones arqueológicas en Tula durante las VI, VII, y VIII temporadas, 1946–1950. *Anales del Instituto Nacional de Antropología e Historia,* ép. 6, 8: 37–115.

1956–57 Interpretación de algunos datos obtenidos en Tula relativos a la época tolteca. *Revista Mexicana de Estudios Antropológicos* 14 (2): 75–110.

1957 Resúmen de los informes de las exploraciones arqueológicas en Tula, Hgo. durante las novenas y décimas temporadas. *Anales del Instituto Nacional de Antropología e Historia,* ép. 6, 9: 119–169.

1960 Las exploraciones en Tula, Hidalgo, durante la XI temporada, 1955. *Anales del Instituto Nacional de Antropología e Historia,* ép. 6, 11: 39–72.

1961a La doceava temporada de exploraciones en Tula, Hidalgo, *Anales del Instituto Nacional de Antropología e Historia,* ép. 6, 13: 29–58.

1961b La indumentaria de las cariátides de Tula. In *Homenaje a Pablo Martínez del Río:* 221–229. Instituto Nacional de Antropología e Historia, Mexico.

1964 La decimotercera temporada de exploraciones en Tula, Hgo. *Anales del Instituto Nacional de Antropología e Historia,* ép. 6, 16: 45–76.

1974 La pirámide de El Corral de Tula, Hgo. In Eduardo Matos Moctezuma (coord.) 1974: 27–49.

BAIRD, ELLEN TAYLOR

n. d. The Toltecs as 'Inheritors' of the Teotihuacan Tradition. Paper presented at the 46th Annual Meeting of the Society for American Archaeology, San Diego, 1981.

BROTHERSTON, GORDON

1976 Mesoamerican Description of Space II: Signs for Direction. *Ibero-Amerikanisches Archiv,* n.f., 2 (1): 39–62.

BROTHERSTON, GORDON, and DAWN ADES

1975 Mesoamerican Description of Space I: Myths, Stars and Maps, and Architecture. *Ibero-Amerikanisches,* n.f., 1 (4): 279–305.

BRUNDAGE, BURR C.
 1979 *The Fifth Sun: Aztec Gods, Aztec World.* University of Texas Press, Austin.

CHARNAY, DÉSIRÉ
 1887 *The Ancient Cities of the New World* (J. Gonino and Helen S. Conant, trans.). Harper and Brothers, New York.

COGGINS, CLEMENCY
 1980 The Shape of Time: Some Political Implications of a Four-Part Figure. *American Antiquity* 45: 727–739.

DAVIES, NIGEL
 1977 *The Toltecs.* University of Oklahoma Press, Norman.

Diehl, Richard (ED.)
 1974 *Studies of Ancient Tollan: A Report of the University of Missouri Tula Archaeological Project.* University of Missouri Monographs in Anthropology 1. Columbia, Missouri.

DURAN, DIEGO DE
 1971 *Book of the Gods and Rites and the Ancient Calendar* (Fernando Horcasitas and Doris Heyden, trans. and eds.). University of Oklahoma Press, Norman.

DUTTON, BERTHA P.
 1955 Tula of the Toltecs. *El Palacio* 62 (7–8): 195–251.

KELLEY, DAVID H.
 1955 Quetzalcoatl and His Coyote Origins. *México Antiguo* 8: 397–416.

KLEIN, CECELIA F.
 1975 Post-Classic Mexican Death Imagery as a Sign of Cyclic Completion. In *Death and the Afterlife in Pre-Columbian America* (Elizabeth P. Benson, ed.): 69–85. Dumbarton Oaks, Washington.
 1976a *The Face of the Earth: Frontality in Two-Dimensional Mesoamerican Art.* Garland Publishing, New York.
 1976b The Identity of the Central Deity on the Aztec Calendar Stone. *Art Bulletin* 58: 1–12.
 1980 Who Was Tlaloc? *Journal of Latin American Lore* 6 (2): 155–204.

KUBLER, GEORGE
 1962 *The Art and Architecture of Ancient America.* Penguin Books, Baltimore.

MARTÍNEZ DEL RÍO, PABLO, and JORGE P. ACOSTA
 1957 *Guide to Tula.* Instituto Nacional de Antropología e Historia, Mexico.

MATOS MOCTEZUMA, EDUARDO (COORD.)
 1974 *Proyecto Tula (primera parte).* Colección Científica, Arqueología 15, Instituto Nacional de Antropología e Historia, Mexico.
 1976 *Proyecto Tula (segunda parte).* Colección Científica, Arqueología 33. Instituto Nacional de Antropología e Historia, Mexico.

MOEDANO KOER, HUGO
 1947 El friso de los caciques. *Anales del Instituto Nacional de Antropología e Historia*, ép. 6, 2: 113–136.

MORRIS, EARL H., JEAN CHARLOT, and ANN AXTELL MORRIS
 1931 *The Temple of the Warriors at Chichén Itzá, Yucatán.* 2 vols. Carnegie Institution of Washington, Publication 406. Washington.

NICHOLSON, H. B.
 1968 The Religious-Ritual System of Late Pre-Hispanic Central Mexico. In *Verhandlungen des XXXVIII Internationalen Amerikanistenkongresses* 3: 223–238. Stuttgart-Munich.

PASZTORY, ESTHER
 1974 *The Iconography of the Teotihuacan Tlaloc.* Studies in Pre-Columbian Art and Archaeology 15. Dumbarton Oaks, Washington.
 1978 Artistic Traditions of the Middle Classic Period. In *Middle Classic Mesoamerica* (Esther Pasztory, ed.): 108–142. Columbia University Press, New York.

SAHAGÚN, BERNARDINO DE
 1950–71 *Florentine Codex: General History of the Things of New Spain* (Arthur J. O. Anderson and Charles E. Dibble, eds. and trans.). 12 vols. School of American Research and University of Utah, Santa Fe.
 1981 *Florentine Codex: General History of the Things of New Spain* (Arthur J. O. Anderson and Charles E. Dibble, eds. and trans.). Vol. 3, bk. 2. 2nd ed., rev. School of American Research and University of Utah, Sante Fe.

SELER, EDUARD
 1960–61 *Gesammelte Abhandlungen zur Amerikanischen Sprach- und Altertums-kunde.* 5 vols. Akademische Druck- und Verlagsanstalt, Graz, Austria. (Reprinted from 1902–23 edition).

THOMPSON, J. ERIC S.
 1934 *Sky Bearers, Colors and Directions in Maya and Mexican Religion.* Carnegie Institution of Washington, Publication 436. Washington.
 1942 Representations of Tezcatlipoca at Chichén Itzá. *Carnegie Institution, Notes on Middle American Archaeology and Ethnology* 1 (12): 48–50.
 1943 Representations of Tlalchitonatiuh at Chichén Itzá, and at Baul, Escuintla. *Carnegie Institution, Notes on Middle American Archaeology and Ethnology* 1 (19): 117–121.
 1950 *Maya Hieroglyphic Writing; Introduction.* Carnegie Institution of Washington, Publication 589. Washington.

TOZZER, ALFRED M.
 1957 *Chichén Itzá and Its Cenote of Sacrifice; A Comparative Study of Contemporaneous Maya and Toltec.* Memoirs of the Peabody Museum of American Archaeology and Ethnology 11, 12. Harvard University, Cambridge.

Ellen Taylor Baird

VAILLANT, GEORGE (ED.)

1940 *A Sacred Almanac of the Aztecs* (*Tonalamatl of the Codex Borbonicus*).
American Museum of Natural History, New York.

144

Polychrome on Aztec Sculpture

H. B. NICHOLSON

UNIVERSITY OF CALIFORNIA AT LOS ANGELES

Although the University of California at Los Angeles Aztec Archive Project (Nicholson 1980) is still in its early stages, it probably comprises the largest collection of black-and-white photographs, drawings, and color slides of Aztec-style sculptures yet compiled. Based on this extensive corpus and personal inspection of hundreds of original pieces in public and private collections, it is clear that the majority of Aztec stone sculptures were originally polychromed. This is congruent with the great importance of polychromy in Aztec art in general, particularly in the multicolored images of the ritual-divinatory pictorials.[1]

Symbolic color connotations undoubtedly represent a very ancient feature of Mesoamerican religious ideology, but it was during the Postclassic, with the emergence of the Mixteca-Puebla stylistic-iconographic tradition (Nicholson 1981, 1982), that color appears to have most clearly come into its own as a major aspect of the iconography. From a broad perspective, the late Pre-Hispanic Central Mexican or "Aztec" stylistic-iconographic tradition (Nicholson 1973) belongs within a "greater Mixteca-Puebla universe" and consequently displays in characteristic fashion its intense preoccupation with color symbolism. Certain colors were assigned in a structured system especially to cosmogonical and cosmological imagery, ritual buildings and paraphernalia, calendric symbolism, and deity costume and insignia.

As has been long recognized, one of the most prominent employments of color symbolism in Pre-Hispanic Mesoamerica was the assignment of certain colors to the cardinal directions—and sometimes to the center. There seems to have been a considerable amount of variation in these directional color associations (Thompson 1934: 211–221; Soustelle 1959:

[1] I would like to thank Eloise Quiñones Keber for her constructive criticism of a preliminary version of this paper.

79–80; Nowotny 1970: 153–185; Nicholson 1971b: table 1, 404–405). The system that prevailed in the Maya region, which went back at least to the Classic (Kelley and Berlin 1961), was particularly standardized: east = red; north = white; west = black; south = yellow. Green may have been associated with the center (Thompson 1934: 220).

Judging from the diversity of color-directional schemes in both native tradition pictorial and early Colonial textual sources, Western Mesoamerica was less standardized. In late Pre-Hispanic Central Mexico four colors clearly stand out as preeminent: red, yellow, white, and blue-green. In the Anales de Cuauhtitlan, a passage describing the migratory period of the Chichimec ancestors of the people of Cuauhtitlan gives the directional color assignments as: east = blue-green; north = white; west = yellow; south = red (Lehmann 1974: 49, 65). It is interesting that this same order seems to be followed by the ritual impersonators on Codex Borbonicus 30–31 (1974) (Ochpaniztli-Teotleco [Pachtontli]). On the other hand, the colors assigned to the four Tlaloque on the Tizapan stone box (Caso 1932) rotate in a different order (blue-green, red, white, yellow), as do, in a different fashion, those specified by Sahagún (1950–82, bk. 11: 166) for Topiltzin Quetzalcoatl's four houses in Tollan (east = yellow; north = red; west = blue-green; south = white). When sets of five colors are mentioned, the fifth is usually black, which may have been assigned, in some schemes at least, to the center (Thompson 1934: 220–221, citing primary sources).

In spite of the evident regional and temporal variations, directional chromatic symbolism, which is virtually global in its overall distribution (Nowotny 1970), represents perhaps the most tightly structured example of the employment of color to express religious-ritualistic ideological concepts in Pre-Hispanic Mesoamerica.

Color was also highly important in relation to the costume and insignia of deities, and this aspect is most relevant to the surviving sculptures, since so many clearly represent them. Certain deities characteristically displayed a consistent overall body and facial color. In the Aztec subtradition of the broader Mixteca-Puebla stylistic-iconographic tradition, examples worth mentioning include (utilizing their most common Nahuatl names): black on Tezcatlipoca and Tlaloc in their principal aspects, Quetzalcoatl, Mictlantecuhtli, and the *octli* gods (rarely, bicolored black-red); red on Xipe Totec, Xiuhtecuhtli (or yellow), Tonatiuh, Xochipilli-Macuilxochitl, and Centeotl; yellow on Xiuhtecuhtli (alternatively, red) and most of the fertility goddesses; blue on Huitzilopochtli; white on Otontecuhtli, Tlahuizcalpantecuhtli, and Mixcoatl (the latter two often with red stripes). The facial area was sometimes decorated in multicolored formats of some complexity

(Nicholson 1973: 84–85) and constituted an important focus of iconographic distinctiveness. Ornaments and costume elements, especially headdresses, ear and nose plugs, necklaces, pectorals, bracelets, armlets, anklets, and sandals, were usually colored in fairly standard ways, often related to the original material. For example, blue-green was used for jade and turquoise and appropriate feathers (especially those of the quetzal), yellow for gold, white for shell, red for leather, etc. Clothing and accompanying insignia were frequently colored in a manner appropriate to the conceptual connotations of the deity (e.g., red-white for Xipe Totec, white for Mictlantecuhtli, blue for Chalchiuhtlicue, etc.).

Some attempts have been made to analyze and interpret the broader ideological connotations of color in late Pre-Hispanic Central Mexico (e.g., Beyer 1965: 471–487; Soustelle 1959: 80–84). Certain associations seem reasonably obvious and "natural," such as black with night and darkness and the sub-terrestrial realm, blue with the diurnal celestial sphere and aquatic phenomena, green with vegetation and preciousness in general, red with sacrificial blood, and red and yellow in combination with fire and solar heat. However, more subtle and complex connotations were probably also involved and are in need of additional research.

In approaching problems of this kind it must always be kept in mind that the late Pre-Hispanic Central Mexican religious-ritual-iconographic system was the inheritor of numerous earlier patterns and traditions, perhaps in some cases stretching back many centuries to Olmec times or even before. It is likely that some color connotations and associations had simply become traditional, and even the most knowledgeable Contact period priest might have found it difficult to have satisfactorily explained their original significance. The history of indigenous Mesoamerican religion, which must be based largely on the accidents of archaeological preservation, is still poorly known and full of gaps. If and when a fuller reconstruction of the evolution of Mesoamerican religious concepts and their accompanying iconographies can be achieved, a more satisfactory understanding of the role of color in the overall system can hopefully also be attained.

So much for general background. How much polychromy has survived on Aztec-style sculptures and how successfully can it be interpreted? On the majority of pieces, including often the most important ones, very little traces of color actually remain. However, a sufficient number of sculptures with considerable original color have survived so that we can derive some notion of the polychrome formats most favored and of the techniques of application that were employed.

Although most sculptures appear to have been painted, there are some,

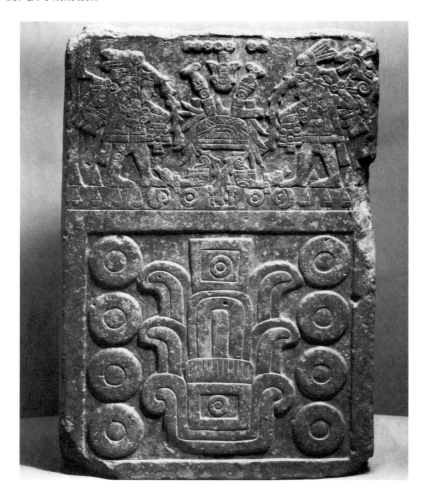

Fig. 1 The Dedication Stone of the Templo Mayor of Mexico Tenochtitlan, 1487. Museo Nacional de Antropología, Mexico. Photograph by José Naranjo, courtesy of the National Gallery of Art.

carved from very hard stones that take a high polish, to which colors were apparently never applied. Two well-known examples are the Dedication Stone of the Templo Mayor of Mexico Tenochtitlan (Fig. 1) (e.g., Bernal 1975: 79; Caso and Mateos Higuera n.d.: 1, *roca de contacto*) and the colossal head of Coyolxauhqui-Chantico (Fig. 2) (e.g., Bernal 1975: 71; Caso and Mateos Higuera n.d.: 43, *porfirita o andesita de augita con carbonatos*), both highly polished greenstones without traces of added color. On the

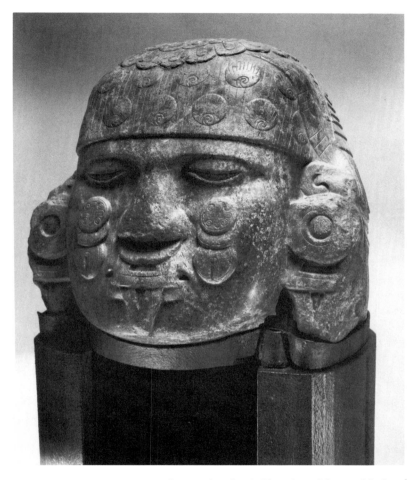

Fig. 2 The colossal head of Coyolxauhqui-Chantico. Museo Nacional de Antropología, Mexico. Photograph by José Naranjo, courtesy of the National Gallery of Art.

other hand, the giant Cuauhxicalli of Tizoc (Fig. 3) (e.g., Bernal 1975: 73), classified mineralogically as *andesita de hiperstena* (Caso and Mateos Higuera n.d.: 43) and which is also highly polished, does exhibit slight traces of applied color (red) on gesso.

The most common colors on the pieces that still exhibit some traces of polychromy are, interestingly, precisely those hues that were most commonly associated with the cardinal points: red, yellow, blue-green, white,

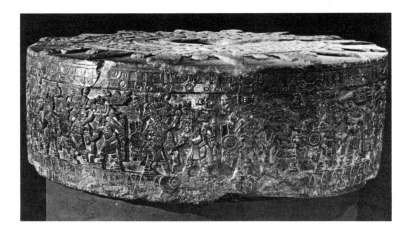

Fig. 3 The Cuauhxicalli of Tizoc. Museo Nacional de Antropología, Mexico (after Townsend 1979: fig. 19).

and black. The overall late Pre-Hispanic palette was obviously much more extensive than this, and a rich vocabulary of color was a prominent feature of the Nahuatl language. Our most important source, besides Fray Alonso de Molina's basic Nahuatl-Spanish dictionary of 1571 (Molina 1970), is Fray Bernardino de Sahagún's *Historia universal de las cosas de Nueva España* (1569–80), especially book 10, chapter 21, describing the activities of the color vendors, the *chiquippantlacatl,* and book 11, chapter 11, which consists of a catalogue of the colors themselves (Sahagún 1979, bk. 10: 55r–57r, bk. 11: 216r–222v).

In two useful articles, Anderson (1948, 1963) has translated and discussed Nahuatl color terminology, based primarily on these two Sahagúntine chapters. As he states (Anderson 1948: 20), book 11, chapter 11,

> which enumerates the colors used by the *tlacuilo* (scribe and artist), as well as by the dyer and designer of fabrics, the potter and others who used colors, gives the impression that the colorist was well versed in the knowledge of materials, their preparation, and their application.

In his later article, he summarizes this same chapter thus:

> El catálogo de colores, tal como aparece en el capítulo XI, es bastante interesante. Se divide en cuatro secciones, de los cuales la primera se dedica mayormente a los colores sacados de varias plantas; la segunda, categoría no muy bien determinada, se ded-

ica a pigmentos algunos de los cuales requieren alguna refinación; la tercera, mayormente a sustancias minerales; y la cuarta, a los resultados de la mezcla de colores. Las informaciones contenidas en este capítulo se comprueban y a veces se amplian comparándoles con las observaciones del protomédico Francisco Hernández y con otros estudios modernos. (Anderson 1963: 75)

He then goes on to discuss in detail the color terms included by Sahagún in this chapter, attempting to identify them mineralogically and botanically.

It seems likely that the pigments used in the native tradition pictorials painted on skin, bark paper, and cloth and those employed to decorate the sculptures were essentially the same. Two significant pigmental analyses of the colors used in a Pre-Hispanic Mixteca pictorial, Codex Colombino-Becker I, have been published (Nowotny and Strebinger 1959: 225–226 [reprinted in Nowotny 1964: 18]; Torres 1966: 91–99). Durand-Forest (1974: 30) has also analyzed the colors of the Central Mexican Codex Borbonicus, keying them to the Ostwald color classification. From the technical microanalyses of Strebinger and Torres, it appears that most of the colors employed in the Codex Colombino-Becker I, which were probably typical of the late Pre-Hispanic *tlacuilo's* palette in general, were of mixed mineral and vegetal origin. Durand-Forest's analysis of the colors in the Codex Borbonicus demonstrates that their variety and range were significantly greater than those in the Mixteca pictorial. However, no pigmental microanalysis of the colors of this Central Mexican screenfold was undertaken.

Turning now to the sculptures, in 1913, during the excavation of the southwest corner of the later stages of the Templo Mayor of Mexico Tenochtitlan by the Inspección General de Monumentos Arqueológicos of the Dirección de Antropología, directed by Manuel Gamio, a number of polychromed *tezontle* (porous volcanic stone) slabs were discovered (Fig. 4). They were first partially illustrated and analyzed by Hermann Beyer in an article written in 1917 and posthumously published in 1955. They formed part of a polychromed banquette sculptured frieze of a type that featured files of richly attired warriors, a frieze type that apparently appeared first at Tula and Chichen Itza (Moedano Koer 1947; Salazar Ortegón 1955). Much of the original coloration of this frieze was preserved, and it was one of the first polychromed Aztec sculptures to be seriously discussed in terms of pigments and techniques of application.

The frieze consisted of fifty-two quadrangular *tezontle* slabs, averaging sixty centimeters in height, and as many narrower cornice pieces. These were fitted together to form the vertical face and slightly projecting cor-

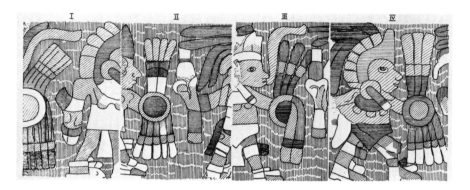

Fig. 4 Processional frieze of warriors in the Templo Mayor of Tenochtitlan dis-
covered in 1913 (after Beyer 1955: fig. E, lower left).

nice of a low bench whose sculptured frieze featured a procession of over
fifty representations of fully accoutered warriors, with undulating serpents
on the cornice. They were discovered laid down in a horizontal position
and thus reused in later construction fill. Twenty of the slabs and nine of
the cornice pieces—presently reassembled and displayed in the Sala Mexica
of the Museo Nacional de Antropología—were extracted, the rest left *in
situ*. Those that were removed were studied by Beyer, including their
coloration. Drawings of six of the figures, with hatchings to indicate the
colors, were published in the article, plus one of the cornice serpents (Fig.
4).

According to Beyer, only five colors were employed: white, yellow,
red, blue-green, and, sporadically, black. The white (*tizatlalli*) was utilized
primarily as a kind of whitewash, with two purposes: to fill in and smooth
the porosities of this rough volcanic stone and to intensify the clarity of
the colors applied to it. The yellow (*tecozahuitl*) he identified as yellow
ochre. The red (*tlachichilli*) he identified as red ochre and commented that
this pigment was used, in addition to coloring various costume elements,
as a general background on all of the slabs. Blue (*texotli*) only survived in
scant traces in the deeper hollows of the stone. It is actually a blue-green
which Beyer compared to the color of turquoise, and he noted that it was
used to decorate both blue (e.g., turquoise mosaic) and green (e.g., quetzal
feathers) features. He concluded by emphasizing that yellow, red, and blue
very much predominated in the coloration of this frieze, since the white
had nearly disappeared and the black, observed on only a few slabs, was
used just to accentuate lines.

A few isolated polychromed slabs from other similar friezes were dis-

covered in the same general area before the 1913 Gamio excavation and were known to Beyer (e.g., Seler 1902–23, 2: 891, abb. 96, 97); he believed them to belong to the Gamio frieze (Beyer 1955: 9–10). However, it was not until late in 1981, during the final stages of the Instituto Nacional de Antropología e Historia's Proyecto Templo Mayor, directed by Eduardo Matos Moctezuma, that various of these polychromed banquette friezes, edging two connecting rooms, were discovered *in situ* in the eastern portion of and below the "Platform of the Eagles," located to the north of the Templo Mayor structure proper (Matos Moctezuma 1982: 61–70, Rangel Plan of December 1981; Saunders 1982: 12, 14; Bouton 1982: 78, 81). This structure belongs to Matos Moctezuma's Stage VI, which he suggests might correspond to the reign of Ahuitzotl (1486–1502); in any case, at the time of the Conquest it was apparently completely covered by the final great platform of the temple, his Stage VII (Matos Moctezuma 1981: 37–50). Although these friezes have not been adequately published or studied to my knowledge at the time of writing, based on my personal inspection of the portions of them visible on two visits in 1982 and 1983, they are basically very similar to the frieze studied by Beyer and exhibit fundamentally the same coloration. One hopes a microanalysis of the pigments will be undertaken by the Proyecto Templo Mayor team.

Although long available to students in manuscript in the Archivo Técnico of the Instituto Nacional de Antropología e Historia (I was able to consult it first in 1946), Beyer's useful study of the Templo Mayor carved frieze was not published until 1955 and consequently did not really figure in the literature of the subject until that date. Much earlier, in 1935, two significant articles that included analyses of the polychrome on Aztec-period stone sculptures did appear. These were the articles of Miguel Angel Fernández on the painting, and of Moisés Herrera on the large number of colossal serpents edging the south, east, and west sides of the Pyramid of Tenayuca which were uncovered during the Dirección de Arqueología's excavation and restoration project of 1925–1930 (Fig. 5) (Fernández 1935; Herrera 1935). Fernández was a trained artist, perhaps best known for his later studies of the wall paintings at the Postclassic site of Tulum on the east coast of Yucatan; his study is especially interesting. He noted that all of the bodies (a mixture of mortar and small stones) and heads (solid stone) of the colossal snakes were painted with up to five layers of pigment on stucco. He examined in detail three examples on the east side (nos. 8, 46, 47), including as illustrations to his article color paintings (láms. II, IV, VI) of portions of all three as they appeared to him, plus color reconstructions of Serpent 8 (Fig. 5) and part of the body of Serpent 46 (lám. V). He observed that the painters sometimes trickled

paint while brushing it on, indicating to him that the paint was quite fluid and that it was applied to moist stucco, i.e., they employed the *al fresco* technique.

He identified five colors: black, *rojo indio,* cerulean blue, ochre, and white. He undertook no detailed pigmental analysis, but suggested that the black was the so-called *negro de humo o negro de hueso,* leaving as background the natural color of the stucco that was clear ochre in tone, the result of mixing the lime not with sand but with ground-up *tepetate* which provided the reddish color. In his reconstruction, all of the serpents of the south side and part of the east were painted blue, while the rest of the east and all of the north side serpents were painted black. He also examined the wall paintings (essentially skulls and crossed bones) of the hollow platform "altar" abutting the southwest corner of the pyramidal substructure— which Caso (1940) later identified as a ritual tomb for the interment of a representation of the 52-year cycle—but that does not concern us here since it does not involve sculpture.

Herrera was particularly preoccupied with attempting to identify the actual ophidian models for the Tenayuca serpents, but he also discussed their coloration. He stressed the ubiquity of red and blue, suggesting that this indicated that they were intended to represent the *xiuhcoatl,* the "fire serpent." He agreed with Fernández that the colors were applied more than once to successive stucco layers, employing the *al fresco* technique. He singled out four colors as most prominent: cobalt blue, emerald green, *rojo indio,* and black, with slight traces of ochre. He described the colors of three examples (east: Serpent 15; south: Serpents 10 and 13) in some detail. He also illustrated, in schematic charts, the superpositions of colors on three specimens (south: Serpents 2 and 10; east: Serpent 8). He included color paintings (láms. I–IV) of the present state of the coloration on five examples—south: snake abutting the wall of the first stage of the pyramidal substructure, Serpent 39; east: Serpents 8 and 9; north: Serpent 27. These two articles together constituted an important pioneer contribution to a better understanding of the topic of this paper.

Recently, a more significant pigmental analysis of the colors applied to late Aztec sculptures was published in Vega Sosa's symposium volume on the excavations undertaken during the Mexico City subway project of 1968–69 in the western portion of the ceremonial precinct of the Templo Mayor of Mexico Tenochtitlan, and those in 1975–76 under the Catedral Metropolitano and the adjacent Sagrario (Huerta Carrillo 1979: 87–94). Huerta Carrillo determined that only four colors—white, black, red, and blue-green—had been applied to three sculptured stone plaques on which were carved the symbol for *chalchihuitl* (jade or precious greenstone) set

Fig. 5 Serpent 8 of the east *coatepantli* at Tenayuca (after Fernández 1935: lám. 3).

into the north and west *taluds* of the Templo del Sol or Structure A, directly under the Sagrario (Vega Sosa 1979). The white was used as a general base color and for some details and was analyzed as calcium carbonate. The black was a carbon and/or (mixed with) black earth. The red was red ochre. The blue-green was the famous "Maya blue," which Huerta Carrillo, citing the well-known research of Gettens and others, accepts as composed of a mixture of indigo (anil) and a special clay (*attapulgita*).

Huerta Carrillo also analyzed the techniques employed in the application of the colors to these *chalchihuitl* symbols. Microscopic examination of sample cuts revealed that both *al fresco* and *al temple* (or *seco*) techniques had been used. He described the first technique thus:

> En la técnica al FRESCO los pigmentos se penetran en la base blanca, observándose claramente la fusión entre ambos. Esta penetración se debe a que los pigmentos se aplican, mezclados con agua, sobre la base húmeda.

With regard to the second technique, he stated:

> Cuando se trata de TEMPLE, la capa de pigmentos está depositada en la superficie de la base blanca y en algunas fisuras de la misma. En esta técnica los pigmentos se aplican con un aglutinante sobre la base seca y no hay difusión de la partículas de pigmento hacia el interior de la base; el fisurado de esta nos indica que los pigmentos se aplicaron cuando ya estaba seca. (Huerta Carrillo 1979: 90)

As indicated above, most surviving Aztec-style stone sculptures bear few traces of their original coloring. However, there are some significant exceptions. The most famous Aztec sculptured monument is the intricate relief carving of the solar disk known as the "Calendar Stone" or "Piedra del Sol," discovered in the Zocalo of Mexico City in 1790 and now the centerpiece of the Sala Mexica of the Museo Nacional de Antropología (Pl. 10). A few traces of polychromed gesso remain on the stone. Primarily on the basis of these remnants, the Abadiano brothers, who made various casts of the monument and discovered these traces in their molds, proposed a color reconstruction of the stone that was published in 1916 on the cover of a Mexican periodical, *Acción Mundial* (vol. 1, no. 1). Hermann Beyer, who in 1921 published the up-to-that-time most thorough and successful iconographic interpretation of the monument, briefly and critically commented on the Abadiano reconstruction (Beyer 1921: 16). He did not attempt any comprehensive reconstruction of his own apart from a line drawing of the central face, with colors—derived from relevant depictions in the native tradition pictorials—indicated by different hatchings (Beyer 1921: fig. 36).

In 1939 Roberto Sieck Flandes presented to the 27th International Congress of Americanists in Mexico City the most conscientious attempt to reconstruct fully the original coloring of the "Calendar Stone." His color plate (Pl. 10) and accompanying discussion were published in 1942, in volume one of the proceedings of the congress. Enlarged, "popular" versions of his color plate (copyrighted in 1936), accompanied by a brief explanatory text, have been sold in book and souvenir stores in Mexico for many years. Sieck Flandes's sources were the traces of color remaining on the stone, polychromed ceramic vessels in the Museo Nacional de Antropología, and relevant representations in the Codices Borbonicus, Telleriano-Remensis, Magliabechiano, Mendoza, Matrícula de Tributos, Borgia, Laud, Zouche-Nuttall, and Vindobonensis. Although one might quibble with a few details, it can be said that the original coloration of the monument quite likely did closely approximate his reconstruction. Certainly, when its colors were still intact, this magnificently carved stone, "unquestionably one of the most successful examples of intricate concentric patterning in the history of art" (Nicholson 1971a: 132), was much more spectacular than its drab gray appearance would suggest today—and its symbolic connotations were conveyed far more effectively.[2]

The "Calendar Stone" is the most renowned example of an intricate,

[2]The color painting of this monument by Felipe Dávalos, included as an illustration in Molina Montes 1980: facing p. 759, follows the Sieck Flandes reconstruction, although the colors are somewhat muted.

Fig. 6 The "Teocalli de la Guerra Sagrada." Museo Nacional de Antropología, Mexico (after Townsend 1979: fig. 22a).

late Aztec-style relief sculpture that originally had a variegated poly-chromed format with important symbolic significance. Another well-known example is the "Teocalli de la Guerra Sagrada" (Fig. 6), first dis-covered in 1831 embedded in the foundations at the southern edge of the Palacio Nacional, which borders the east side of the Zocalo of Mexico City. Rediscovered in 1926 during alteration of the palace foundations to carry an additional third story, it has been on display in the Museo Na-cional de Antropología since that year. Caso, who in 1927 published the most detailed and adequate iconographic analysis of this monument, ex-pressed his opinion that it had been "probablemente policromada, pero no

Fig. 7 "Standard-bearers" leaning against the steps of Stage III of the Templo Mayor. Photograph by Salvador Guil'liem, courtesy of the Instituto Nacional de Antropología e Historia, Mexico.

quedan restos de los colores que tuvieron las figuras, si se exceptúa un tono rojo que cubre todavía algunas partes del relieve." He believed that this *capa roja* constituted "más bien el fondo, y sobre ella se extendía la capa de mezcla blanca sobre la que se pintaban después los diversos colores." He compared this technique with that observable on the Gamio Templo Mayor banquette frieze studied earlier by Beyer and discussed above (Caso 1927: 11–12).

The 1978–82 Proyecto Templo Mayor, mentioned above, was a landmark in the history of "Aztec archaeology." Never before had so many important pieces of sculpture been uncovered under controlled conditions, some of them, such as the colossal Coyolxauhqui-Chantico monument (Aguilera 1978; Nicholson n.d.), unmoved from their original locations. Many of these display considerable surviving polychromy, the most spectacular example being the "Chacmool" image (Pl. 11) fronting the doorway to the Tlaloc shrine of Stage II in the Matos Moctezuma scheme (Matos Moctezuma 1981: 19–23, foto 3; Bonifaz Nuño and Robles 1981:

pl. 42). This stage can possibly be dated to 1390 on the basis of a relief carving on the top step leading to the Huitzilopochtli shrine that could represent the year 2 Tochtli (Matos Moctezuma 1981: 19, foto 2).

A detailed account of the restoration of this remarkable sculpture, by María Luisa Franco (1982: 319–322), reveals interesting details concerning its well-preserved polychromy. The stone is identified mineralogically as "un toba vítrea de composición andesítica de origen volcánico-extrusivo." The preserved colors are identified as blue, red, black, and ochre. The last two, of mineral origin, could be cleaned while the encasing mud was still moist, while the blue and black pigments could only be cleaned after the mud had dried. Apparently the colors were applied directly to the stone in some areas; in others (headdress, bracelets, and loincloth), they were painted on a layer of stucco.

A striking group of sculptures bearing considerable color was discovered leaning against the steps of the structure Matos Moctezuma has designated Stage III (Fig. 7). They were apparently deposited ritually at the time of the subsequent enlargement, eight on the Huitzilopochtli side and one on the Tlaloc side. All nine have been published and described in Hernández Pons 1982, and color photographs of three (B, G, J) have appeared in *El Templo Mayor de México* (1982: 72–74). They are decorated in the standard colors—white, black, blue, red, and orange—on gesso, which, as in the case of the Chacmool, are unusually well preserved. All but two (A, D) display perforations in one hand that indicate they may have originally held something; these have, accordingly, been designated *portaestandartes*. As Hernández Pons (1982: 227–229) recognized, they often in their insignia and color schemes (particularly Figure J whose body is painted half red and half black) exhibit close iconographic connections with the *octli* (pulque) deities.

Another large group of sculptures found in offertory caches during the Proyecto Templo Mayor, that display considerable traces of their original coloration, consists of seated male figures whose most characteristic diagnostic is two "horns" on the head (e.g., *El Templo Mayor de México* 1982: 17, 19–20, 36). In the most realistic examples (Fig. 8) (e.g., Ahuja O. 1982: 203; Anders, Pfister-Burkhalter, and Feest 1967: tafel 42) these "horns" are seen to be two mounds or thick locks of hair, drawn through two tortoise carapaces. This feature appears to support an identification with Tepeyollotl rather than, as is more usual, Xiuhtecuhtli (Nicholson 1983). The polychromy that has survived on certain of the Templo Mayor examples, particularly the coloring of the lower face (a red area around the mouth flanked by dark-colored zones), also points in this direction. The example found in 1970 in an offertory cache in the second (L-3) of the superpositions of the *adoratorio* of the Pino Suarez Metro station (Gussi-

Fig. 8 Probable Tepeyollotl figure. Museum für Völkerkunde, Basel. Photograph by José Naranjo, courtesy of the National Gallery of Art.

nyer 1970; Heyden 1970) displays a remarkable amount of its original coloration, more than any other example (Fig. 9). Again, in my view, its scheme of polychromy supports the Tepeyollotl identification.

One of the most strikingly polychromed Templo Mayor cache figures (Pl. 12), found in Ofrenda 6, is quite similar to those I have suggested can best be identified as Tepeyollotl; however the figure wears a different headdress, the peaked crown of the lords (*xiuhuitzolli*), and the lunar nasal

Fig. 9 Polychrome probable Tepeyollotl image from the Pino Suarez metro station excavations. Museo Nacional de Antropología, Mexico. Photograph by José Naranjo, courtesy of the National Gallery of Art.

ornament (*yacametztli*) (*El Templo Mayor de México* 1982: 18; Bonifaz Nuño and Robles 1981: 91). The latter attribute is typical of the *octli* deities. This identification is supported by the coloration of the face, a central red zone flanked by dark areas that, together with the dark body paint, constitutes one of the most diagnostic features of the iconography of the deities in this group (discussion in Seler 1900–01: 87–89).

Fig. 10 Relief of Coyolxauhqui-Chantico, Templo Mayor of Mexico Tenochtitlan (after Bonifaz Nuño 1981: 17).

Various examples of architectural sculpture were encountered *in situ* during the Proyecto Templo Mayor. The most famous example, of course, is the great Coyolxauhqui-Chantico monument (Fig. 10), whose chance discovery in 1978 sparked it all. This complex, deep relief was probably fully polychromed, and some traces of color—red, yellow, and white—remain (García Cook and Arana A. 1978: 33). Carmen Aguilera, who in 1978 published a detailed iconographic analysis of the monument, has advanced a hypothesis of its complete original coloration based on

various primary sources, especially relevant representations in the native tradition pictorials. She outlined her reconstruction, illustrated with a color slide, following my presentation of this paper during the conference. An article, which will contain all of the supporting evidence for her chromatic reconstruction, is in press. She has kindly supplied me with a copy of her color slide. For the most part, her reconstruction appears cogent and reasonable, comparing favorably with that of Sieck Flandes for the "Calendar Stone," and adds significantly to an improved knowledge of the probable original appearance of this extraordinary sculpture.

Various colossal serpent heads decorating the Templo Mayor substructure and its platforms were found during the project. Two had been found earlier: the feathered serpent head, uncovered by Gamio in 1913, that projects from the south balustrade of the stairway leading up to the Huitzilopochtli shrine (Matos Moctezuma's Stage IV; e.g., Bonifaz Nuño and Robles 1981: 38), and a plainer head, flanked by hourglass braziers decorated with giant knots, that projects from the south base of the substructure and that apparently dates from the same construction epoch, found by Moedano Koer and Estrada Balmori in 1948 (Matos Moctezuma 1981: 31). Neither exhibited much trace of color, but some of those discovered between 1978 and 1982 retained considerable polychromy, mainly red and white. These included the feathered serpent head projecting from the north balustrade of the Huitzilopochtli shrine stairway of Matos Moctezuma's Stage IV; the two stylistically quite different snake heads projecting from the balustrades of the northern, Tlaloc shrine stairway of the same stage; the heads of the colossal sinuous snakes adorning the western edge of the platform fronting the temple (Matos Moctezuma's Stage IVB); a similar head, by itself, at the edge of the same platform on the axis where the two stairways join; and the serpent head, paralleling in position and style that found by Moedano Koer and Estrada Balmori on the south side, that projects from the base of the northern portion (i.e., the Tlaloc side) of the eastern edge of the temple and that is also flanked by hourglass-shaped braziers, in these cases decorated with figures of Tlaloc, both of which retained considerable color: red, white,, blue, and black (Matos Moctezuma 1981: 30–35; Bonifaz Nuño and Robles 1981: 37, 64, 68). Many detached sculptures, some of which display various amounts of surviving polychromy, were found during the project outside of the caches. Above all, there were a large number of heads of Tlaloc, the majority encountered in Colonial fill in the eastern portion of the site area, painted mainly in blue, red, white, and black (e.g., *El Templo Mayor de México* 1982: 7, 8; Contreras S. and Pilar Luna E. 1982).

Another famous Aztec polychromed monument that once might have been located within the ceremonial precinct of the Templo Mayor deserves

some mention. Strangely, it could be termed "the monument that never was," or perhaps more apt would be "the monument that might never be." This is the "Piedra Pintada" or "Piedra del Sacrificio Gladiatorio," supposedly still buried somewhere in Mexico City's Plaza de la Constitucion, the Zocalo. Brantz Mayer, secretary to the United States Legation in 1841–42, is our only source for the circumstances of its discovery (Mayer 1844: 123–124):

> When the square was undergoing repairs, some years past, this monument was discovered a short distance beneath the surface. Mr. Gondra [director of the Museo Nacional de México] endeavored to have it removed, but the Government refused to incur the expense; and its dimensions, as he tells me, being exactly those of the Sacrificial Stone (viz. nine feet by three,) he declined undertaking it on his own account. Yet, anxious to preserve, if possible, some record of the carving with which it was covered (especially as that carving was painted with yellow, red, green, crimson, and black, and the colors still quite vivid,) he had a drawing made, of which the sketch in this work is a fac-simile.

The "fac-simile" published by Mayer was actually a drawing of the central portion of Fonds Mexicain 20, a Pre-Hispanic Mixteca ritual-divinatory skin sheet collected between 1736 and 1743 by Lorenzo Boturini and now in the Bibliothèque Nationale, Paris (full bibliography in Glass and Robertson 1975: 90–91). Mayer was supplied by Gondra with a full copy of this sheet, in color, probably derived from a copy that still belongs to the collection of the Museo Nacional de Antropología (35-12; Glass 1964: 51–52). Gondra also supplied V. García Torres, editor of a Spanish translation of William H. Prescott's *History of the Conquest of Mexico,* published in the same year as Mayer's book, with another copy of the sheet that was included, in full, as an illustration in volume one (p. 85), with the caption, "Relieves en la Piedra de los Gladiadores." This caption reflected the idea of Gondra, discussed critically by Mayer, that the monument had been a gladiatorial stone (*temalacatl*).

Exactly how the confusion arose between the copy of Fonds Mexicain 20 and the polychromed reliefs alleged to be on the Zocalo monument is unclear. Lehmann (1905: 851) attributed it to "ein Misverständnis oder eine Mystifikation" of Gondra, while Caso (1969: 35) inclined to the view that the confusion was more likely due to a misunderstanding of Mayer. According to Orozco y Berra (1880, 3: 348-note 3), in 1877 Vicente Riva Palacio, then Ministro de Fomento, ordered various excavations in the Zocalo in a futile attempt to relocate the monument—which Chavero

(1888: 788) believed was "enterrada frente á la puerta norte de Palacio." Caso (1969) believed he could accurately calculate the location of the "Piedra Pintada," which he suggested was discovered in 1803 during the erection of a cross marking the southeast corner of the cathedral cemetery. However, his view seems dubious since Mayer strongly implied that it was uncovered while Gondra was director of the National Museum (1834–52). Much work has been done in and around the Zocalo in the intervening years, but the monument has never appeared. From Mayer's description, it sounds as if it might have been another colossal *cuauhxicalli* similar to that of Tizoc, discovered in 1791—and various primary sources indicate that other *tlatoque* of Mexico Tenochtitlan, before and after Tizoc (1481–86), ordered the carving of these great monuments. If the "Piedra Pintada" really exists and if it is ever found, it certainly would rank as a major archaeological event and should add significantly to our knowledge of Aztec polychromy.

Many more Aztec-style sculptures retain significant amounts of polychromy, often of key iconographic relevance, and all deserve further analysis. More pigmental microanalysis is also needed. This summary article is intended only to introduce a research topic that has so far not received attention commensurate with its significance. One of the principal objectives of the Aztec Archive Project is to compile a somewhat larger sample of pieces that display polychromy than has hitherto been available. One hopes this section of the archive should eventually facilitate an improved understanding of this important aspect of the great religious art of late Pre-Hispanic Central Mexico.

BIBLIOGRAPHY

AGUILERA, CARMEN
 1978 *Coyolxauhqui: ensayo iconográfico.* Biblioteca Nacional de Antropología
 e Historia, Instituto Nacional de Antropología, Cuadernos de la Bi-
 blioteca, Serie Investigación 2. Mexico.
 n.d. La policromía del Coyolxauhqui. *Estudios de Cultura Náhuatl.* (In
 press.)

AHUJA O., GUILLERMO
 1982 Excavación de la Cámara II. In *El Templo Mayor: excavaciones y estu-
 dios* (Eduardo Matos Moctezuma, coord.): 191–212. Instituto Na-
 cional de Antropología e Historia, Mexico.

ANDERS, FERDINAND, MARGARETE PFISTER-BURKHALTER, and CHRISTIAN F. FEEST
 1967 *Lukas Vischer (1780–1840), Kunstler-Reisender-Sammler: Ein Beitrag zur
 Ethnographie der Vereinigten Staaten von Amerika so wie zur Archäologie und
 Völkskunde Mexikos.* Völkerkundlich Abhandlungen 2. Kommissions-
 verlag Münstermann-Druck, Hanover.

ANDERSON, ARTHUR J. O.
 1948 Pre-Hispanic Aztec Colorists. *El Palacio* 55: 20–27.
 1963 Materiales colorantes prehispánicos. *Estudios de Cultura Náhuatl* 4: 73–
 83.

BERNAL, IGNACIO
 1975 *Museo Nacional de Antropología: Arqueología.* 3rd ed. rev. M. Aguilar,
 Mexico.

BEYER, HERMANN
 1921 *El llamado "Calendario Aztec": descripción e interpretación del cuauhxicalli
 de la "Casa de las Aguilas."* Verband Deutscher Reichsangehöriger,
 Mexico.
 1955 La "Procesión de los señores," decoración del primer teocalli de
 piedra en México-Tenochtitlan. Introducción de Ponciano Salazar
 Ortegón. Notas de Rafael Orellana Tapia. *El México Antiguo* 8: 1–42.
 1965 El color negro en el simbolismo de los antiguos Mexicanos. El color
 azul en el simbolismo de los antiguos Mexicanos. El color rojo en el
 simbolismo de los antiguos Mexicanos. In *Mito y simbología del México
 antiguo, segundo tomo especial de homenaje consagrado a honrar la memoria
 del ilustre antropólogo Doctor Hermann Beyer, fundador de la Sociedad
 Alemana Mexicanista y de El México Antiguo, primer tomo de sus obras
 completas* (Carmen Cook de Leonard, ed.). *El México Antiguo* 10: 471–
 475; 476–481; 482–487. (Reprint of three articles originally published
 in *Revista de Revistas* in 1921.)

BONIFAZ NUÑO, RUBEN, and FERNANDO ROBLES
 1981 *El arte en el Templo Mayor, México-Tenochtitlan.* Instituto Nacional de Antropología e Historia, Mexico.

BOUTON, KATHERINE
 1982 Mexico's Find of the Century. *Connoisseur* July 1982: 72–82.

CASO, ALFONSO
 1927 *El Teocalli de la Guerra Sagrada (descripción y estudio del monolito encontrado en los cimientos del Palacio Nacional).* Publicaciones de la Secretaría de Educación Pública, Monografías del Museo Nacional de Arqueología, Historia y Etnografía. Talleres Gráficos de la Nación, Mexico.

 1932 El culto al dios de la lluvia en Tizapan, D.F. *Boletín del Museo Nacional de Arqueología, Historia y Etnografía,* n.s., ép. 5, 1: 235–237.

 1940 El entierro del siglo. *Revista Mexicana de Estudios Antropológicos* 4: 65–76.

 1969 Y mientras el mundo exista, no cesará la gloria de México-Tenochtitlan; la legendaria "Piedra Pintada," regio monumento prehispánico puede ser rescatado ahora, al abrirse la ruta del "metro." *Nuestra Gente; Revista al Servicio de la Seguridad Social* 33: 30–37. (Reprint of article originally published in *El Nacional,* edición dominical, May 28, 1939).

CASO, ALFONSO, and SALVADOR MATEOS HIGUERA
 n.d. Catálogo de objetos arqueológicos del Museo Nacional de Antropología (Monolitos), México, 1944. Manuscript in the Archivo Histórico, Museo Nacional de Antropología. Instituto Nacional de Antropología e Historia, Mexico.

CHAVERO, ALFREDO
 1888 Historia antigua y de la conquista. In *México a través de los siglos* (Vicente Riva Palacio, ed.) 1. Espasa, Barcelona.

CODEX BORBONICUS
 1974 *Codex Borbonicus, Bibliothèque de l'Assemblée Nationale-Paris (Y 120)* (Karl Anton Nowotny and Jacqueline de Durand-Forest, eds.). Akademische Druck- u. Verlagsanstalt, Graz, Austria.

CONTRERAS S., EDUARDO, and PILAR LUNA E.
 1982 Excavaciones: Sección 2. In *El Templo Mayor: excavaciones y estudios* (Eduardo Matos Moctezuma, coord.): 71–102. Instituto Nacional de Antropología e Historia, Mexico.

DURAND-FOREST, JACQUELINE DE
 1974 Codex Borbonicus—Description codicologique. In *Codex Borbonicus* 1974: 27–32.

EL TEMPLO MAYOR DE MÉXICO
 1982 *El Templo Mayor de México* (Belén Martínez Diaz and Juan Blánquez Pérez, eds.). Dirección General de Bellas Artes, Archivos y Bibliotecas del Ministerio de Cultura de España. Madrid. (Exhibition catalogue.)

FERNÁNDEZ, MIGUEL ANGEL

 1935 Estudio de la pintura en la pirámide de Tenayuca. In *Tenayuca: estudio arqueológico de la pirámide de este lugar, hecho por el Departamento de Monumentos de la Secretaría de Educación Pública*: 103–106. Talleres Gráficos del Museo Nacional de Arqueología, Historia y Etnografía, Mexico.

FRANCO B., MARÍA LUISA

 1982 El tratamiento de conservación en piedra: tres casos. In *El Templo Mayor: excavaciones y estudios* (Eduardo Matos Moctezuma, coord.): 313–356. Instituto Nacional de Antropología e Historia, Mexico.

GARCIA COOK, ANGEL, and RAUL M. ARANA A.

 1978 *Rescate arqueológico del monolito Coyolxauhqui: informe preliminar*. Departamento de Salvamento Arqueológico, Instituto Nacional de Antropología e Historia, Mexico.

GLASS, JOHN B.

 1964 *Catálogo de la colección de códices*. Museo Nacional de Antropología, Instituto Nacional de Antropología e Historia, Mexico.

GLASS, JOHN B., with DONALD ROBERTSON

 1975 A Census of Native Middle American Pictorial Manuscripts. In *Handbook of Middle American Indians* (Robert Wauchope, Howard F. Cline, Charles Gibson, and H. B. Nicholson, eds.) 14: 81–252. University of Texas Press, Austin.

GUSSINYER, JORDI

 1970 Deidad descubierta en el Metro. *Boletín del Instituto Nacional de Antropología e Historia* 40: 41–42. Mexico.

HERNANDEZ PONS, ELSA C.

 1982 Sobre un conjunto de esculturas asociadas a las escalinatas del Templo Mayor. In *El Templo Mayor: excavaciones y estudios* (Eduardo Matos Moctezuma, coord.): 221–232. Instituto Nacional de Antropología e Historia, Mexico.

HERRERA, MOISÉS

 1935 Estudio comparativo de las serpientes de la pirámide con los crótalos vivos. In *Tenayuca: estudio arqueológico de la pirámide de este lugar, hecho por el Departamento de Monumentos de la Secretaría de Educación Pública*: 203–232. Talleres Gráficos del Museo Nacional de Arqueología, Historia y Etnografía, Mexico.

HEYDEN, DORIS

 1970 Deidad del agua encontrada en el Metro. *Boletín del Instituto Nacional de Antropología e Historia* 40: 35–40. Mexico.

HUERTA CARRILLO, ALEJANDRO

 1979 Apéndice 3: Analysis de la policromía de los petroglifos de la Estructura A. In *El Recinto Sagrado de México-Tenochtitlan: excavaciones,*

1968–69 y 1975–76 (Constanza Vega Sosa, coord.): 87–94. Instituto Nacional de Antropología e Historia, Mexico.

KELLEY, DAVID H., and HEINRICH BERLIN

1961 The 819-Day Count and Color-Direction Symbolism among the Classic Maya. *Middle American Research Institute, Tulane University, Publication* 26: 9–20. New Orleans.

LEHMANN, WALTER

1905 Die fünf im Kindbett gestorbenen Frauen des Westens und die fünf Götter des Südens in der mexikaner Mythologie. *Zeitschrift für Ethnologie* 37: 848–871.

1974 *Die Geschichte der Königreiche von Colhuacan und Mexico.* Text mit Ubersetzung von Walter Lehmann. Zweite, um ein Register vermehrte und berichtigte Auflage herausgegeben von Gerdt Kutscher. Quellenwerke zur alten Geschichte Amerikas aufgezeichnet in den Sprachen der Eingeborenen, herausgegeben vom Ibero-Amerikanischen Institut Preussischer Kulturbesitz, Schriftleitung Gerdt Kutscher 1. Verlag W. Kohlhammer, Stuttgart, Berlin, Köln, Mainz.

MATOS MOCTEZUMA, EDUARDO

1981 *Una visita al Templo Mayor de Tenochtitlan.* Instituto Nacional de Antropología e Historia, Mexico.

1982 Las excavaciones del Proyecto Templo Mayor (1978–1981); Sección 1. In *El Templo Mayor: excavaciones y estudios* (Eduardo Matos Moctezuma, coord.): 11–70. Instituto Nacional de Antropología e Historia, Mexico.

MAYER, BRANTZ

1844 *Mexico As It Was and As It Is.* J. Winchester, New York.

MOEDANO KOER, HUGO

1947 El friso de los Caciques. *Anales del Instituto Nacional de Antropología e Historia* 2: 113–136.

MOLINA, ALONSO DE

1970 *Vocabulario en lengua castellana y mexicana y mexicana y castellana* (Miguel León-Portilla, introd.) Facsimile ed. Editorial Porrúa, Mexico.

MOLINA MONTES, AUGUSTO F.

1980 The Building of Tenochtitlan. *National Geographic* 158 (6): 735–764.

NICHOLSON, H. B.

1971a Major Sculpture in Pre-Hispanic Central Mexico. In *Handbook of Middle American Indians* (Robert Wauchope, Gordon Ekholm, and Ignacio Bernal, eds.) 10: 92–134. University of Texas Press, Austin.

1971b Religion in Pre-Hispanic Central Mexico. In *Handbook of Middle American Indians* (Robert Wauchope, Gordon Ekholm, and Ignacio Bernal, eds.) 10: 395–446. University of Texas Press, Austin.

1973 The Late Pre-Hispanic Central Mexican (Aztec) Iconographic System. In *The Iconography of Middle American Sculpture:* 72–97. The Metropolitan Museum of Art, New York.

1980 Aztec Archive Established. *UCLA Latin Americanist* 3: 3.

1981 The Mixteca-Puebla Concept in Mesoamerican Archaeology: A Re-Examination. In *Ancient Mesoamerica: Selected Readings* (John A. Graham, ed.): 253–258. 2nd ed. Peek Publications, Palo Alto, California. (Reprint of 1960 article.)

1982 The Mixteca-Puebla Concept Revisited. In *The Art and Iconography of Late Post-Classic Central Mexico* (Elizabeth H. Boone, ed.): 227–254. Dumbarton Oaks, Washington.

1983 The Iconography of Tepeyollotl, a Postclassic Western Mesoamerican Deity. *Latin American Indian Literatures Association Newsletter* 2 (1): 3–4.

n.d. The New Tenochtitlan Templo Mayor Coyolxauhqui-Chantico Monument. To be published in the Festschrift for Prof. Gerdt Kutscher. Ibero-Amerikanisches Institut, Berlin. (In Press.)

NOWOTNY, KARL ANTON

1964 *Códices Becker I/II. Museo de Etnología de Viena. No. de inventario 60306 y 60307* (Karl A. Nowotny, ed., Baron W. v. Humboldt, trans., Gastón García Cantú, revis.). Instituto Nacional de Antropología e Historia, Mexico.

1970 *Beiträge zur Geschichte des Weltbildes: Farben und Weltrichtungen.* Wiener Beiträge zur Kulturgeschichte und Linguistik 17. Verlag Ferdinand Berger und Söhne, Ohg. Horn, Vienna.

NOWOTNY, KARL ANTON, and ROBERT STREBINGER

1959 Der Codex Becker (Le Manuscrit du Cacique). Technische Beschreibung und mikroanalytische Untersuchung der Farbstoffe. *Archiv für Völkerkunde* 13: 222–226.

OROZCO Y BERRA, MANUEL

1880 *Historia antigua y de la conquista de México.* 4 vols. and atlas. Mexico.

PRESCOTT, WILLIAM H.

1844 *Historia de la conquista de Méjico con un bosquejo preliminar de la civilización de los antiguos Mejicanos y la vida del conquistador Hernando Cortés* . . . (D. José María Gonzalez de la Vega, trans., D. Lucas Alaman, ed.). 2 vols. Imprenta de V. G. Torres, Mexico.

SAHAGÚN, BERNARDINO DE

1950–82 *Florentine Codex. General History of the Things of New Spain* (Arthur J. O. Anderson and Charles E. Dibble, eds. and trans.). 13 vols. School of American Research and University of Utah, Santa Fe.

1979 *Historia universal de las cosas de Nueva España.* Florentine Codex. 3 vols. Color photoreproduction. Mexico and Florence.

SALAZAR ORTEGÓN, PONCIANO

1955 Introducción. In Beyer 1955: 1–7.

SAUNDERS, NICK

1982 El Templo Mayor. *Popular Archaeology* 4 (5): 9–16.

SELER, EDUARD

1900–01 *The Tonalamatl of the Aubin Collection: An Old Mexican Picture Manuscript* (A. H. Keane, trans.). Hazell, Watson, and Viney, London and Aylesbury.

1902–23 *Gesammelte Abhandlungen zur Amerikanischen Sprach- und Altertumskunde.* 5 vols. A. Asher & Co. and Behrend & Co., Berlin.

SIECK FLANDES, ROBERT

1942 ¿Como estuvo pintada la piedra conocida con el nombre de "El Calendario Azteca?" In *Vigesimoséptimo Congreso Internacional de Americanistas, Actas de la primera sesión celebrada en la Ciudad de México en 1939* 1: 550–556. Instituto Nacional de Antropología e Historia, Mexico.

SOUSTELLE, JACQUES

1959 *Pensamiento cosmológico de los antiguos Mexicanos (representacion del mundo y del espacio)* (María Elena Landa A., trans.). Federación Estudiantil Poblana 1959–60, Puebla.

THOMPSON, J. ERIC S.

1934 *Sky Bearers, Colors and Directions in Maya and Mexican Religion.* Carnegie Institution of Washington, Publication 436. Washington.

TORRES, LUÍS

1966 Estudio de los colores del Códice Colombino. In Alfonso Caso, *Interpretación del Códice Colombino;* Mary Elizabeth Smith, *Las glosas del Códice Colombino:* 89–99. Sociedad Mexicana de Antropología, Mexico.

VEGA SOSA, CONSTANZA

1979 El Templo del Sol. Su relación con el glifo Chalchihuitl. El Templo de Ehecatl-Quetzalcoatl. In *El Recinto Sagrado de México-Tenochtitlan: excavaciones, 1968–69 y 1975–76* (Constanza Vega Sosa, coord.): 75–94. Instituto Nacional de Antropología e Historia, Mexico.

The Color of Mesoamerican
Architecture and Sculpture

ELIZABETH HILL BOONE

DUMBARTON OAKS

IN MESOAMERICA, color was an important aspect of both architecture and monumental sculpture from Olmec times to the Spanish Conquest. Although not all buildings and sculptures were painted, a sufficient number were colored red, or with a rich polychrome, to suggest that most Mesoamerican ceremonial and political centers were either entirely painted in brilliant hues or were highlighted with color. Thus, one can speak of the color of the city of Teotihuacan or of Cerros in a way not applicable to the neutrally hued urban centers of the twentieth century.

Buildings and sculptures in Mesoamerica seem not to have been painted as an afterthought; rather, paint was an integral part of the creative process and was probably carefully considered before and during construction and the carving of monuments. In this regard, color functioned less as decoration than as a vehicle for iconographic readings and symbolic meanings. Specific colors could aid in the identification of separate deities, living things, or objects, and they could refer broadly to more abstract phenomena and principles such as the cardinal directions, night, lineage, preciousness, and sacredness. Color, in many cases, completed the work of art.

In summarizing this symposium volume and looking at the use of color throughout Mesoamerica, I wanted to see whether the patterns of color use revealed by the specific essays held true also for other areas and periods such as the Gulf Coast, Classic Central Mexico, and Postclassic Yucatan. They do, by and large, and I have therefore tried to indicate the appearance of color in these regions and elsewhere, if only briefly and with the realization that this is only scratching the surface. The origin of the use of color on architecture and monumental sculpture was also a concern, and I was grateful to see that color accompanied the first examples of permanent ceremonial architecture and of monumental sculpture, among the Olmec.

THE PRECLASSIC

Color was clearly important to the Olmec, who expended great efforts to color the floors and platforms of their ceremonial centers and probably also polychromed their monumental sculptures. Even the multiple layers of fill that underlay constructions and covered the offerings were composed of distinctly colored sands and clays. Beneath colored layers of sand and clay at La Venta, monumental jaguar masks and pavements of serpentine blocks were set in clays of yellowish-olive, red, and green (Drucker, Heizer, and Squier 1950: 93, 129, 130). The Olmec also used different colored sands and clays for the floors of the ceremonial precinct, varying the colors in periodic rebuildings. At La Venta, Philip Drucker, Robert F. Heizer, and Robert J. Squier (1959: 17–26, 30–31, 36–37, 64–66) report floor surfaces or fills of pink, old-rose, purple, red, orange, yellow, olive, white, grey, cinnamon, buff, and brown. At one point, the La Venta builders, "always on the lookout for bright-colored materials for floors and structure surfacings," even spread a layer of finely crushed green serpentine (probably remnants from the manufacture of celts and mosaic pavements) over a white sandy floor for color (Drucker, Heizer, and Squier 1959: 23). At San Lorenzo, Michael D. Coe and Richard A. Diehl (1980: 39–41, 52–61) found floors of black-brown, pink, white, yellow, rust, and red, with such additional colors as orange, grey, and gold used for sub-floor layers. Both La Venta and San Lorenzo had platforms and walls surfaced with colored clays, especially yellow, red, and purple (Drucker, Heizer, and Squier 1959: 16, 65, 98; Coe and Diehl 1980: 52–54). Red covered some of the platforms at Cerro de las Mesas, too (Stirling 1943: 43).

Considering the conspicuous use of color on Olmec architecture, one might expect that the Olmec also colored their sculpture, and it seems they did. Little paint remains on Olmec monuments, which is not surprising considering the climate of the area, the age of the sculptures, and the abrasion of most of the stone, but red paint has survived on some sculptures. At San Lorenzo, a fragment of stone rope and Monument 42 (a column with an arm carved in relief) were covered with red pigment, and another basalt fragment had red pigment on one side (Coe and Diehl 1980: 246, 294, 351). Matthew Stirling (1943: 23) reports that Tres Zapotes Monument J (the lower portion of a seated figure) was once also painted red and that Monument 4 at La Venta (the largest colossal head at the site) was also originally painted; buried next to Monument 4, Stirling (1943: 58) found a fragment of the head "coated with a smooth-surfaced dark purplish-red paint." Although ancient traces of other colors have not been

found, I suspect Olmec sculpture was largely polychrome. This supposition is supported both by the conscious use of differently hued sands and clays in the architecture and by the polychrome Olmec-style murals in and around the caves of Juxtlahuaca and Oxtotitlan in Guerrero.

Mural 1 of Oxtotitlan, in particular, may well depict a richly costumed human seated on a polychrome altar (Grove 1970: frontispiece). The male figure in the mural sits on a jaguar-monster head that is nearly identical to the conventionalized jaguar masks carved on the altars at La Venta and San Lorenzo (Grove 1970: 8–10). The Oxtotitlan jaguar-mask is painted in blue-green, other shades of green, yellow, purple, and blue-black, on base colors of red-brown and red. The La Venta and San Lorenzo altars were likely to have been colored just as richly.

Elsewhere in the Preclassic and into the Protoclassic, monuments were also painted. In the highlands of the Pacific Coast, the well-preserved Izapa Stela 25 still has red pigment in the recesses of the carving (Norman 1976, 2: 132), as does Kaminaljuyu Stela 28 and the large stone incense pots from this site (Parsons n.d.: 200; Borhegyi 1965: 16). El Baul Stela 1 and Abaj Takalik Stela 3 were likewise painted red originally (Miles 1965: 261). It has additionally been suggested that the large number of smoothed, uncarved stelae at Izapa and other related Preclassic sites may have borne painted images similar to those depicted on the carved stelae (Norman 1976, 1: 4; Parsons n.d.: 37). According to Stephan Borhegyi (1965: 14), earthen mounds of Middle and Late Preclassic Kaminaljuyu were brightly painted; the structure of Mound E-III-3 was painted in several colors (Shook and Kidder 1952: 66). In Oaxaca, however, John Paddock (this volume) reports that existing exterior painted decoration is limited to red designs on white plaster.

More evidence for Preclassic painted architecture is available from the Maya Lowlands, and as David Freidel (this volume) explains, there seems to have been a shift from the exclusive use of red, black, and white to a more full polychromy in the Late Preclassic. At Cuello, Cerros, and Tikal, at least some of the early public buildings were painted a solid red. In the Late Preclassic, however, polychrome paint came to be used extensively in conjunction with sculptural programs of modeled stucco that decorated the pyramid facades.

By the close of the Preclassic period, painted buildings and sculptures were not uncommon throughout Mesoamerica. Extant traces of this paint may be relatively scarce, but this is to be expected since the unprotected painted surfaces would naturally be scoured and damaged by wear before the sculptures or buildings themselves were affected.

THE CLASSIC

With the Classic period there is increasing evidence for the use of specific chromatic schemes on architecture and sculpture in the Maya region. In the Southern Maya Lowlands, the polychrome facades of the Preclassic were replaced by exterior surfaces that were either left with the white color of the stucco and stone or were painted entirely in red; and the interior walls of Classic Maya buildings, where they were not covered with murals, were either left white, painted a solid red, or decorated with patterns of red and white (Schele, this volume). Polychrome paint was reserved for interior figural murals and for free-standing and architectural sculpture; the stelae and the interior and exterior relief panels were left white, were painted monochromatic red, or were polychrome. Where these reliefs were polychrome, they must have stood in sharp visual contrast to the plain walls. In the Northern Maya Lowlands, polychrome was apparently used with somewhat greater variety, for Jeff Kowalski (this volume) reports that some interior and exterior walls were covered with colors other than red. Red still dominated, however, and the Northern Maya mask panels, when they were not polychrome, were red.

Of the Classic period sites in Mesoamerica with painted architecture, Teotihuacan comes readily to mind, for almost all the exposed wall surfaces there were painted, and much of this paint is still visible. The interior wall murals have been well documented, but most of the exterior surfaces were painted, too, with red being the color most commonly found on outside walls, temple platforms, stairs, and even streets (Marquina 1964: 66–67; Miller 1973: 29, 36). The *taluds* were generally painted red, but the *tablero* panels were decorated with polychrome geometric motifs (Miller 1973: 36). Where the *taluds* and *tableros* were covered with relief sculpture, as with the Temple of Quetzalcoatl, this sculpture was polychrome. At nearby Cholula, the Teotihuacan period *tableros* were likewise sculptured and/or painted with polychrome (Marquina 1964: 121). Later, at Xochicalco, the Pyramid of the Feathered Serpent seems to have been polychromed and then covered later with a coat of red (Marquina 1964: 138).

As Teotihuacan influence spread to highland Guatemala, the decorative program of its architecture was carried as well. During the Esperanza phase at Kaminaljuyu the cornices, summit platforms, and *tableros* came to be decorated with Teotihuacan-like motifs painted in various colors, and red paint was applied to the stairways (Kidder, Jennings, and Shook 1977: 15, 18, 43).

In the Gulf Coast, a range of colors was used to decorate both architecture and sculpture. The main buildings at El Tajin were painted in brilliant

colors (Marquina 1964: 450), and Wilkerson (1976) specifies structures at the site painted with red and black, red, blue, and exterior murals in blue, yellow, and black. The large terracotta figures at El Zapotal from the Late Classic period, many of which bear traces of red, ochre, blue, green, white, and black paint (Gutiérrez Solana and Hamilton 1977: 36) suggest that other sculptures in the Gulf Coast were polychromed as well.

Only in Oaxaca does exterior painted architecture seem not to have been the rule. Although the floors of some patios seem to have been colored red, and the tombs of the Classic period were decorated with richly colored murals, Paddock (this volume) reports no evidence that the facade *tableros* at Monte Alban, even those bearing relief sculpture, were painted. The large ceramic vases and *braseros* were polychrome in some cases, but the evidence for painted stone sculptures is equivocal.

THE POSTCLASSIC

In the Postclassic the question is not so much whether buildings and sculptures were painted but how they were colored. Throughout Postclassic Mesoamerica, color is found on architectural reliefs and free-standing sculptures, and murals were painted on the interior walls of many important buildings.

In Oaxaca the palette continued to have less variety than elsewhere (Paddock, this volume). Polychromy endured on large-size ceramic figures but is not well documented on stone sculptures. At Mitla the interiors of the palaces were simply painted with red on the floors, around the doorways, and partly up the walls, and the patio floors were colored red. The Mitla *grecas* were coated entirely with red, or the outer surfaces of the stone mosaics were painted white to contrast with the red-colored inset stones. The famous murals at Mitla, too, had this bichrome scheme of principally white figures on a dark red ground.

In Central Mexico the chromatic scheme leaned more heavily toward polychromy, perhaps as a legacy from Teotihuacan. At Tula, Ellen Taylor Baird (this volume) reports that red was consistently used on floors and walls and as the background color on polychrome reliefs. Polychromy seems to have been reserved, as in the Maya area, for architectural reliefs and sculptures in the round and for interior murals. The exteriors of Pyramid B and possibly other buildings were left the white of the stucco coating where the walls were not covered with reliefs. What is striking at Tula, however, and forms the basis of Baird's interpretation of Pyramid B, is that the exterior *tablero* reliefs of Pyramid B were not colored but remained white. The free-standing sculptures and all the other architec-

tural reliefs at Tula—the banquettes, altars, and friezes—were richly painted in a variety of generally naturalistic hues (excepting the pilasters in the back of the Pyramid B temple, which were red).

Comparisons of Tula to its "sister city" Chichen Itza are apt here, for Toltec Chichen was generally painted in the same manner as Tula, with two exceptions. As at Tula, Chichen floors were red, interior walls were decorated with bands of several colors and with murals, and architectural reliefs and three-dimensional sculptures were polychromed; red dominated the backgrounds of the reliefs, and even the serpent columns were colored in the same manner with red and blue (Ruppert 1952: 22, 43, 82; Morris, Charlot, and Morris 1931, 1: 20, 23, 35–36, 235, 257; 2: pls. 6, 14, 28–170). Yet at the Temple of the Warriors at Chichen the carved pilasters and the exterior relief panels (set into the white of the wall) were multicolored. The polychromy of the Temple of the Warriors may relate to the Northern Maya tradition of painting mask panels in red or many colors (Kowalski, this volume), although the chromatic difference between the Temple of the Warriors and Pyramid B may equally reflect a fundamental difference in the nature and iconographic "reading" of the two buildings.

The polychromy of Aztec sculpture, described by H. B. Nicholson (this volume), probably derives directly from the practice in Toltec times, but it may also have been reinforced by the painting of Huastec sculptures, on which traces of many colored pigments can still be found (de la Fuente and Gutiérrez Solana 1980: 113, 145, 215, 304, 312, 328, 348, 369). The majority of Aztec sculpture was colored naturalistically or according to the specifics of the iconographic system, but red still dominated somewhat. As at Tula, red was used by the Aztecs for the background of reliefs.

Probably following the Toltec tradition, the exteriors of Aztec buildings seem not to have been generally colored, except where they were decorated with polychrome sculptures and painted moldings and panels. The archaeological and ethnohistorical evidence does indicate that some color was used, however, and painted buildings have indeed been excavated.

The conquistador Bernal Díaz del Castillo (1956: 196, 217, 218, 223) notes that the temples, palaces, and plazas of Tenochtitlan and Tlatelolco were plastered, burnished, and "gleaming white." Motolinía (1971: 83–84) also describes the temples as white and plastered, and Francisco López de Gómara (1964: 146) and Diego Durán (1964: 32, 1971: 135, 156, 188) both refer to white plastered structures. Yet Durán (1971: 75–76) also says that the temples were "all stuccoed, carved, and crowned with different types of merlons, painted with animals, [covered] with stone figures . . . ," but the painted animals he mentions may be sculptural. In the pictorial manuscripts, Aztec architecture is always depicted as white, with or without

painted sculptural decoration (Sahagún 1905: 269r; Codices Aubin 26r, 38r, 38v, 42r; Azcatitlan 12, 18–22; Borbonicus 15, 24, 25, 29–36; Ixtlilxochitl 112v; Magliabechiano 40r, 70r; Mendoza 69r; Telleriano-Remensis 31r, 32r, 36v, 39r, 40r).

Exterior color appeared along moldings, around doorways, and especially in the decorative panels inset into the roof facades. The chroniclers particularly mention the doorway of the round Temple of Quetzalcoatl, which was "carved in the form of a serpent's mouth and diabolically painted" (López de Gómara 1964: 165). The roof panels and merlons of the Temple Mayor were predominately blue for the Tlaloc temple and red and black for the Huitzilopochtli temple (Durán 1971: 76; Codex Telleriano-Remensis 39r).

Although the principal temples and pyramids were predominately white, the flat exterior walls of some of the smaller temples and shrines were painted. In the vicinity of the Templo Mayor, six painted shrines have been discovered since 1964. Three of these—the two "Red Temples" recently excavated on the north and south sides of the Templo Mayor (Matos Moctezuma 1982: 42, 65–66) and another shrine excavated in 1970 north of the Templo Mayor (Gussinyer 1970)—have *talud/tablero*-style pyramids and low *atrio* walls painted red and white, and a fourth *talud-tablero* pyramid has large Tlaloc masks painted on the *taluds* (Matos Moctezuma 1964). Just to the north of the Templo Mayor are also the small Temple of the Eagles, which has traces of yellow paint on its south face, and the shrine of the skulls, which was colored red (Matos Moctezuma 1982: 61–62). These small temples, with the exception of the shrine of skulls, seem to be conscious archaisms, because their architecture, their color, and the motifs painted on the walls recall earlier Teotihuacan buildings and murals. They would have stood in bright contrast to the white of the main pyramid and plaza.

Aztec royal palaces may have had some color on their exteriors, for Sahagún (1959–70, bk. 2: 270), who does not discuss the color of buildings in general, describes the *tecpancalli,* the house of the ruler, as:

> well made, the product of carved stone, of sculpted stone, plastered, plastered in all places: a plastered house; a red house. It is a red house, an obsidian serpent house. It is an obsidian serpent house, a painted house. It is a painted house—painted. It is wonderful, of diverse striped colors, of intricate design, intricate.

This contrasts with Bernal Díaz del Castillo's (1956: 196) description of the palaces as being "coated with shining cement" and with the white-colored palace depicted in the Codex Mendoza (69r). It may be that Sahagún is

referring to the specific house of the fourth *tlatoani,* Itzcoatl; regardless, it would seem that some palaces must have been painted.

On the inside, the walls of the palaces and temples were often painted or covered with colorful fabrics or feather hangings (Díaz del Castillo 1956: 194; Durán 1971: 99–100, 188; López de Gómara 1964: 148). The recent Templo Mayor excavations have revealed that the interior walls of the twin temples of Phase II were painted with stripes and geometric motifs, in black, red, white, and blue (Bonifaz Nuño and Robles 1981: pl. 41; Matos Moctezuma 1982: 43), and López de Gómara (1964: 164) describes the final shrines atop the Templo Mayor as having stone walls "painted with ugly and horrible figures." Adjacent to the Templo Mayor, figural murals have been uncovered in the palace structure just to the north.

Color on Aztec architecture thus seems to have been used sparingly against the white of the walls and pyramid faces. On moldings, around doorways, and in roof panels it punctuated the architectural features of the structures, and on relief sculpture it made the carved forms more prominent and iconographically readable. On small temples and shrines color was used more broadly, covering and enlivening all the surfaces. One can thus envision the ritual precinct of Tenochtitlan as having been surfaced with glistening white plaster, highlighted with polychrome details.

I have not mentioned the painted exterior and interior architecture of the east coast of the Yucatan peninsula before now because the painting scheme there seems so at odds with those in other parts of Mesoamerica. The Terminal Classic/Early Postclassic murals at Tancah and Tulum (Miller 1982: pls. 6–22) are just barely within the chromatic range seen elsewhere during this time, because at Tancah and Tulum the murals have a white ground, rather than the common red, and the figures are almost completely blue. Then, in the Late Postclassic, the walls and facades are dominated by blue to a surprising degree. Figures rendered in black, white, and light blue on a brilliant blue ground cover the interior walls and exterior columns of Tulum Structure 1 (Miller 1982: pls. 21–24) and the walls and facade of Structure 5 (pls. 25–29); blue figures on a black ground blanket the interior of Tulum Structure 16, which also has much blue on its facade (pls. 30–40); and Xelha Structure A also has figures rendered solely in blue, black, and white (pl. 46). One might speculate that the blueness of Tancah, Tulum, and Xelha was the result of either whim, fashion, an abundance of blue pigment nearby, or a more profound iconographic meaning. Miller (1982: 85–96) sees the murals as expressing the theme of rebirth and renewal with subthemes involving the dawn, Venus and the rising sun, the moon, emergence from the underworld, and the liminal state between the upperworld and the underworld. But blue is

not normally associated with any of these themes. Most of the protagonists and elements in the paintings are still to be identified, however, and we must wait until the iconographic program can be fully worked out to know whether or not the blue is symbolic. Certainly its use here is remarkably different from the more sparing use of blue elsewhere.

<div align="center">COLOR COLORADO</div>

The predominance of red throughout Pre-Columbian Mesoamerica is striking. Red is the pigment most often found remaining on sculptures and buildings, and although this abundance may be due to the tenacity of the pigment itself, red was indeed used more than any other color. The Preclassic and Classic Maya painted some of their buildings and sculptures entirely in red, and they did not use other colors as the basis for monochromatic schemes. When sculptures were painted but not polychromed, they were colored red. There was more variety in the choice of architectural color at Teotihuacan, but red still dominated, and even at Tenochtitlan the colored shrines were largely red. Practically no other color was used in Oaxaca.

Red consistently formed the background for colored and uncolored reliefs. The Lowland Maya used red for the grounds of their polychrome facades in the Late Preclassic and for their polychrome relief panels in the Classic. The lattice panels on northern Maya architecture displayed white lattice work against a red ground, and in Oaxaca the *greca* panels were either all red or were composed of white outer designs and red inset stones. The Toltecs and Aztecs, too, preferred red as the background color for polychrome reliefs.

In the Maya area, in Oaxaca, and in Central Mexico, red was the color used for floors, plazas, and walls when these were not left plain or the walls polychromed. Only at Tancah and Tulum in the Early and Late Postclassic was the ubiquitous red replaced by blue.

Several authors in this volume (Schele, Kowalski, Paddock) have addressed the question of why red was used so extensively. There are certainly economic reasons. Iron-oxide red is a plentiful pigment, inexpensive to process; and the scarcity and cost of other pigments, especially the yellows and blues, may have precluded their use except on a small scale. Economic feasibility was clearly an important factor in the use of color and may have been the underlying reason for the predominance of red, but I would agree with Freidel, Schele, and Kowalski in thinking there were ideological considerations, too. For example, the Aztecs, who commanded great material resources and could presumably afford a lavish display of

rare colors, chose not to paint most of the flat exterior surfaces of their buildings, and they preferred red for such things as the backgrounds of polychrome reliefs.

Red may have been used in the Maya area because of its association with the "blood complex" and the importance of lineage blood in legitimizing political succession and rule (Freidel and Schele), so that the pyramids and temples constructed over the tombs of rulers, and the reliefs carved in their honor, would have been symbolically enveloped in the blood of the lineage. As Kowalski indicates, red is also associated with the east, the preeminent cardinal direction and home of the principal Maya rain god; this association might have been especially significant to the Maya in the Yucatan peninsula where the rains are so important. In Central Mexico, particularly in the Postclassic, the linkage of red with blood and sacrificial liquid—the drink of the gods—surely favored its use. But in all cases, the meaning of red or of other colors would depend on the context of structure or sculpture in that particular culture.

Color on architecture and sculpture in Mesoamerica served not only to enliven the forms, but to identify specific objects, persons, and gods; and it carried broader ideological connotations. Baird has used the symbolic language of color to reevaluate the nature and attribution of Pyramid B at Tula, and Freidel has seen color used by the Late Preclassic Maya as a code to the reading of motifs that could have many meanings. Schele, Kowalski, and Nicholson also discuss the naturalistic and symbolic use of color, among the Maya and the Aztecs, and Schele points out the ideological importance of color to the Maya by noting that the removal or obscuring of color seems to have been one way of "killing" architectural sculpture. Color, when it appears on architecture and sculpture, may sometimes have been a purely decorative element added according to the fashion of the time, but, by and large, color carried with it certain specific and generic meanings that were intrinsically a part of the iconographic program.

BIBLIOGRAPHY

BONIFAZ NUÑO, RUBÉN, and FERNANDO ROBLES
 1981 *The Art in the Great Temple. México-Tenochtitlan.* Instituto Nacional de Antropología e Historia, Mexico.

BORHEGYI, STEPHAN F.
 1965 Archaeological Synthesis of the Guatemalan Highlands. In *Handbook of Middle American Indians* (Robert Wauchope and Gordon R. Willey, eds.) 2: 3–58. University of Texas Press, Austin.

CODEX AUBIN
 1981 *Geschichte der Azteken. Codex Aubin und verwandte Dokumente* (Walter Lehmann and Gerdt Kutscher, eds.): 1–60, 213–294. Gebr. Mann Verlag, Berlin.

CODEX AZCATITLAN
 1949 El Códice Azcatítlan (Robert Barlow, ed.). *Journal de la Société des Américanistes,* n.s. 37: 101–135, atlas.

CODEX BORBONICUS
 1974 *Codex Borbonicus. Bibliothèque de l'Assemblée Nationale, Paris (Y 120)* (Karl Anton Nowotny and Jacqueline de Durand-Forest, eds.). Akademische Druck- u. Verlagsanstalt, Graz, Austria.

CODEX IXTLILXOCHITL
 1976 *Codex Ixtlilxochitl, Bibliothèque Nationale, Paris (MS. MEX. 65–71)* (Jacqueline de Durand-Forest, ed.). Akademische Druck- u. Verlagsanstalt, Graz, Austria.

CODEX MAGLIABECHIANO
 1970 *Codex Magliabechiano CL. XIII, 3 (B. R. 232). Biblioteca Nazionale Centrale di Firenze, Faksimile* (Ferdinand Anders, ed.). Akademische Druck- u. Verlagsanstalt, Graz, Austria.

CODEX MENDOZA
 1938 *Codex Mendoza. The Mexican Manuscript Known as the Collection of Mendoza and Preserved in the Bodleian Library, Oxford* (James Cooper Clark, ed.). 3 vols. Waterlow and Sons, London.

CODEX TELLERIANO-REMENSIS
 1899 *Codex Telleriano-Remensis, Manuscrit mexicain du cabinet de Ch. M. Le Tellier, Archevêque de Reims, à la Bibliothèque Nationale* (E. T. Hamy, ed.). Duc de Loubat, Paris.

COE, MICHAEL D., and RICHARD A. DIEHL
 1980 *In the Land of the Olmec. Volume 1, The Archaeology of San Lorenzo Tenochtitlán.* University of Texas Press, Austin.

Elizabeth Hill Boone

DE LA FUENTE, BEATRIZ, and NELLY GUTIÉRREZ SOLANA
 1980 *Escultura huasteca en piedra: Catálogo.* Instituto de Investigaciones Estéticas, Universidad Nacional Autónoma de México. Mexico.

DÍAZ DEL CASTILLO, BERNAL
 1956 *The Discovery and Conquest of Mexico, 1517–1521* (Irving A. Leonard, ed.). Farrar, Straus, and Cudahy, New York.

DRUCKER, PHILIP, ROBERT F. HEIZER, and ROBERT J. SQUIER
 1959 *Excavations at La Venta, Tabasco, 1955.* Smithsonian Institution, Bureau of American Ethnology, Bulletin 170. Washington.

DURAN, DIEGO
 1964 *The Aztecs. The History of the Indies of New Spain* (Doris Heyden and Fernando Horcasitas, trans. and eds.). Orion Press, New York.
 1971 *Book of the Gods and Rites and The Ancient Calendar* (Fernando Horcasitas and Doris Heyden, trans. and eds.). University of Oklahoma Press, Norman.

GROVE, DAVID C.
 1970 *The Olmec Paintings of Oxtotitlan Cave, Guerrero, Mexico.* Studies in Pre-Columbian Art and Archaeology 6. Dumbarton Oaks, Washington.

GUSSINYER, JORDI
 1970 Un adoratorio azteca decorado con pinturas. *Boletín del Instituto Nacional de Antropología e Historia* 40: 30–35. Mexico.

GUTIERREZ SOLANA, NELLY, and SUSAN K. HAMILTON
 1977 *Las esculturas en terracotta de El Zapotal, Veracruz.* Instituto de Investigaciones Estéticas, Universidad Nacional Autónoma de México, Mexico.

KIDDER, ALFRED V., JESSE D. JENNINGS, and EDWIN M. SHOOK
 1977 *Excavations at Kaminaljuyu, Guatemala.* Pennsylvania State University Press, University Park. (Originally published as Carnegie Institution of Washington, Publication 561, 1946.)

LÓPEZ DE GOMARA, FRANCISCO
 1964 *Cortés. The Life of the Conqueror by His Secretary* (Lesley Byrd Simpson, trans. and ed.). University of California Press, Berkeley.

MARQUINA, IGNACIO
 1964 *Arquitectura prehispánica.* 2nd ed. Instituto Nacional de Antropología e Historia, Mexico.

MATOS MOCTEZUMA, EDUARDO
 1964 El adoratorio decorado de las Calles de Argentina. *Anales del Instituto Nacional de Antropología e Historia* 17: 127–138.
 1982 *El Templo Mayor: excavaciones y estudios.* 1 volume and atlas. Instituto Nacional de Antropología e Historia, Mexico.

MILES, S. W.
1965 Sculpture of the Guatemala-Chiapas Highlands and Pacific Slopes, and Associated Hierogylphs. In *Handbook of Middle American Indians* (Robert Wauchope and Gordon R. Willey, eds.) 2: 237–275. University of Texas Press, Austin.

MILLER, ARTHUR G.
1973 *The Mural Painting of Teotihuacan*. Dumbarton Oaks, Washington.
1982 *On the Edge of the Sea: Mural Painting at Tancah-Tulum, Quintana Roo, Mexico*. Dumbarton Oaks, Washington.

MORRIS, EARL H., JEAN CHARLOT, and ANNE AXTELL MORRIS
1931 *The Temple of the Warriors at Chichén Itzá, Yucatan*. 2 vols. Carnegie Institution of Washington, Publication 406. Washington.

MOTOLINÍA, or TORIBIO DE BENAVENTE
1971 *Memoriales o Libro de las cosas de la Nueva España y de los naturales de ella* (Edmundo O'Gorman, ed.). Instituto de Investigaciones Históricas, Universidad Nacional Autónoma de México. Mexico.

NORMAN, V. GARTH
1973–76 *Izapa Sculpture*. Papers of the New World Archaeological Foundation, 30. 2 vols. Brigham Young University, Provo, Utah.

PARSONS, LEE ALLEN
n.d. The Origins of Maya Art: A Study of the Monumental Stone Sculpture of Kaminaljuyu, Guatemala, and the Southern Pacific Coast. Dumbarton Oaks, Washington. (In press.)

RUPPERT, KARL
1952 *Chichen Itza. Architectural Notes and Plans*. Carnegie Institution of Washington, Publication 595. Washington.

SAHAGUN, BERNARDINO DE
1905 *Historia general de las cosas de Nueva España. Edición parcial en facsímile de los Códices Matritenses en lengua mexicana* (Francisco del Paso y Troncoso, ed.) 1. Hauser y Menet, Madrid.
1950–82 *Florentine Codex. General History of the Things of New Spain* (Arthur J. O. Anderson and Charles E. Dibble, eds. and trans.). 13 vols. School of American Research and University of Utah, Santa Fe.

SHOOK, EDWIN M., and ALFRED V. KIDDER
1952 *Mound E-III-3, Kaminaljuyu, Guatemala*. Carnegie Institution of Washington, Publication 596: 33–127, figs. 1–81.

STIRLING, MATTHEW W.
1943 *Stone Monuments of Southern Mexico*. Smithsonian Institution, Bureau of American Ethnology, Bulletin 138. Washington.

Elizabeth Hill Boone

WILKERSON, S. JEFFREY K.
 1976 *The Sculptures of El Tajin, Veracruz, Mexico: A Special Exhibition of Photographs and Drawings, University Gallery, February 15 through March 21, 1976*. College of Fine Arts, University of Florida, Gainesville.

Pl. 1 Detail of the facade on Str. 6B at Cerros showing the full range of colors used in Late Preclassic polychrome decoration in the Maya lowlands. Photograph by David Freidel.

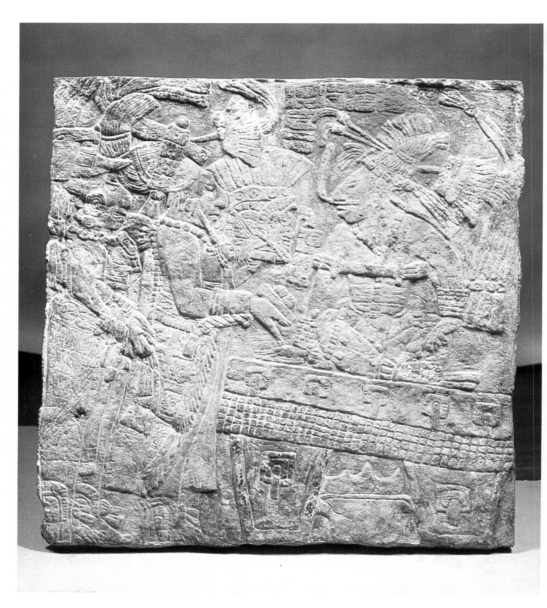

Pl. 2 New York Relief Panel. Michael C. Rockefeller Collection, Metropolitan Museum of Art.

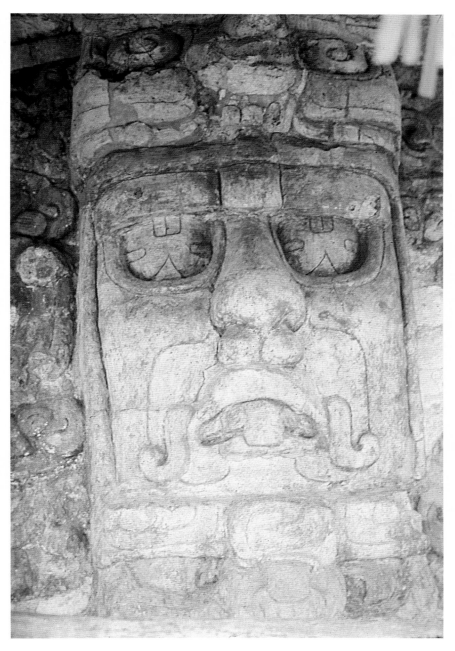

Pl. 3 Kohunlich, Pyramid of the Masks, colossal red-painted stucco mask. Photo-graph by Jeff Kowalski.

Pl. 4 Uxmal, Cemetery Temple, painted doorjamb. Photograph by Jeff Kowalski.

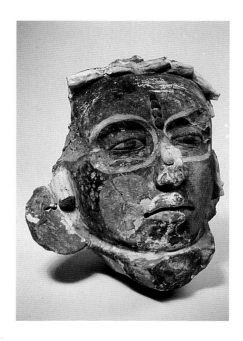

Pl. 5 Uxmal, polychrome stucco portrait head said to have come from the House of the Governor. Height, 27.9 cm. Photograph courtesy of the Museum of the American Indian, Heye Foundation.

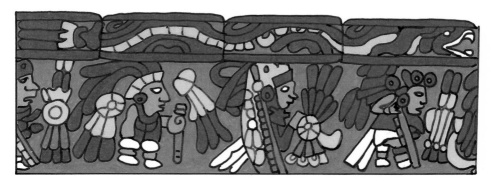

Pl. 6 Processional figures from the Great Vestibule, Tula (drawing by Ellen Baird after Acosta 1945: figs. 25, 26; Moedano 1947: op. p. 114).

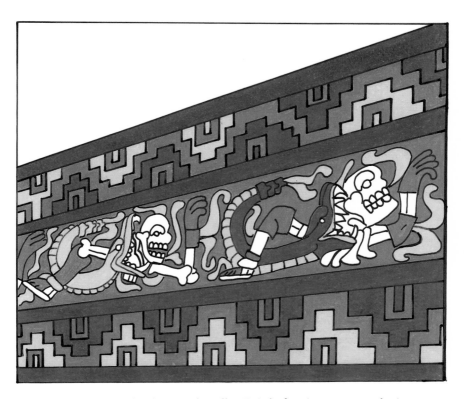

Pl. 7 Coatepantli, Tula (drawing by Ellen Baird after Acosta 1964: pl. 1).

Pl. 8a Bands of color from the north-south passageway on the west side of Pyramid B, Tula (drawing by Ellen Baird after Acosta 1954: fig. 3).

Pl. 8b Bands of color on the east side of the wall east of Building 1, Tula (drawing by Ellen Baird after Acosta 1964: pl. XVI A).

a b

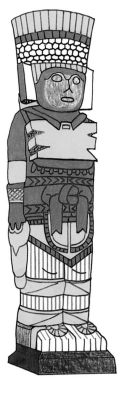

Pl. 9 Atlantid, Pyramid B, Tula (drawing by Ellen Baird after Martínez del Río and Acosta 1957: cover).

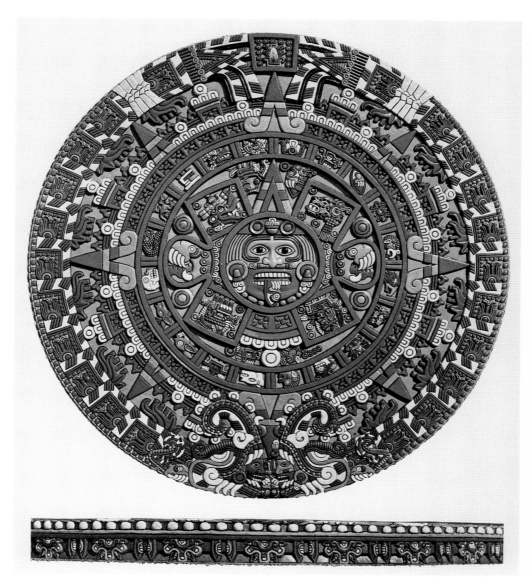

Pl. 10 The Roberto Sieck Flandes color reconstruction of the Stone of the Sun (after Sieck Flandes 1942: 551).

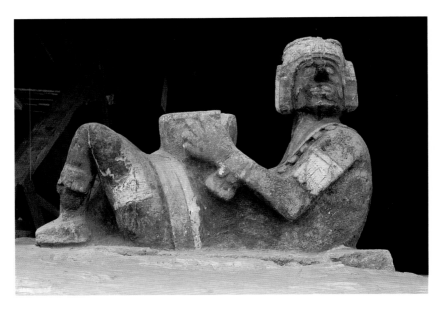

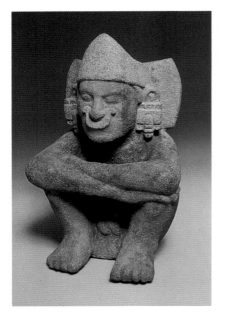

Pl. 11 The Chacmool from Phase II of the Templo Mayor of Mexico Tenochtitlan. Photograph by Salvador Guil'liem, courtesy of the Instituto Nacional de Antropología e Historia, Mexico.

Pl. 12 Polychrome pulque god from Ofrenda 6 of the Templo Mayor of Mexico Tenochtitlan. Photograph by José Naranjo, courtesy of the National Gallery of Art.